SUN VALLEY SIGNATURES III

A PHOTOGRAPHIC PORTRAIT OF THE SUN VALLEY AREA

Photography by David R. Stoecklein

ISBN 0-922029-00-8

Publisher: David R. Stoecklein
Photographer: David R. Stoecklein
Designer/Typographer: Typographics, Ketchum, Id.
Color Separations/Printing: Sun Litho, Salt Lake City, UT

All photos in this book are available in original signed prints.
Please write or call:

David R. Stoecklein
P.O. Box 856
Ketchum, Idaho 83340
208-726-5191
800-727-5191

ACKNOWLEDGEMENTS

I could not do this book or any other photography project without the loving support of my beautiful wife, Mary, or my three naughty boys Drew, Taylor and Colby.

I would like to give special thanks to my team: Gretchen Palmer, Steve Mason, Kris Olenick and Wendy Carter who style models, organize the shoots, edit the film and organize the office. They keep me, and most of all, my clients happy. Thanks guys, I couldn't have done it without you.

F O R W A R D

Sun Valley casts a spell that inspires people to give up lucrative jobs in the city for a lifestyle weighted heavily toward recreation and the outdoors. It can also drive a first-time visitor straight to a real estate office in search of a cabin in the Sawtooths, a home in Ketchum, or a condominium in Sun Valley. This feeling overtook me in 1970 on my first visit to Sun Valley, but I didn't move here until 1979 when I decided that of all the ski resorts I had worked or lived in, Sun Valley was the best to raise a family.

To most of us who live or vacation here, Sun Valley is much more than a resort. It's a great environment with recreational opportunities—a playground, if you will—that is a driving force in our lives.

Within the confines of the Wood River Valley, you can wear yourself ragged with all the possibilities. In the winter you can Alpine ski on Baldy, cross-country ski at Galena, stay at a yurt in the Pioneers or snowmobile up Baker Creek. When the snows leave, there's tennis, swimming, golf, mountain biking, fishing, hunting, horseback riding and much much more.

Expand the playground to include everything accessible within a one hour drive in any direction and you have world-class hunting and fishing on the Snake, Little Wood and Big Lost rivers; hiking and camping in the Pioneer, Sawtooth, or White Cloud mountains; windsurfing and water-skiing at Magic Reservoir; or kayaking and rafting on the Snake, Salmon and Payette rivers.

If it's the recreation and natural beauty that puts us under that Sun Valley spell, it's the warm and friendly people that keep us enchanted. The grand mosaic of ranchers, stock brokers, carpenters, river guides, athletes, restaurant workers and artists all living together in pursuit of a healthy, outdoor lifestyle with room for individuality.

This book is for you, the people of the Wood River Valley. I hope it helps you recall the feeling that you first experienced here, and that it makes you want to get out and continue discovering the beauty of our valley.

David R. Stoecklein

DEDICATION

I would like to dedicate Sun Valley Signatures III to the memory of Lane Parrish.

Lane was always the first in the lift line on a powder morning and the last off the mountain. Most of all he was the first to help a friend in need. Lane never forgot his friends and we'll never forget him.

Thanks Lane, for all your help. We miss you.

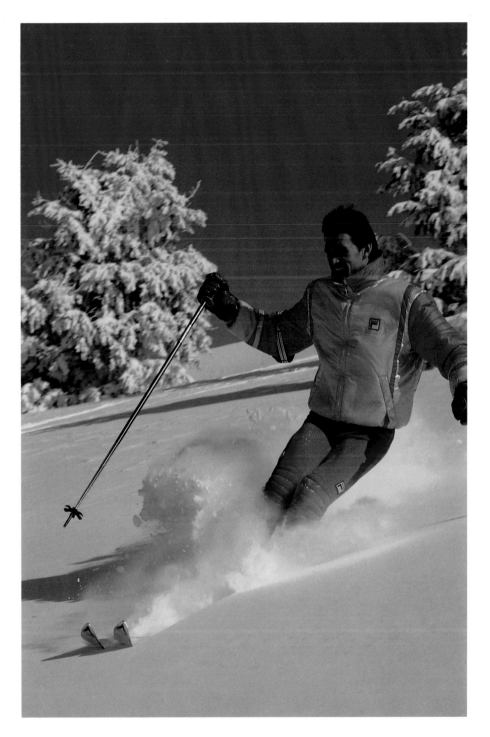

LANE PARRISH, SKIING HIS FAVORITE SPOT,
THE BACKSIDE OF WARM SPRINGS
Plate 1

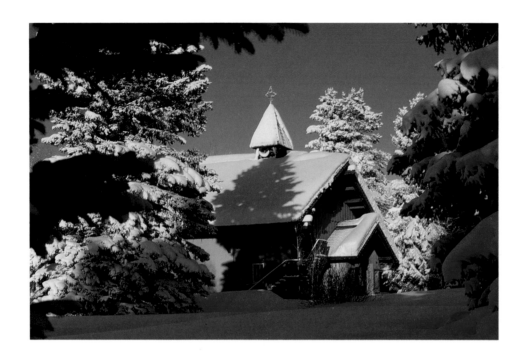

SUN VALLEY OPERA HOUSE
Plate 2

SUN VALLEY LAKE
Plate 3

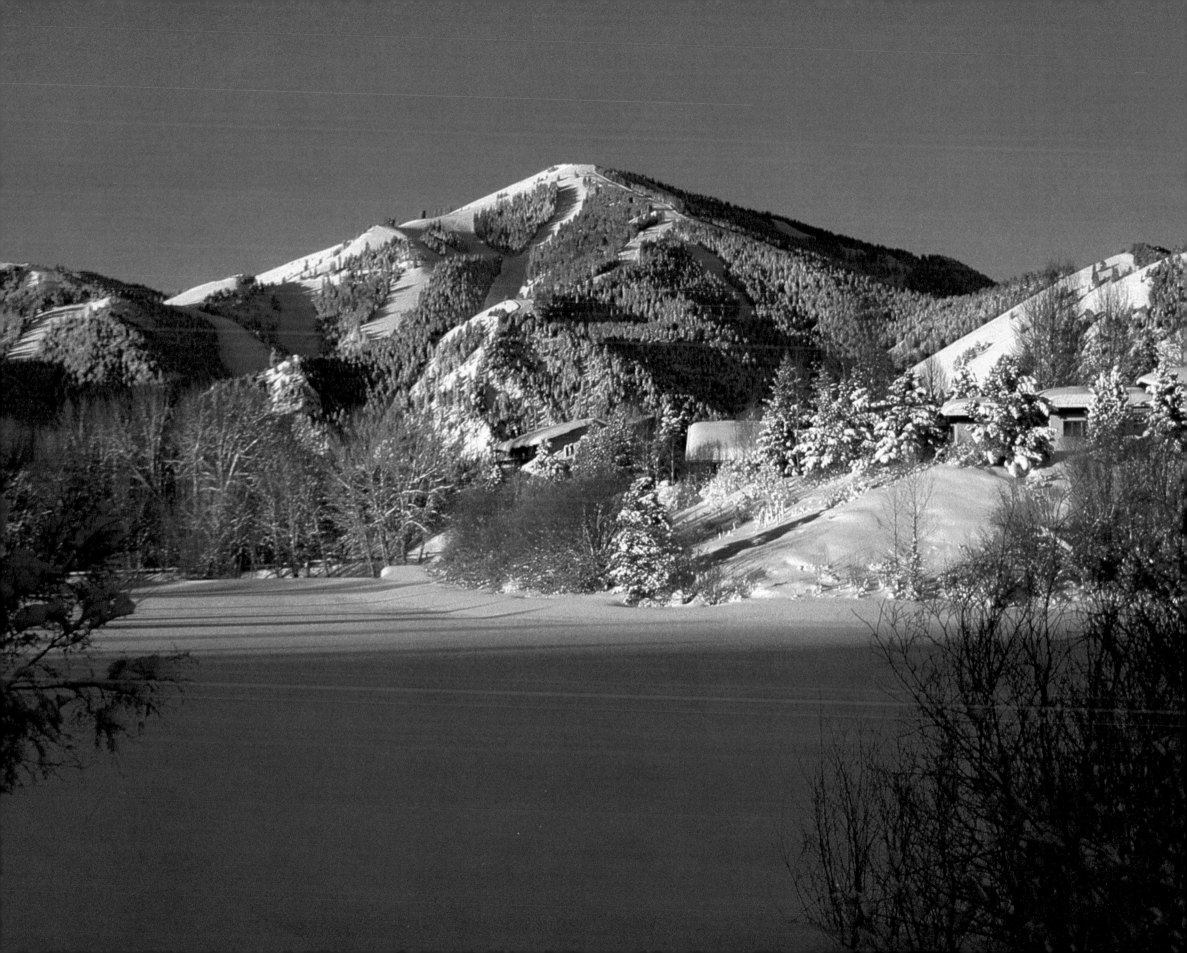

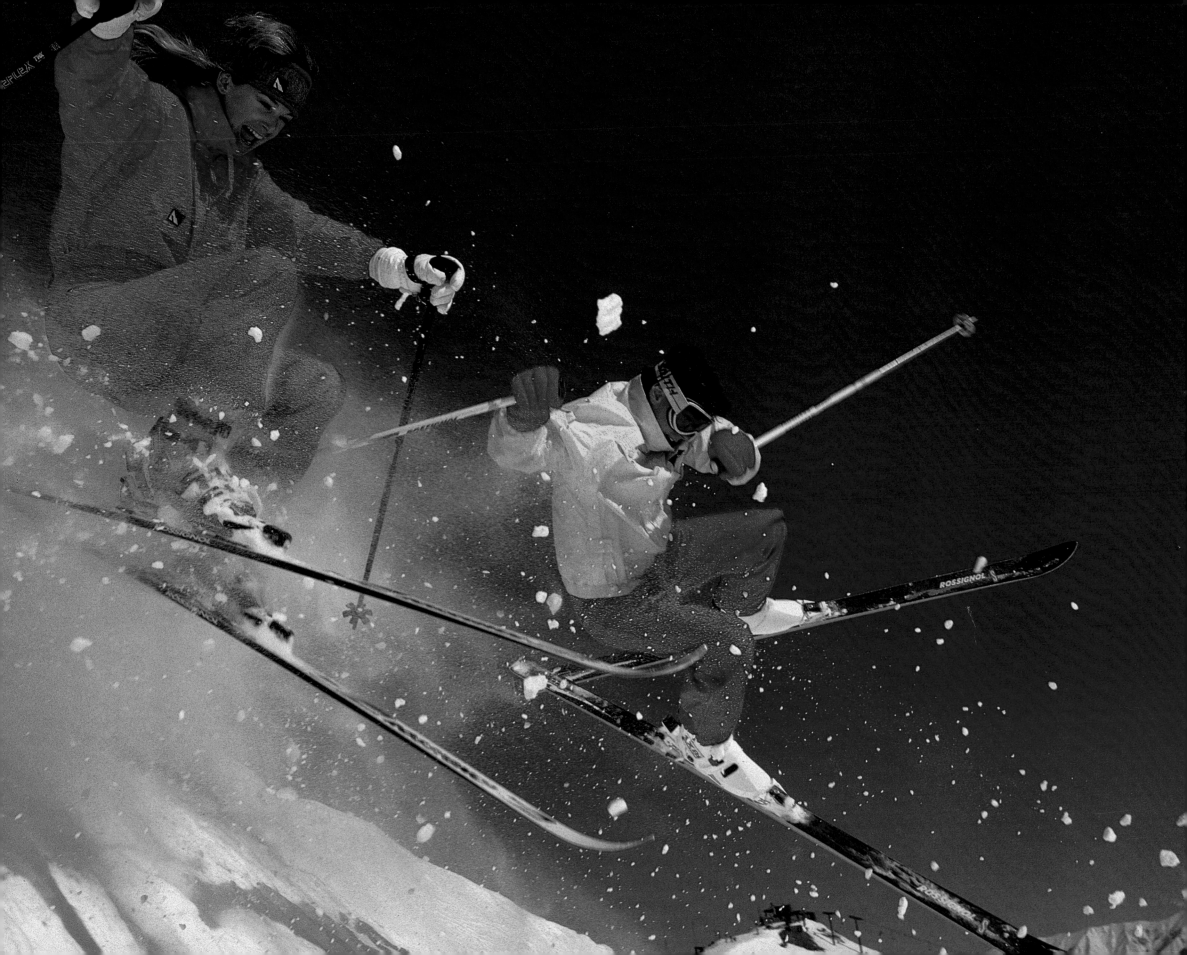

BACKSIDE OF DOLLAR MOUNTAIN
Plate 5

BACKSIDE OF DOLLAR MOUNTAIN
Plate 6

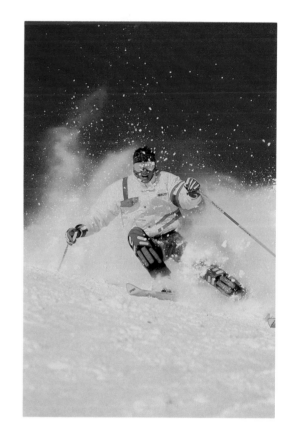

SKIING RIDGE
Plate 7

SKIING THE BOWLS
Plate 4

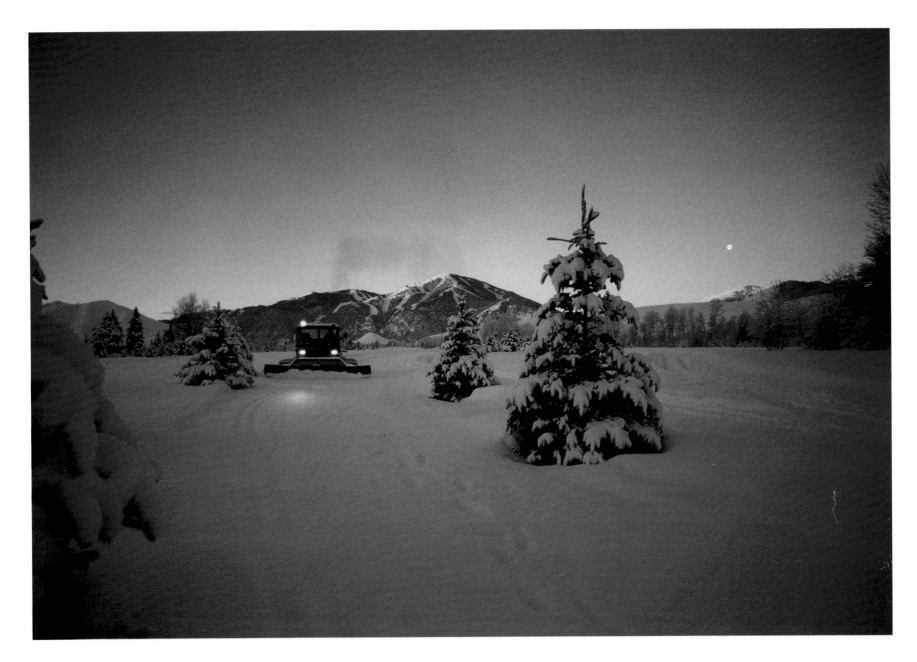

SNOWCAT PREPARES THE CROSS COUNTRY
TRACKS ON THE SUN VALLEY GOLF COURSE
Plate 8

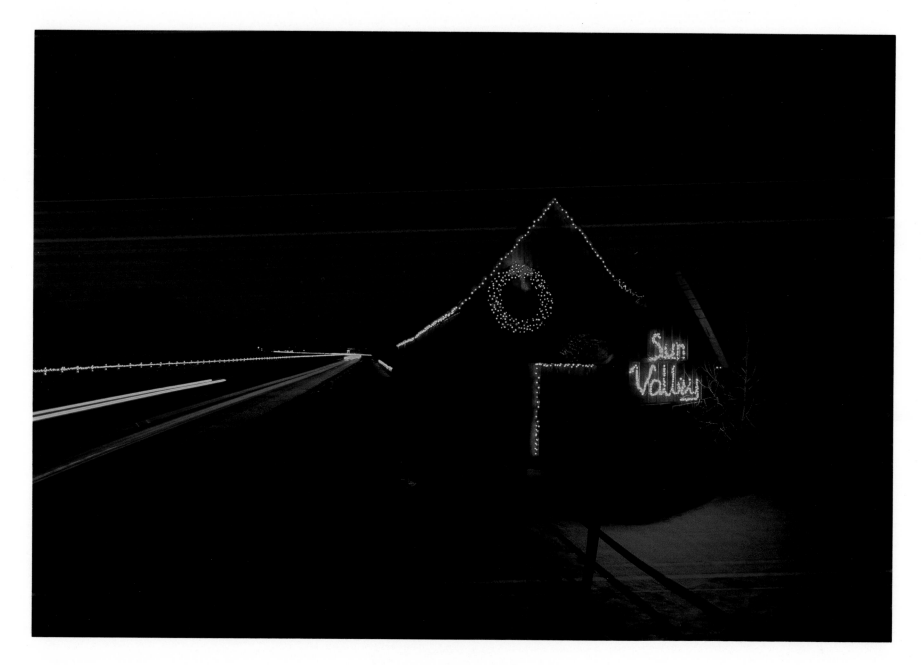

OLD MILK BARN ON SUN VALLEY ROAD
Plate 9

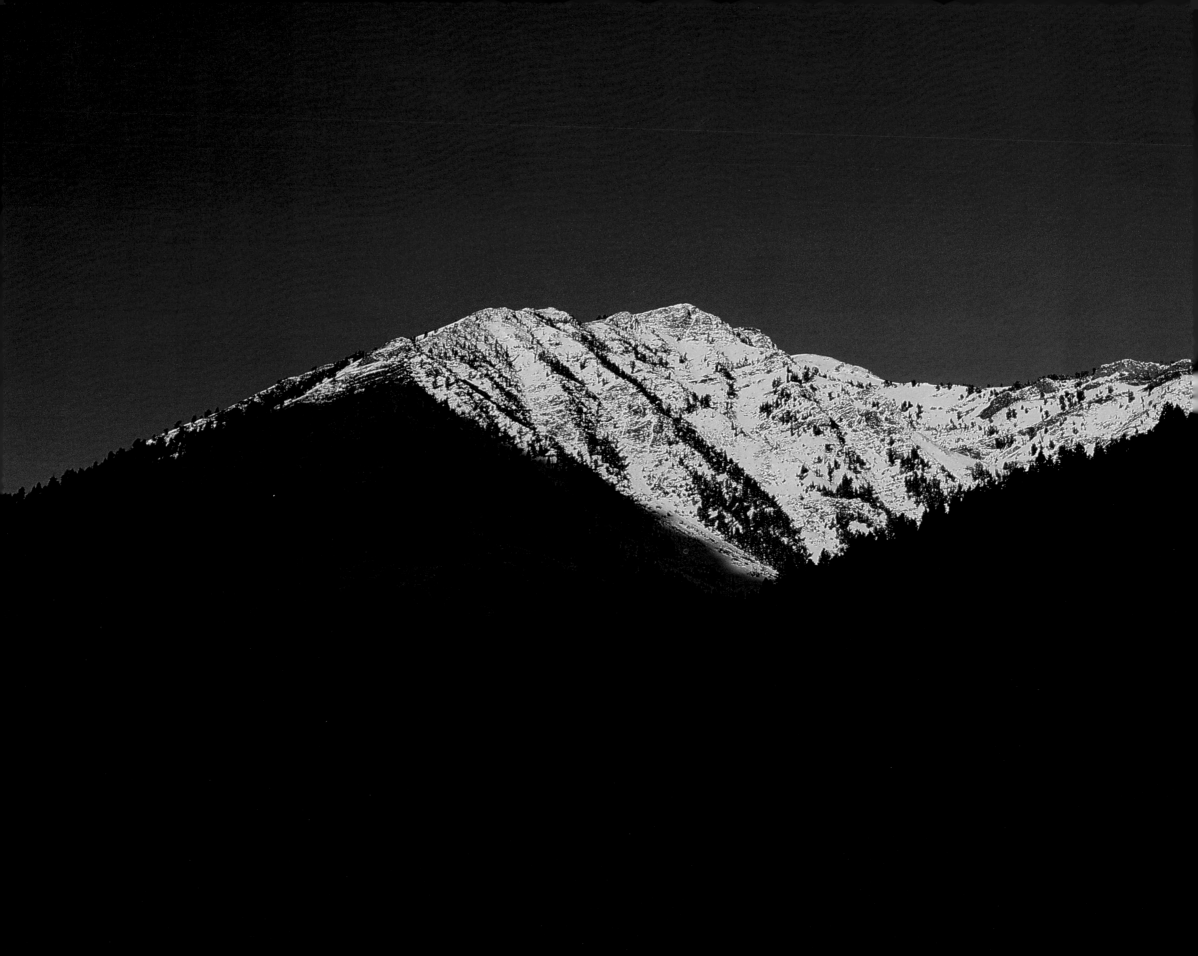

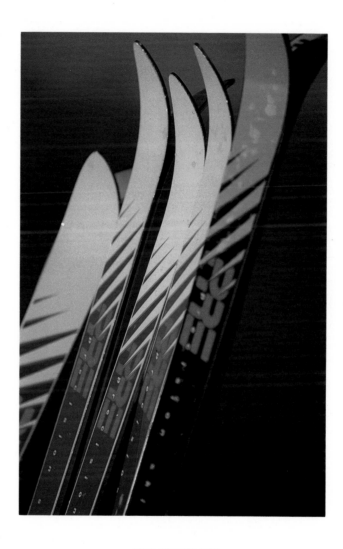

END OF THE DAY
Plate 11

SUNRISE—PHI KAPPA CANYON—COPPER BASIN
Plate 10

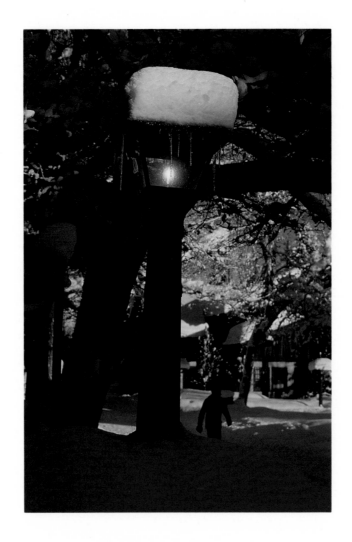

EARLY MORNING—SUN VALLEY MALL
Plate 12

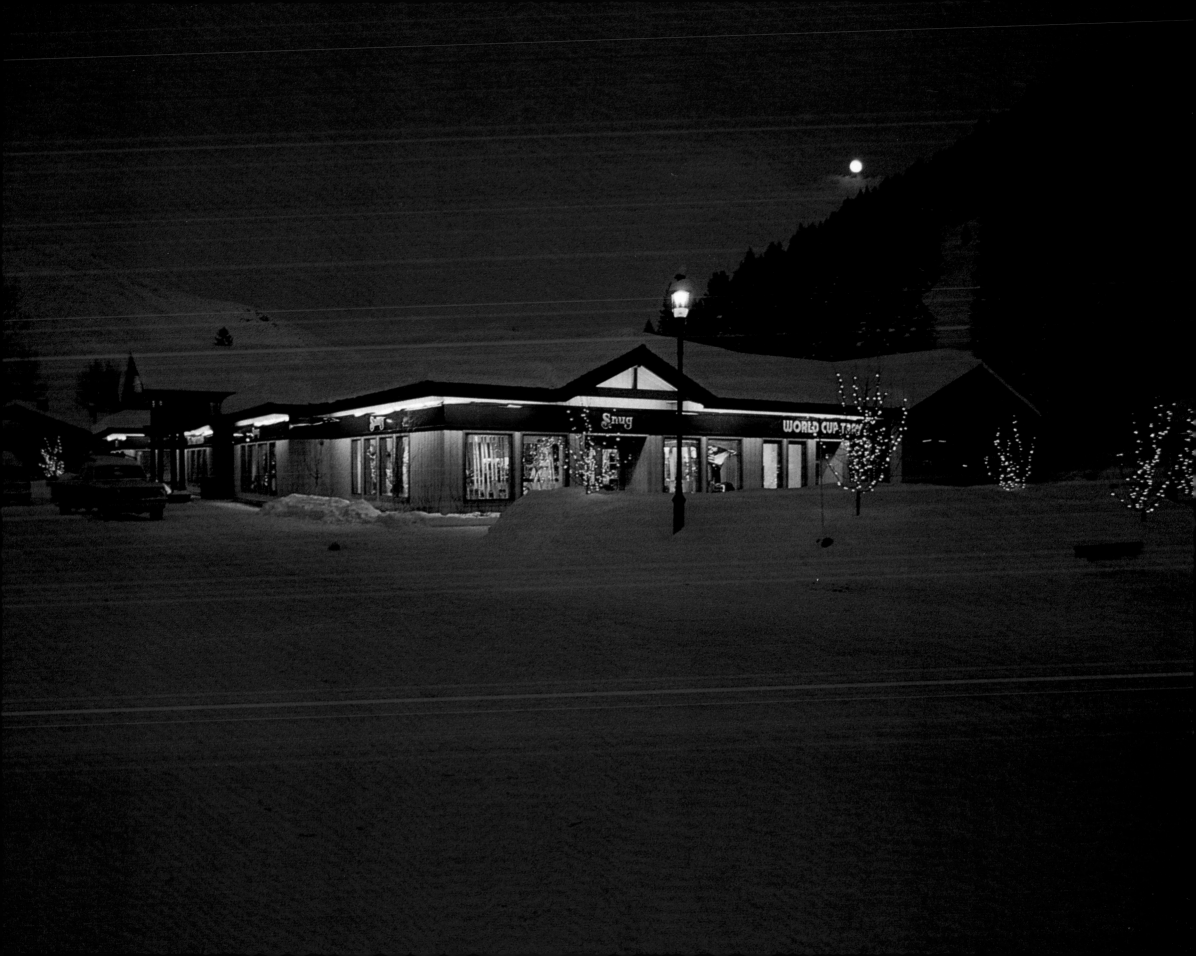

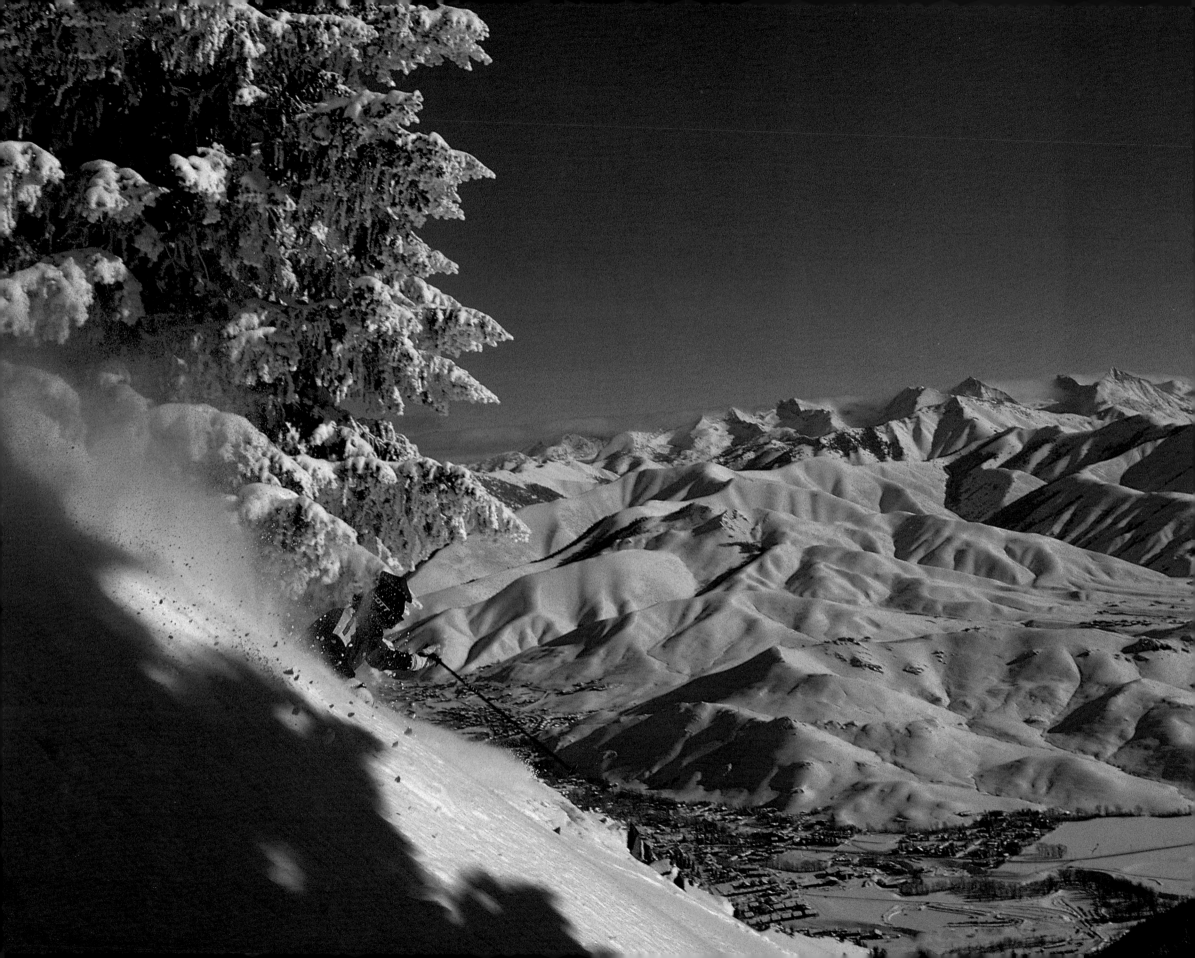

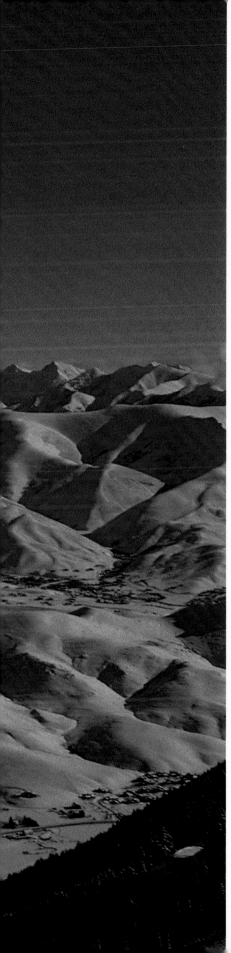

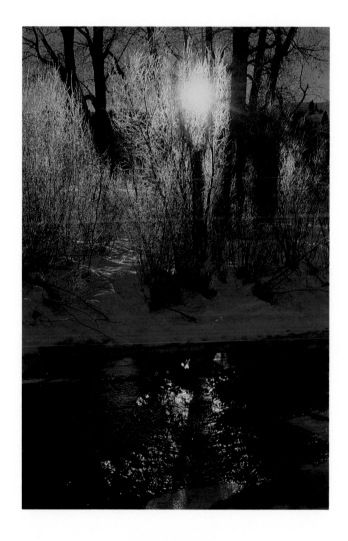

BIG WOOD RIVER
Plate 15

ROCK GARDEN
Plate 14

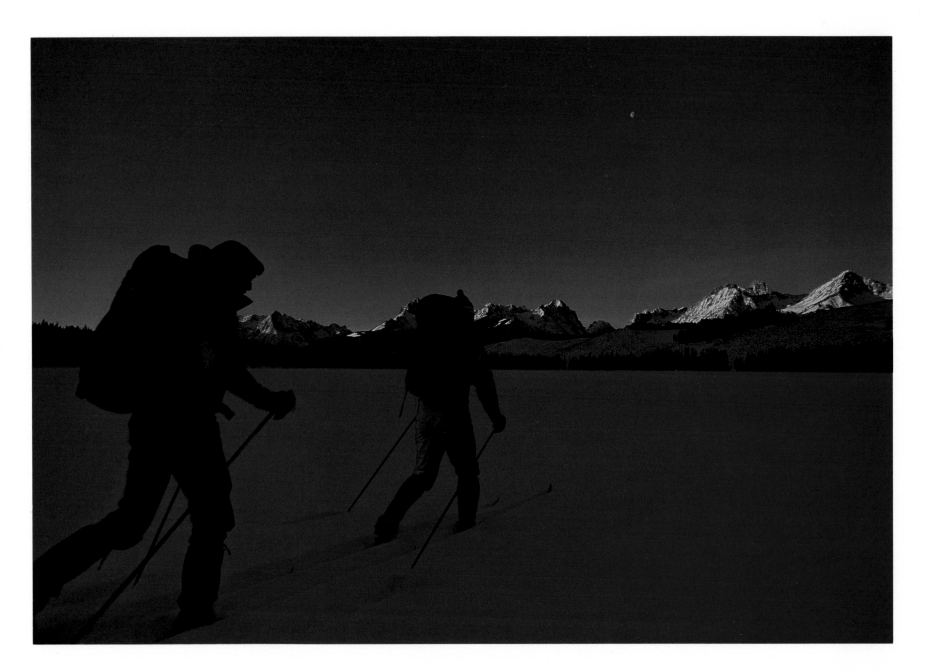

LITTLE REDFISH LAKE
Plate 16

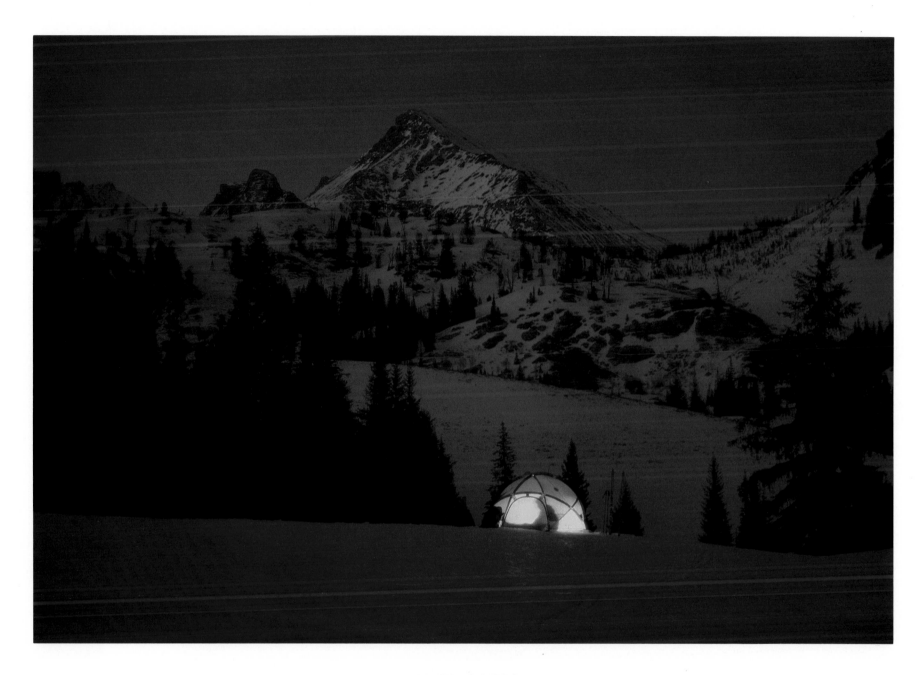

PIONEER MOUNTAINS
Plate 17

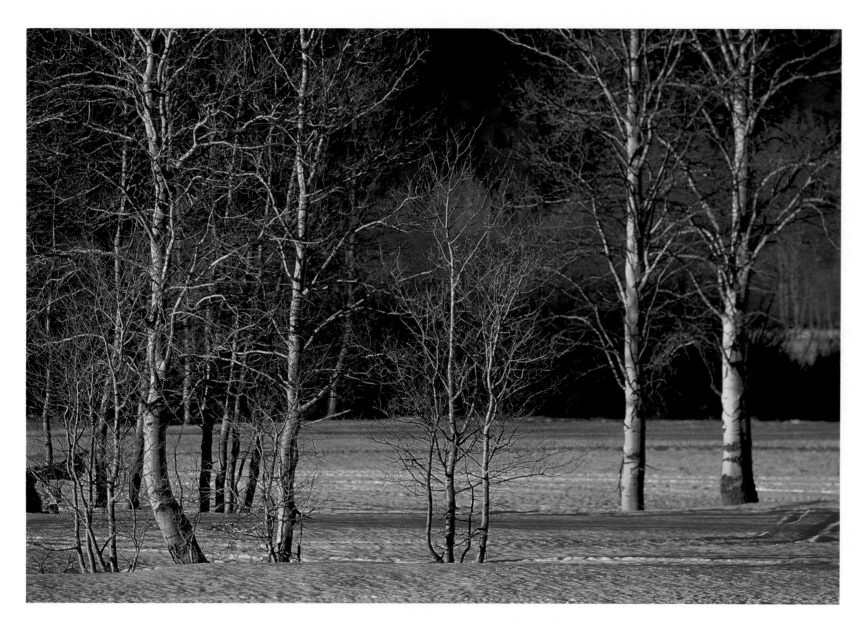
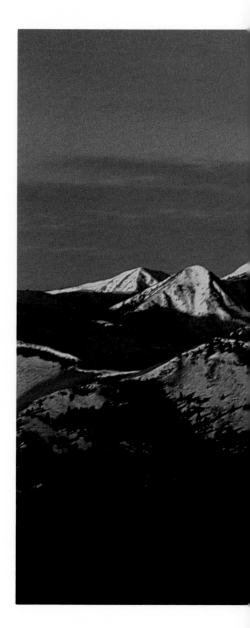

ASPEN TREES NORTH OF TOWN
Plate 18

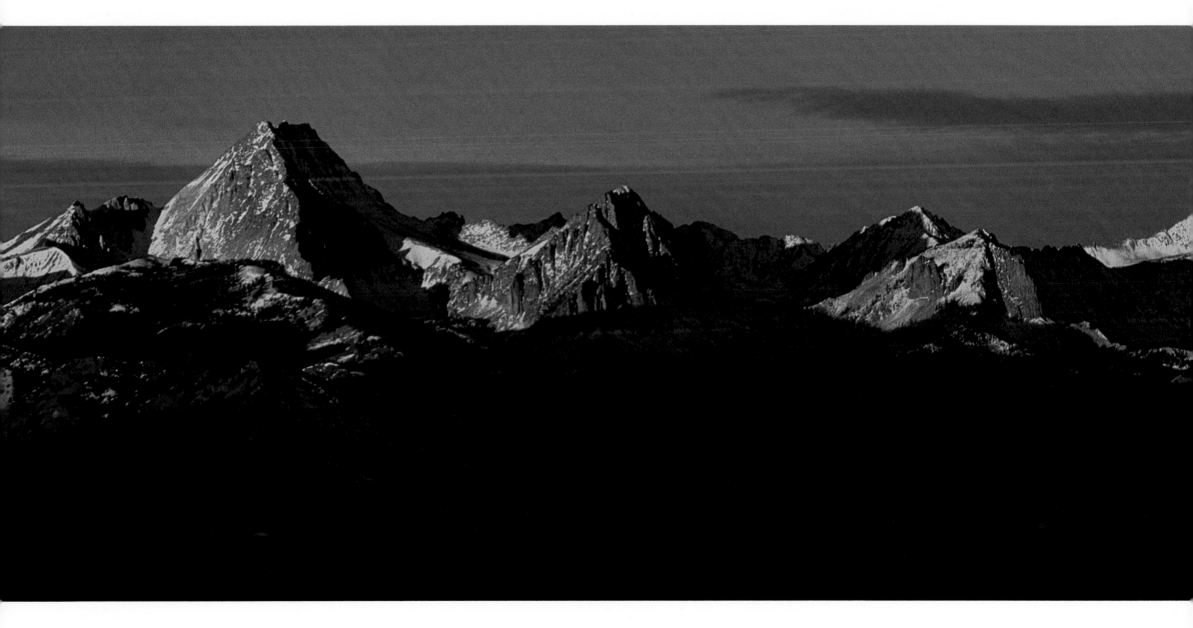

WHITE CLOUD MOUNTAINS
Plate 19

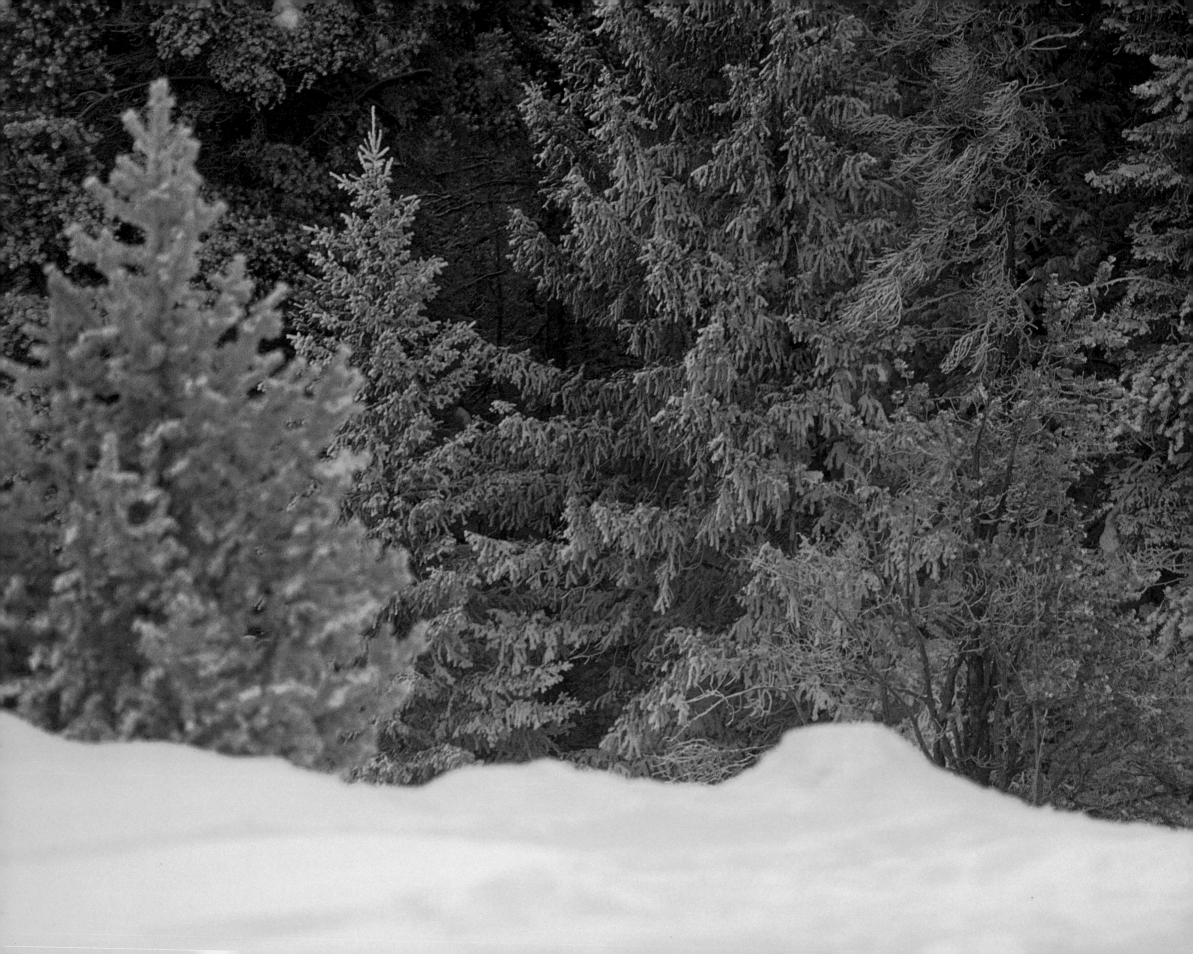

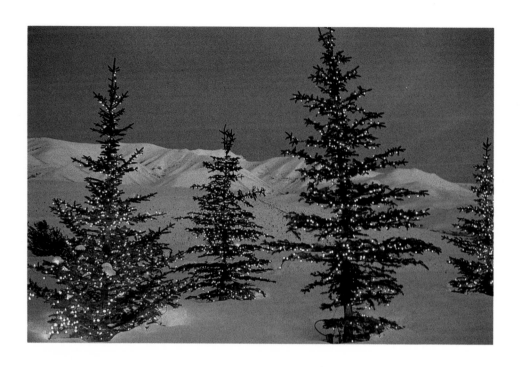

CHRISTMAS—ELKHORN
Plate 21

FROZEN SPRUCE NORTH OF TOWN
Plate 20

ELKHORN RESORT
Plate 22

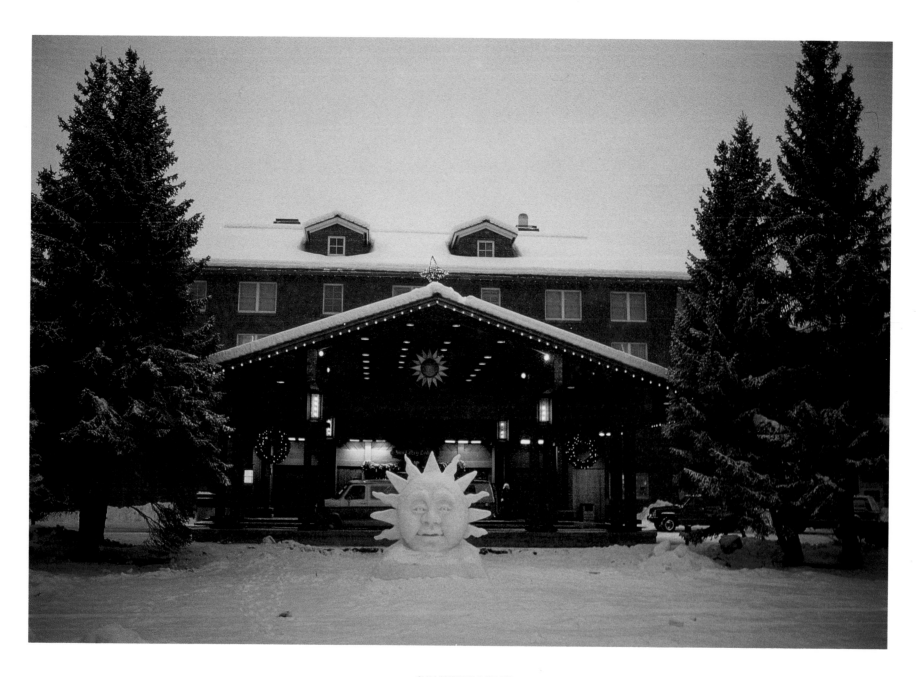

SUN VALLEY LODGE
Plate 23

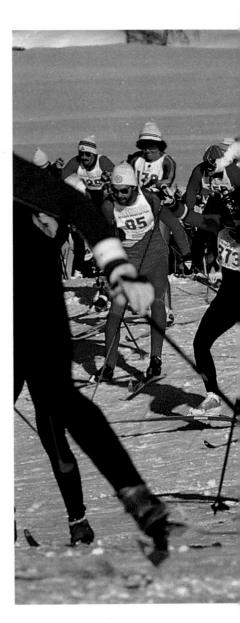

BOULDER MOUNTAIN TOUR
Plate 24

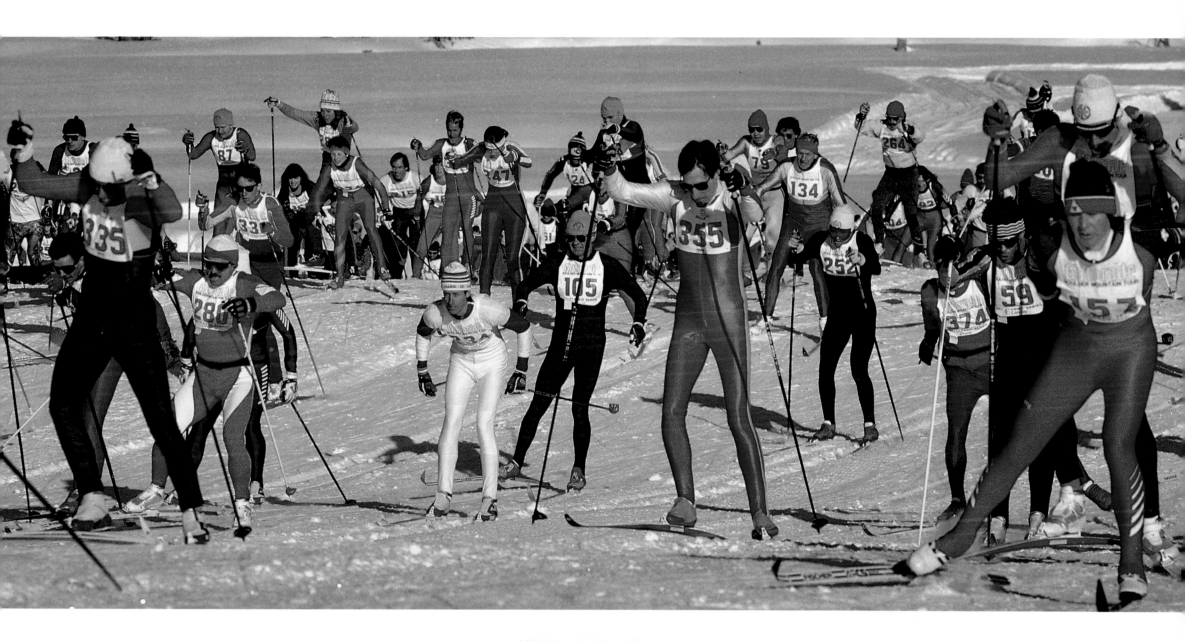

BOULDER MOUNTAIN TOUR
Plate 25

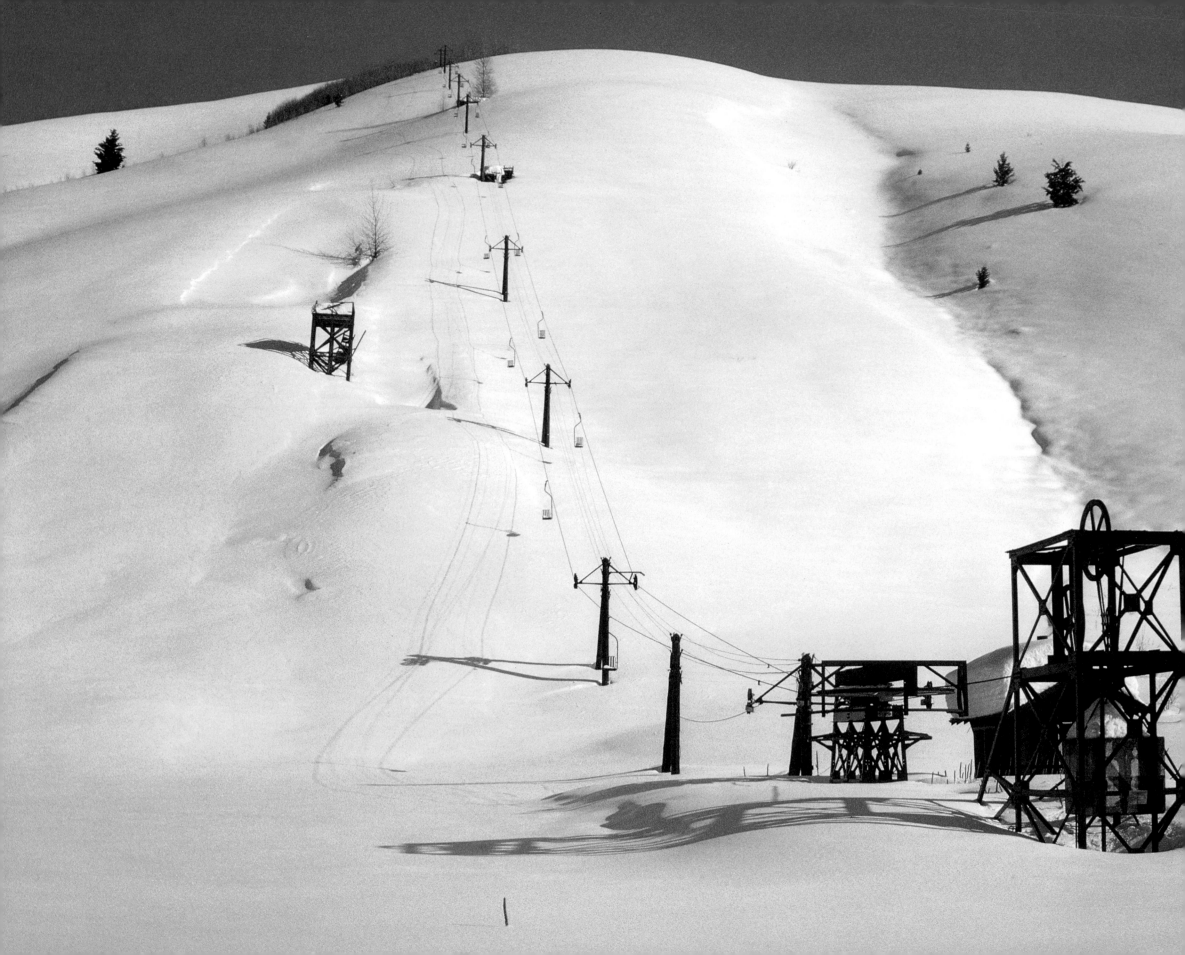

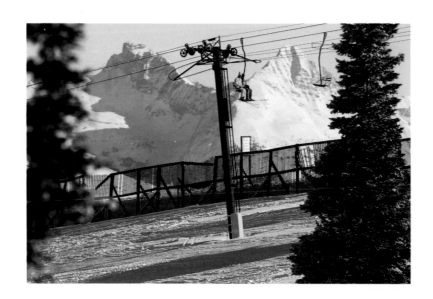

LIMELIGHT
Plate 27

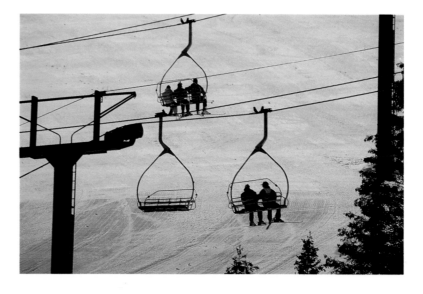

GREYHAWK & CHALLENGER CHAIRLIFTS
Plate 28

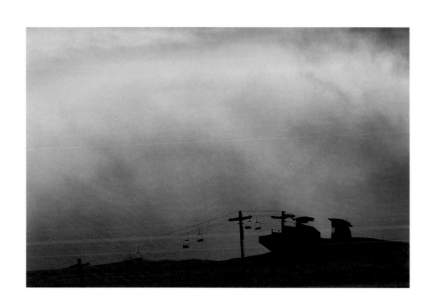

DOLLAR CHAIRLIFT
Plate 29

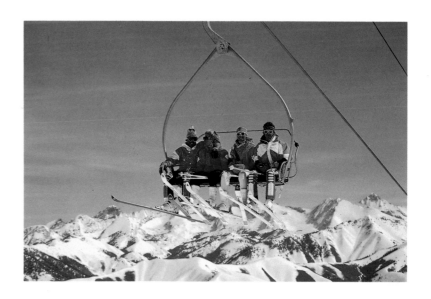

CHALLENGER CHAIRLIFT
Plate 30

RUUD MOUNTAIN CHAIRLIFT
Plate 26

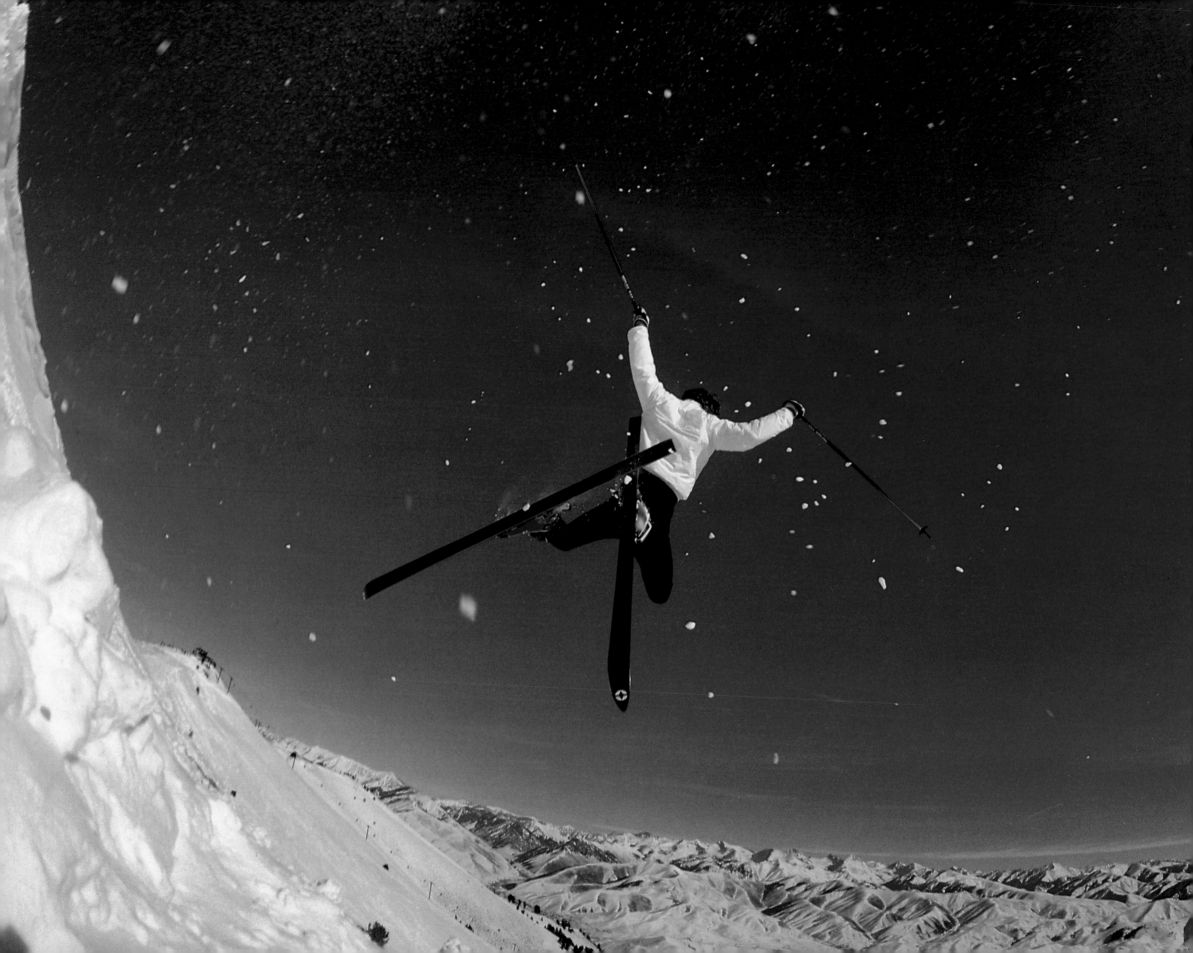

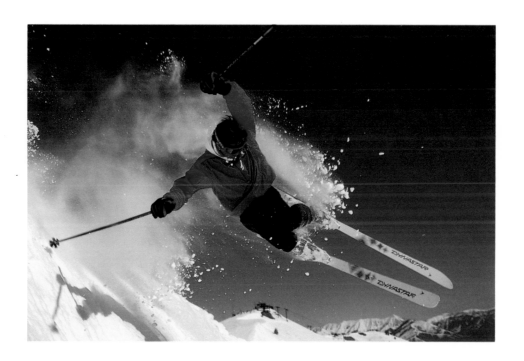

FROM THE TOP
Plate 32

INTO THE BOWLS
Plate 31

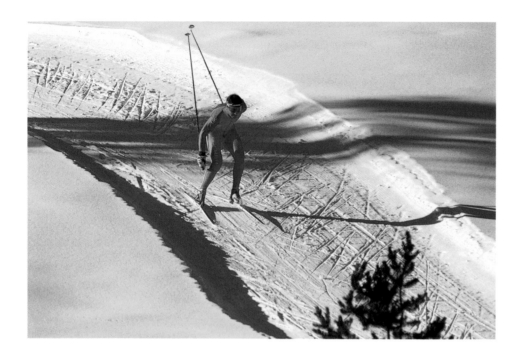

BUSTERBACK RANCH
Plate 33

ALONG THE BIG WOOD RIVER
Plate 34

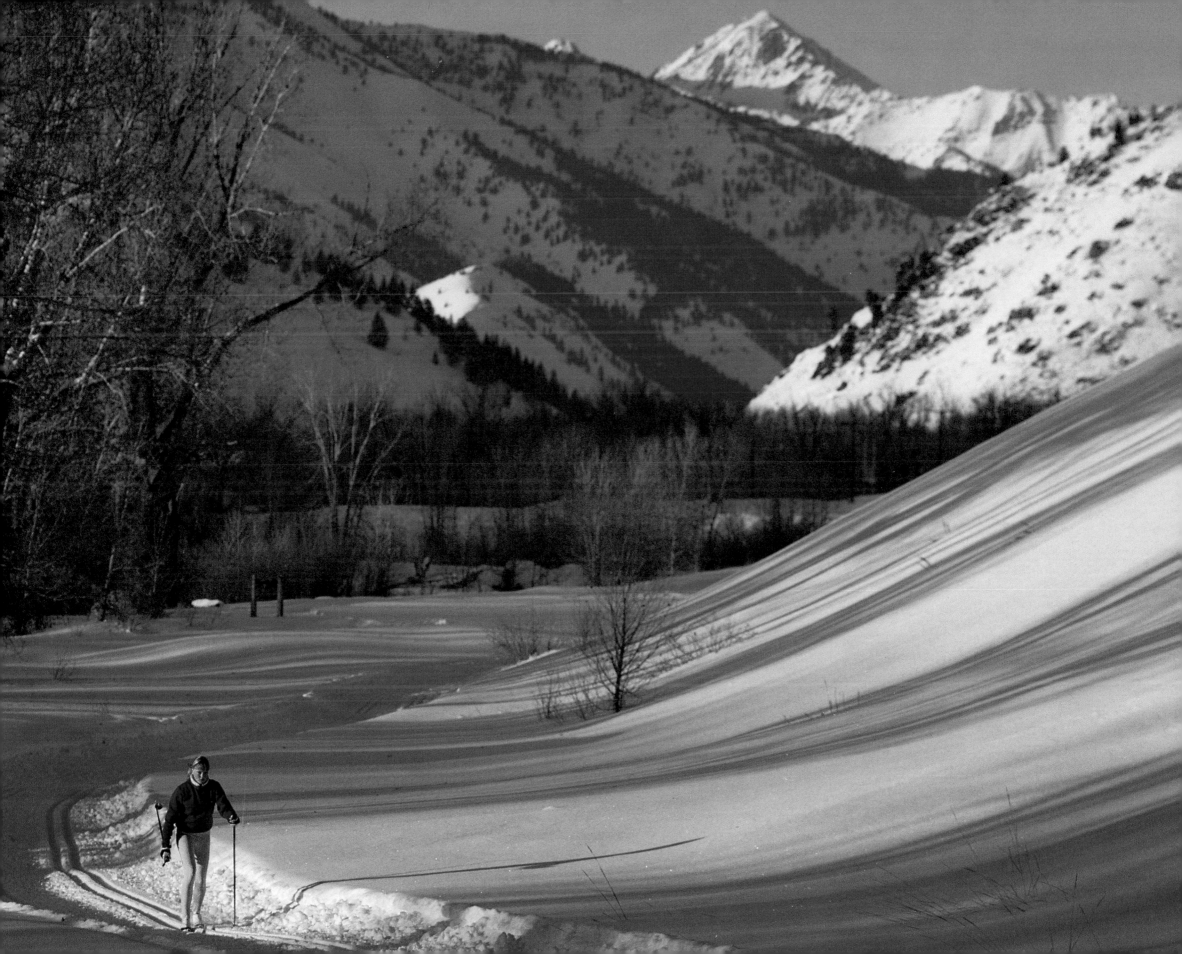

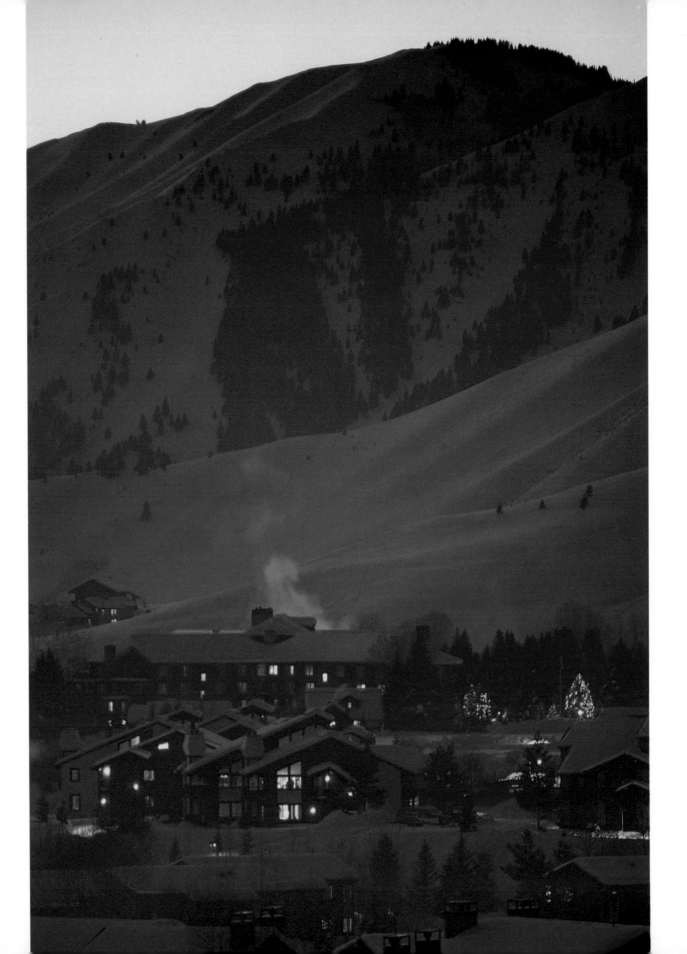

SUN VALLEY LODGE
Plate 35

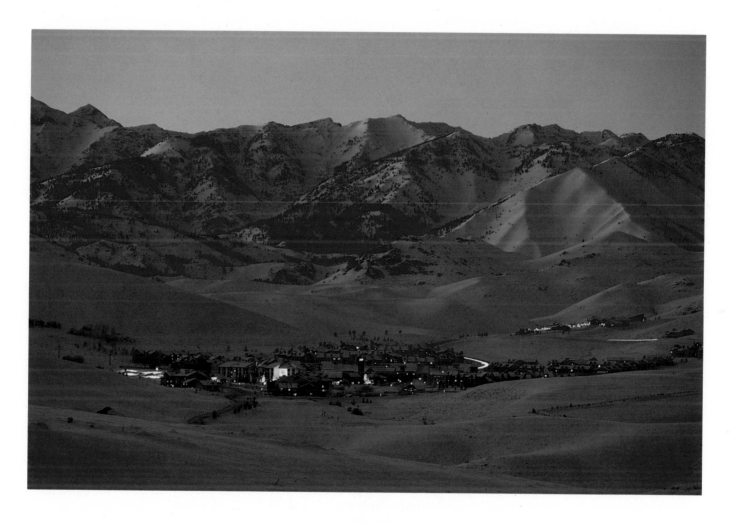

ELKHORN
Plate 36

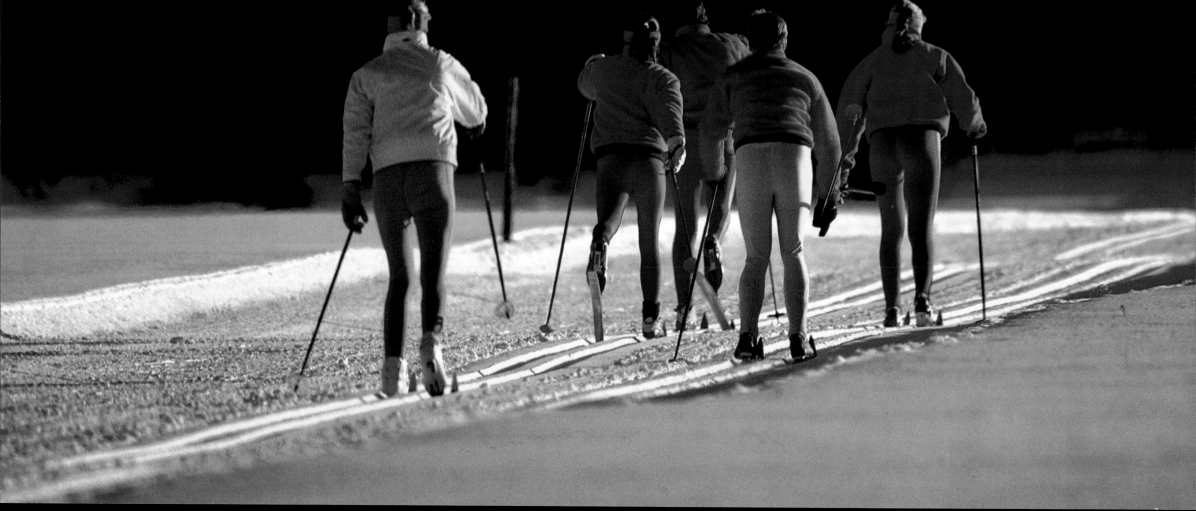

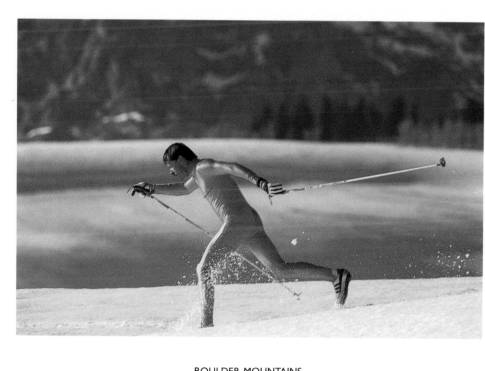

BOULDER MOUNTAINS
Plate 38

BUSTERBACK RANCH
Plate 37

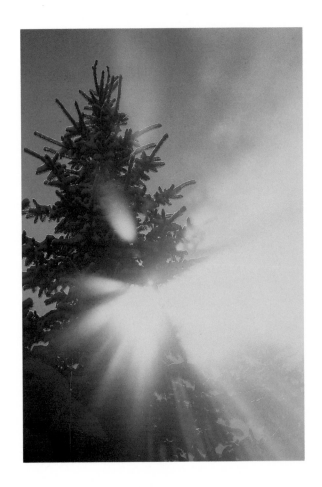

STARBURST
Plate 39

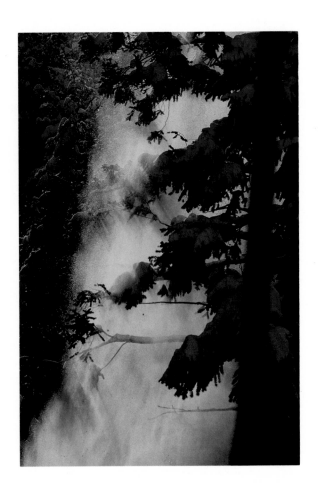

FALLING SNOW
Plate 40

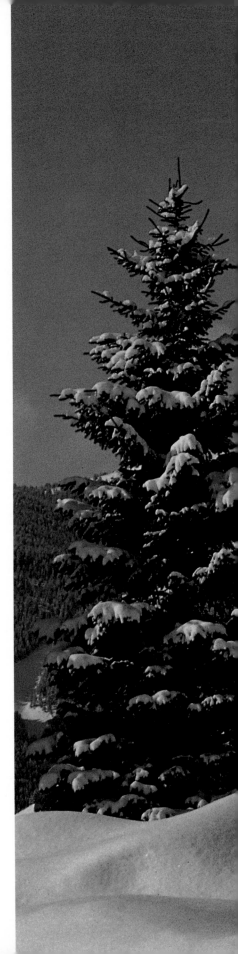

BALDY
Plate 41

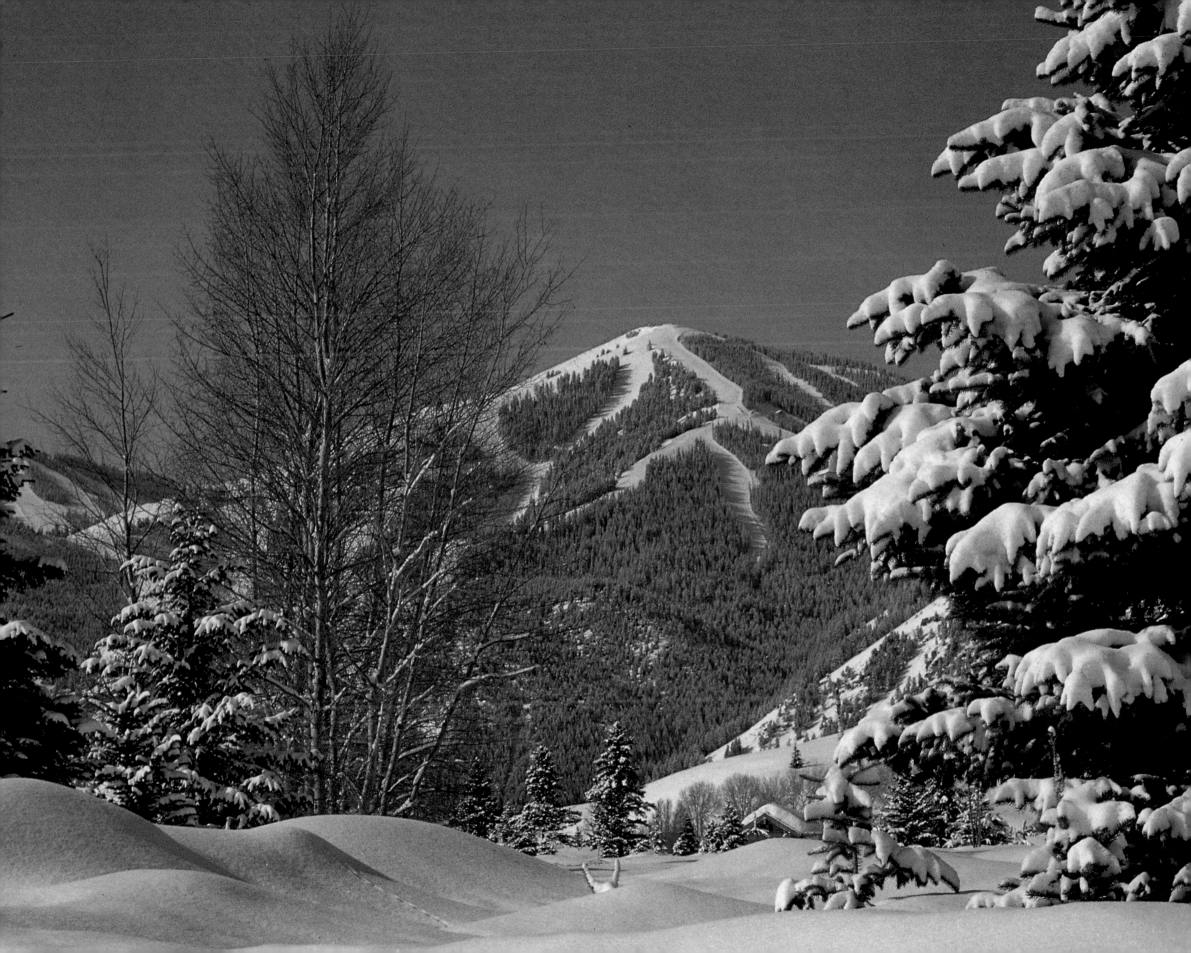

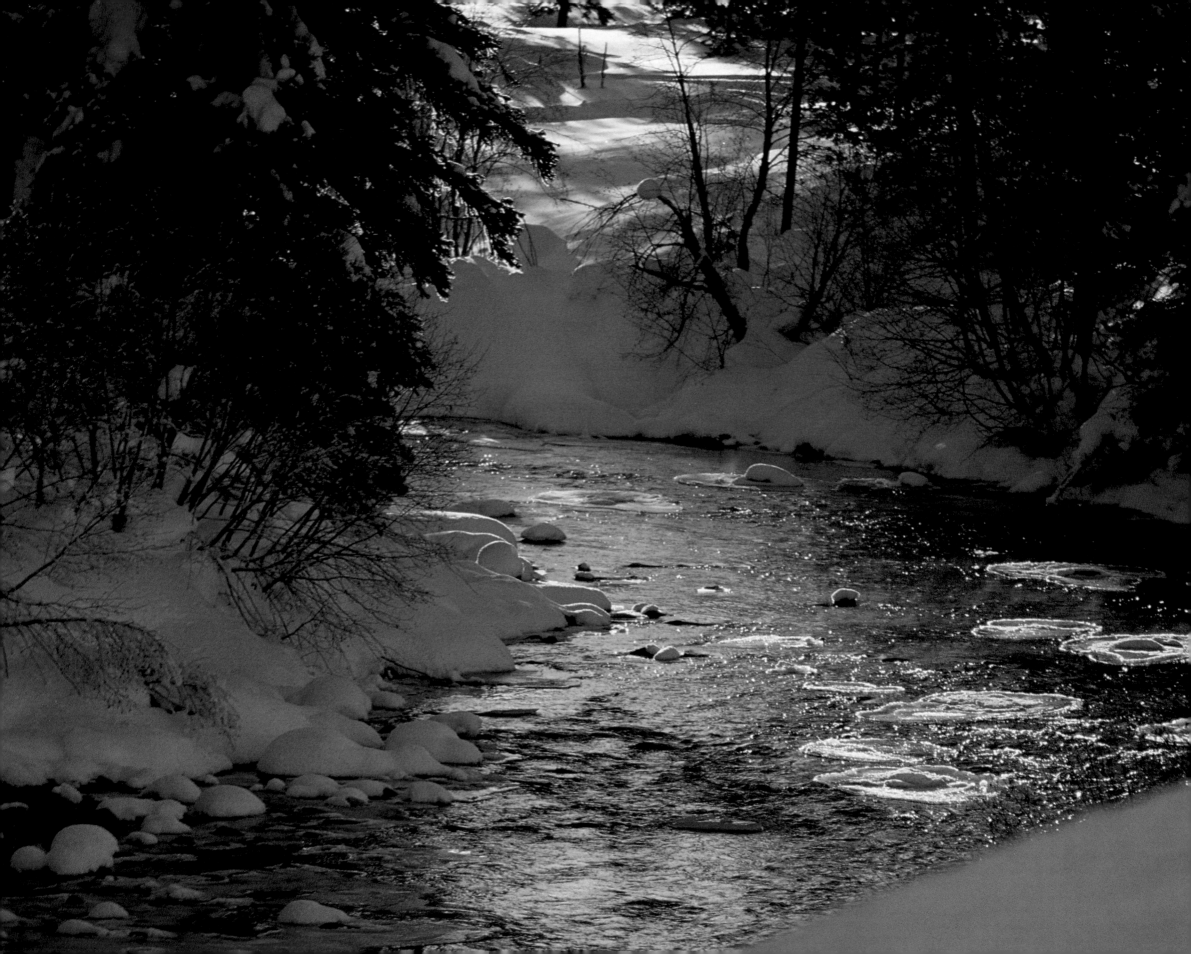

FROZEN TRAIL CREEK
Plate 43

TRAIL CREEK
Plate 42

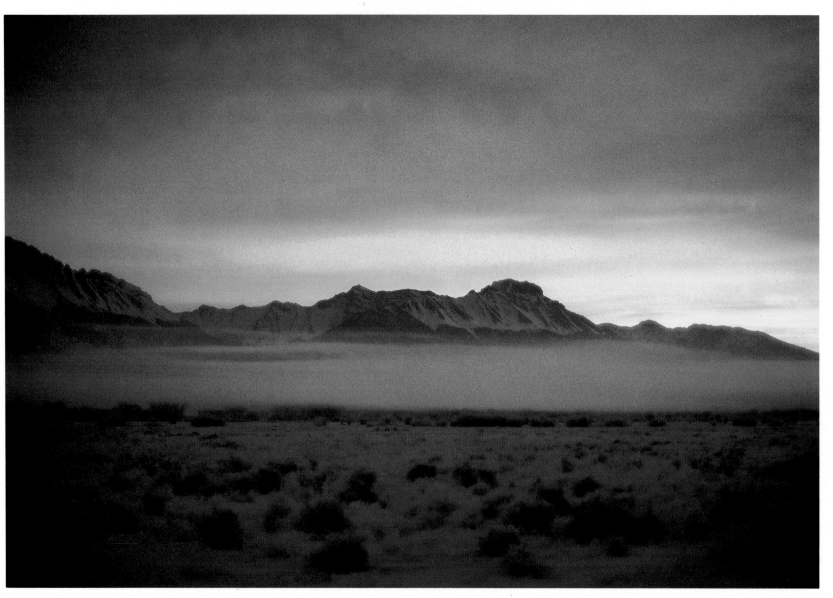

THE BIG LOST RIVER RANGE—MACKAY
Plate 44

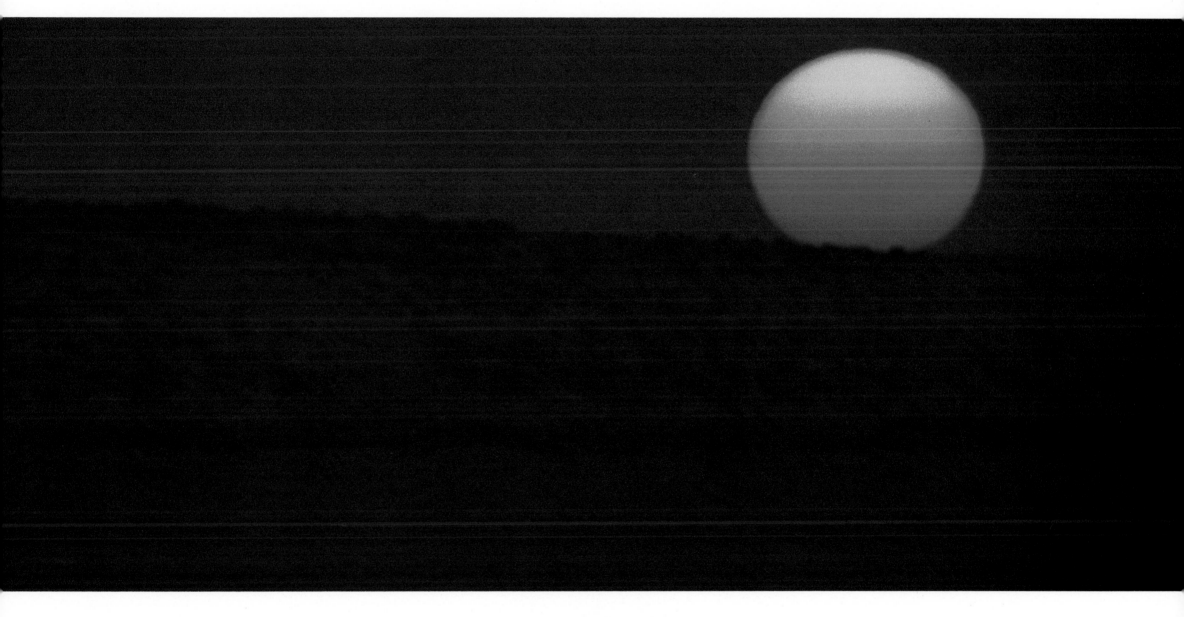

SUNSET ON THE SNAKE RIVER
Plate 45

MOON OVER THE SAWTOOTHS
Next Page: Plate 46

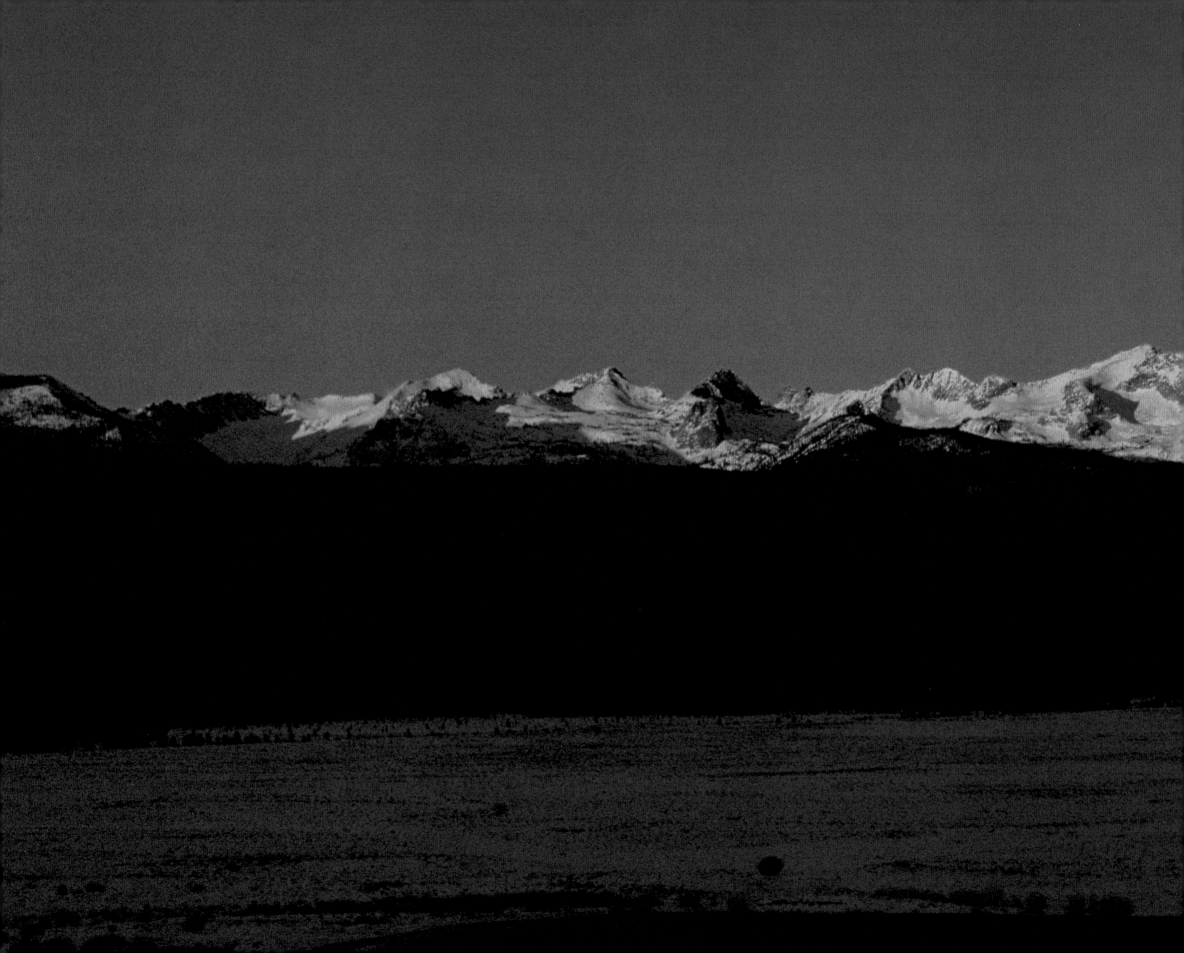

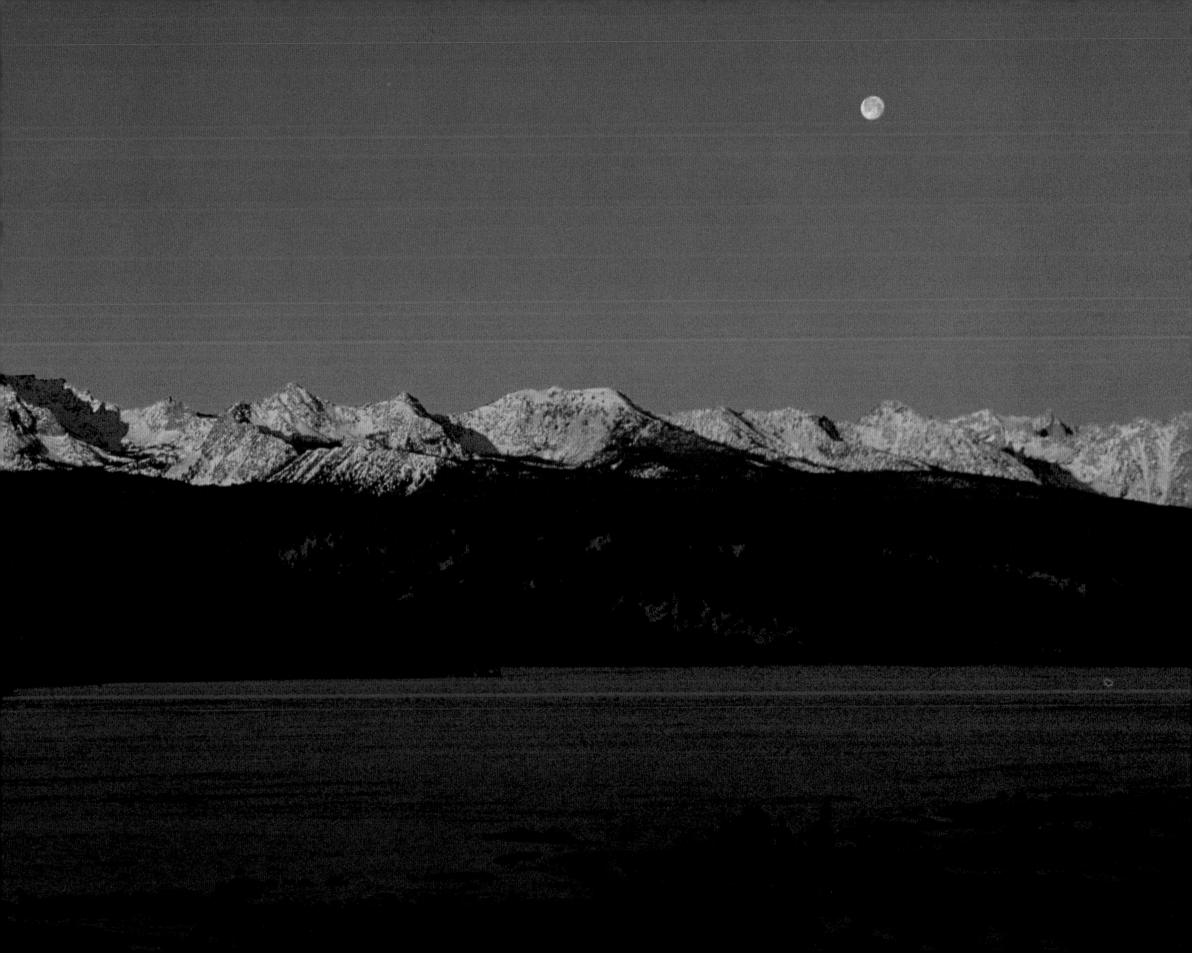

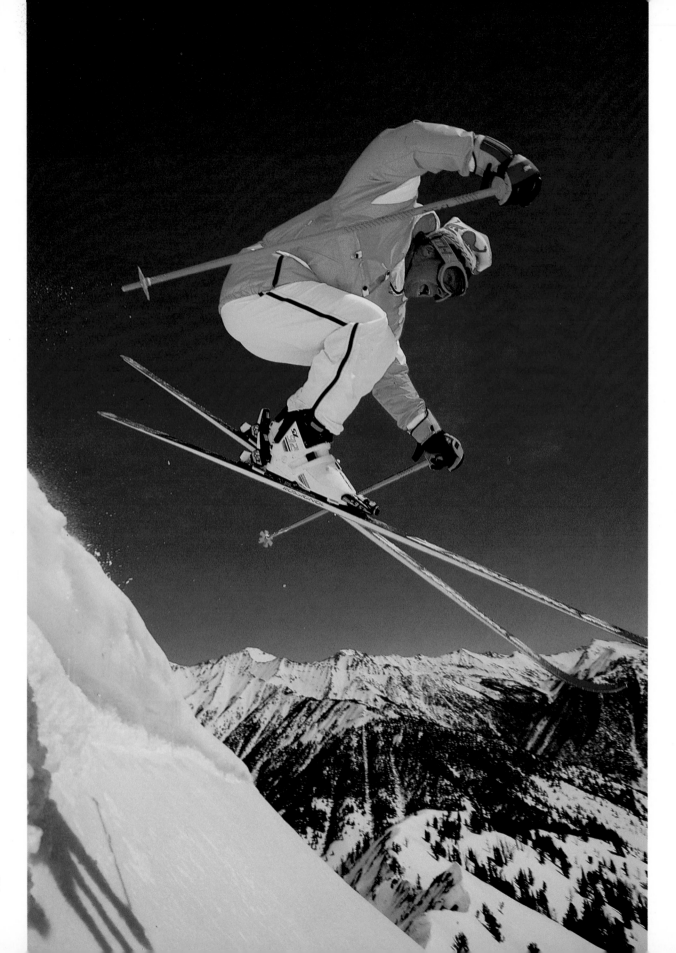

HELI-SKIING BOULDER MOUNTAINS
Plate 47

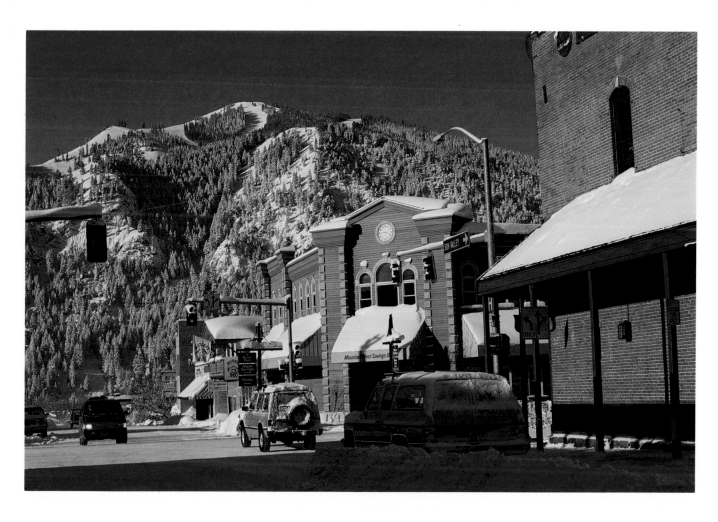

CORNER OF MAIN STREET AND
SUN VALLEY ROAD
Plate 48

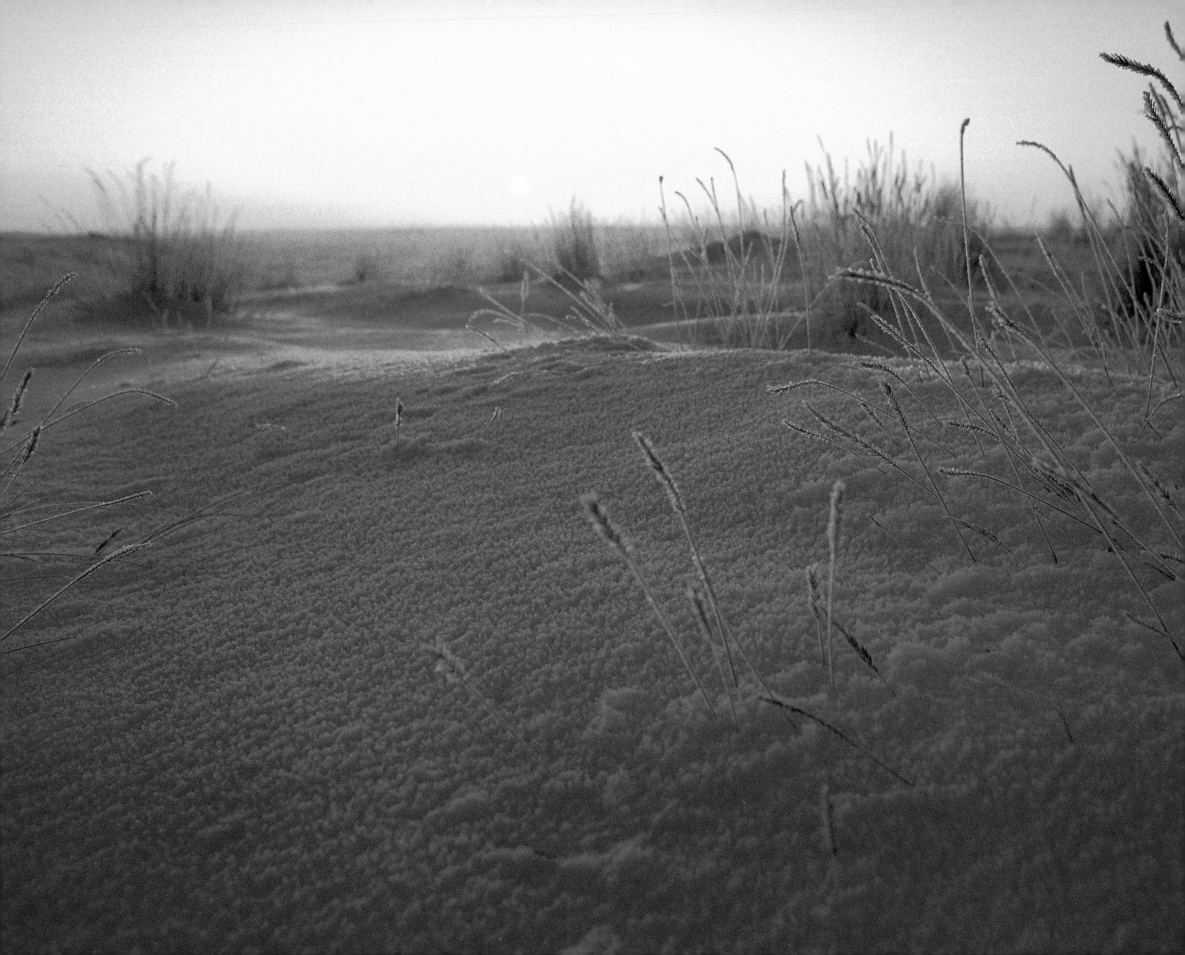

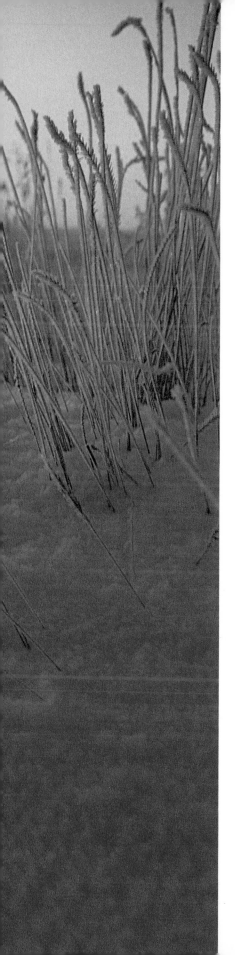

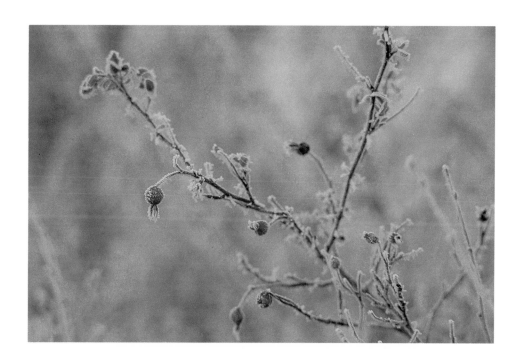

FROST
Plate 50

SUNRISE—CAMAS PRAIRIE
Plate 49

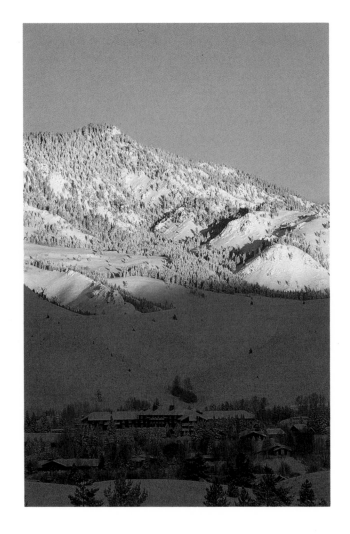

SUN VALLEY VILLAGE
Plate 51

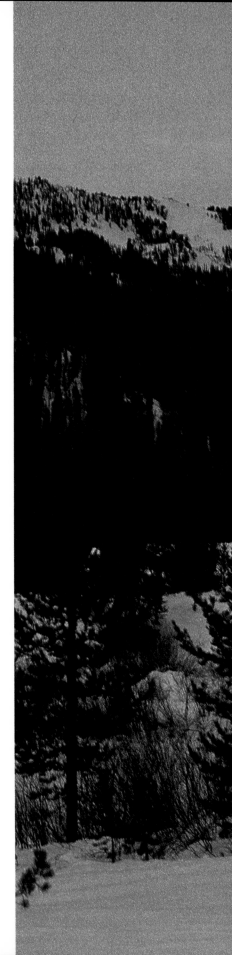

SILVER PEAK—SMOKY MOUNTAINS
Plate 52

MAIN STREET KETCHUM
Next Page: Plate 53

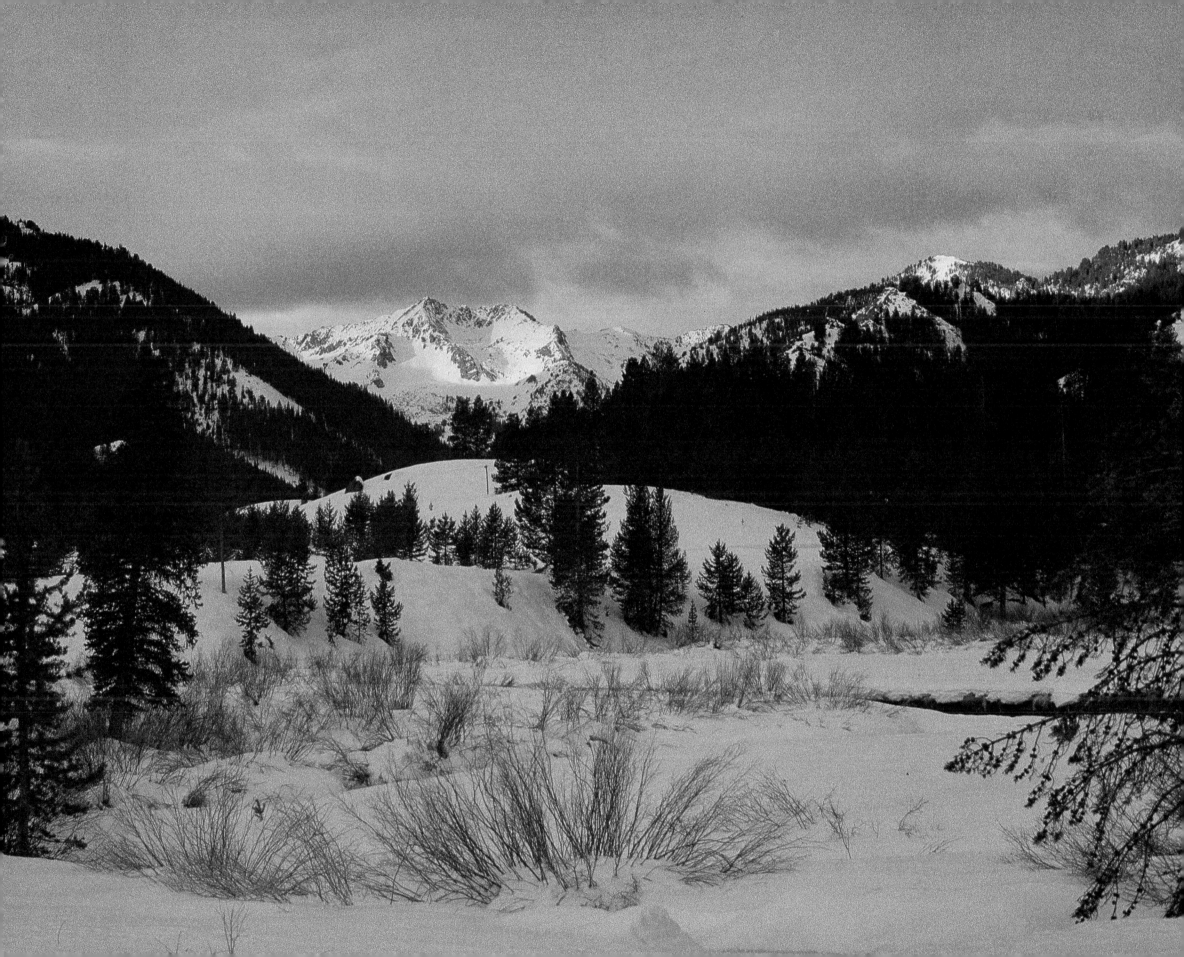

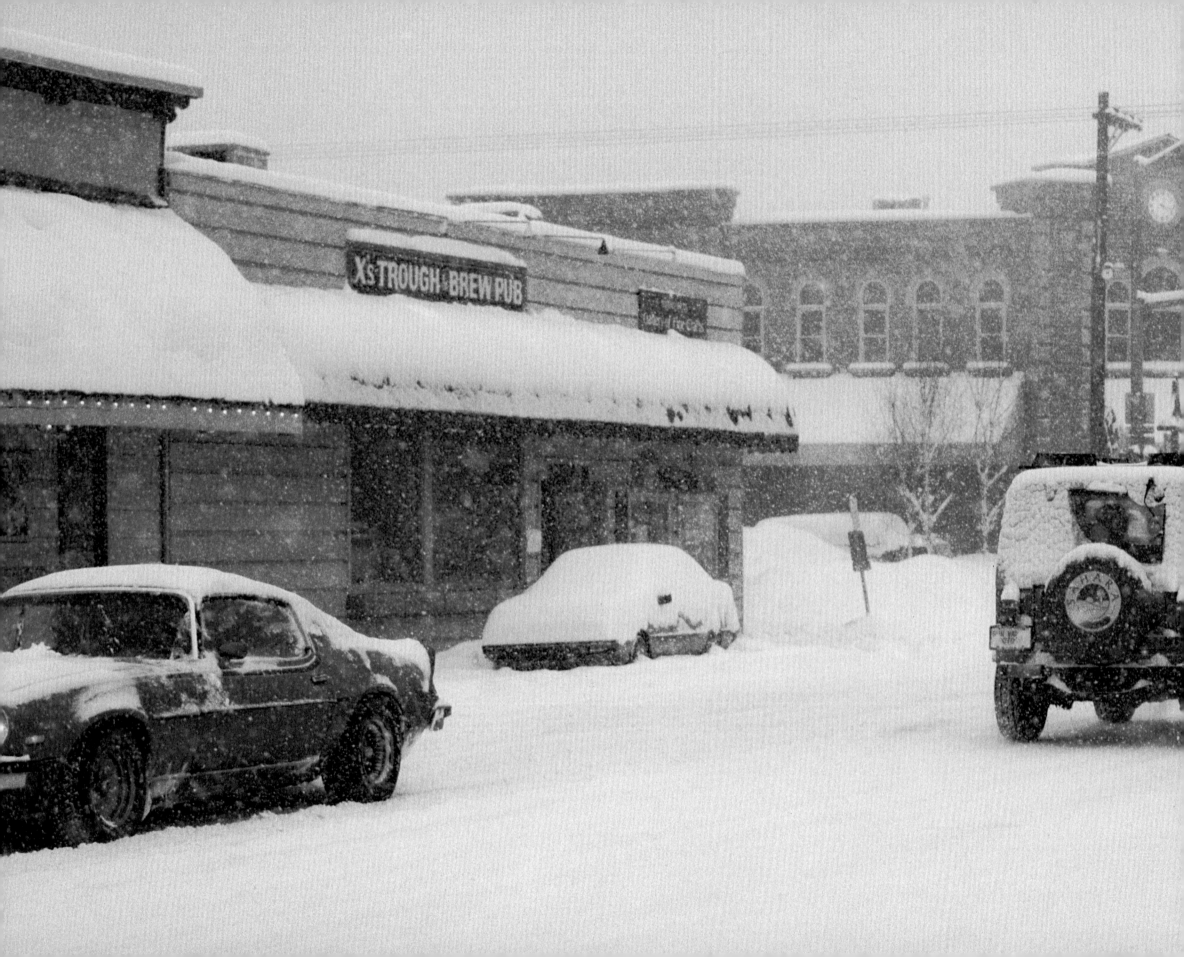

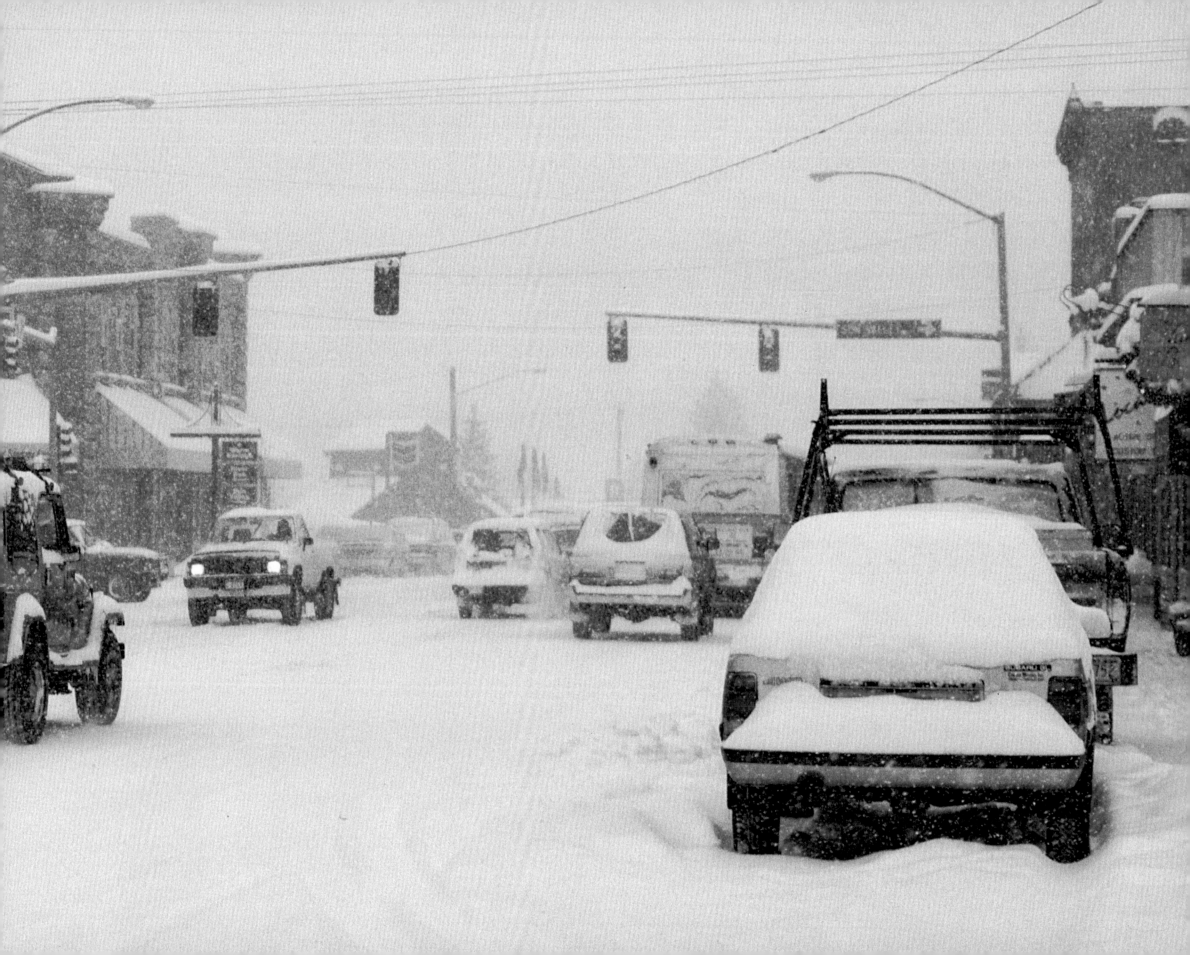

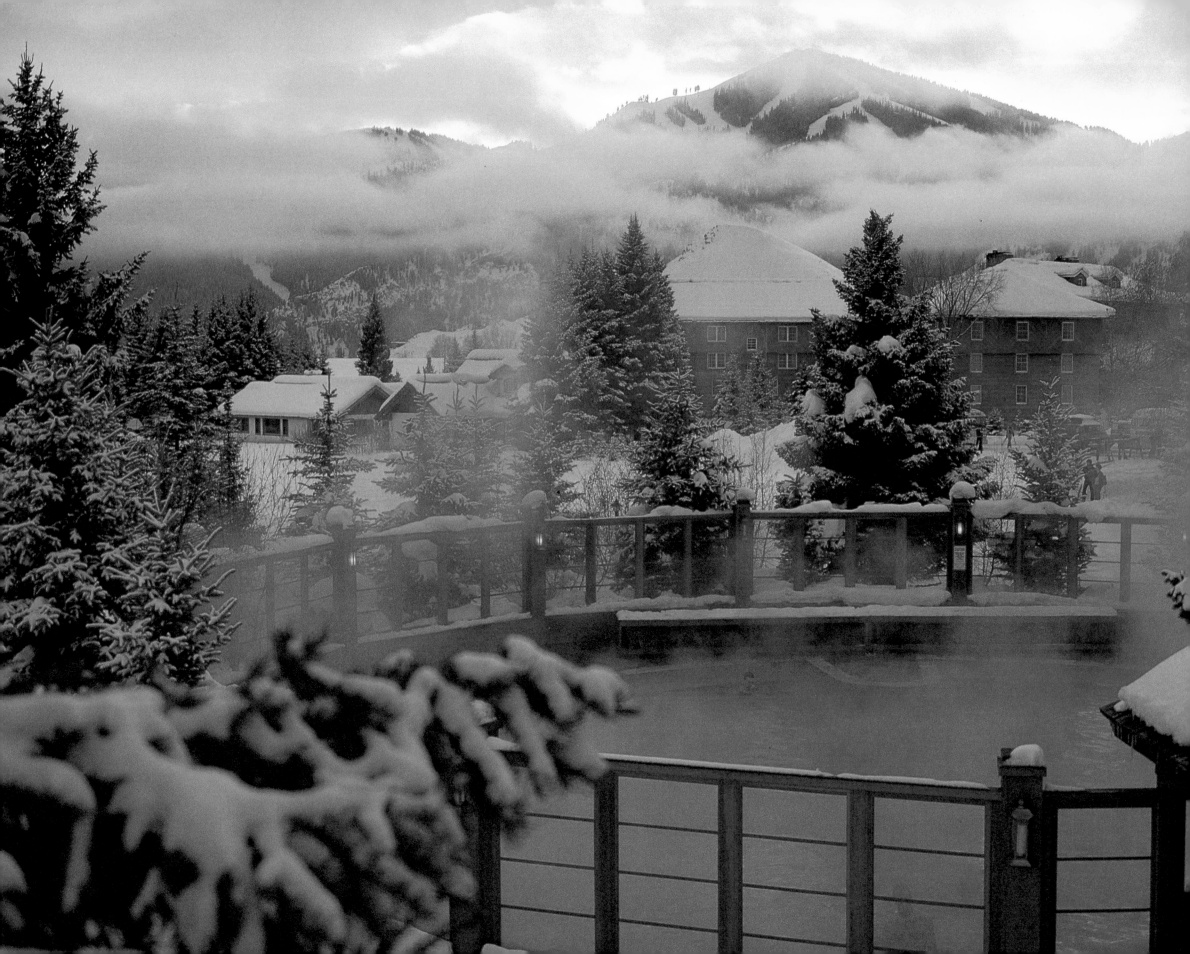

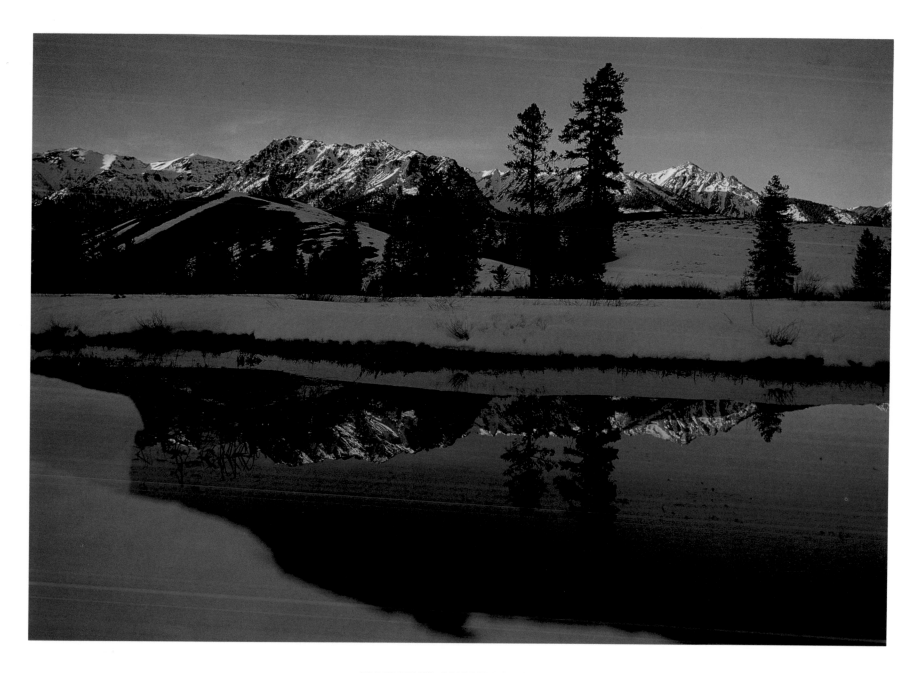

BEAVER PONDS—BOULDER MOUNTAINS
Plate 57

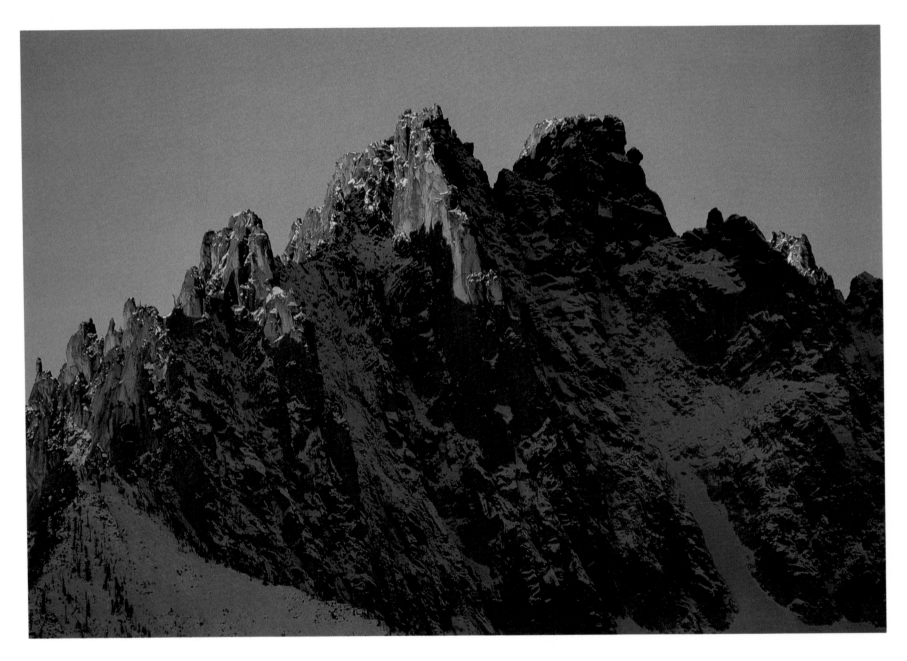

SUNSET MT. HEYBURN—SAWTOOTH MOUNTAINS
Plate 58

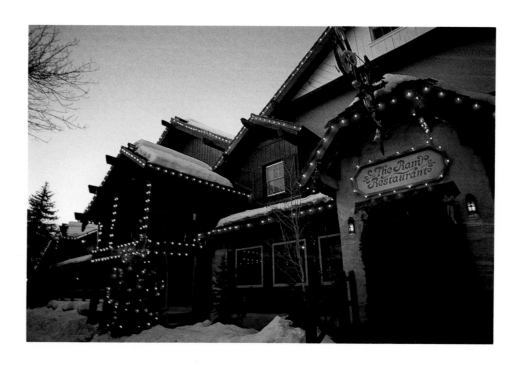

CHRISTMAS ON THE SUN VALLEY MALL
Plate 55

SWIMMING POOL—SUN VALLEY LODGE
Plate 54

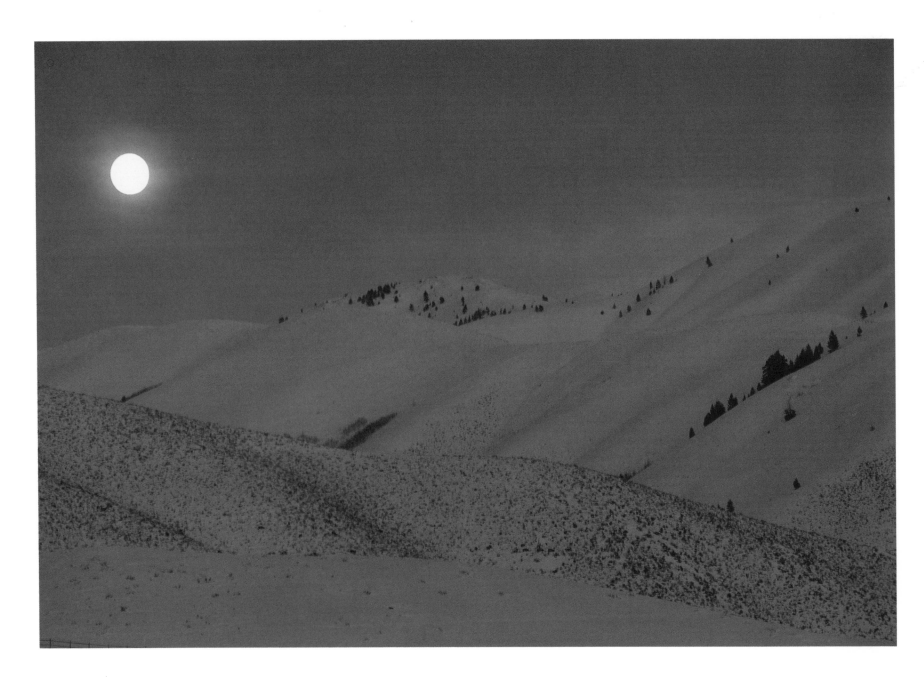

FULL MOON—ELKHORN
Plate 56

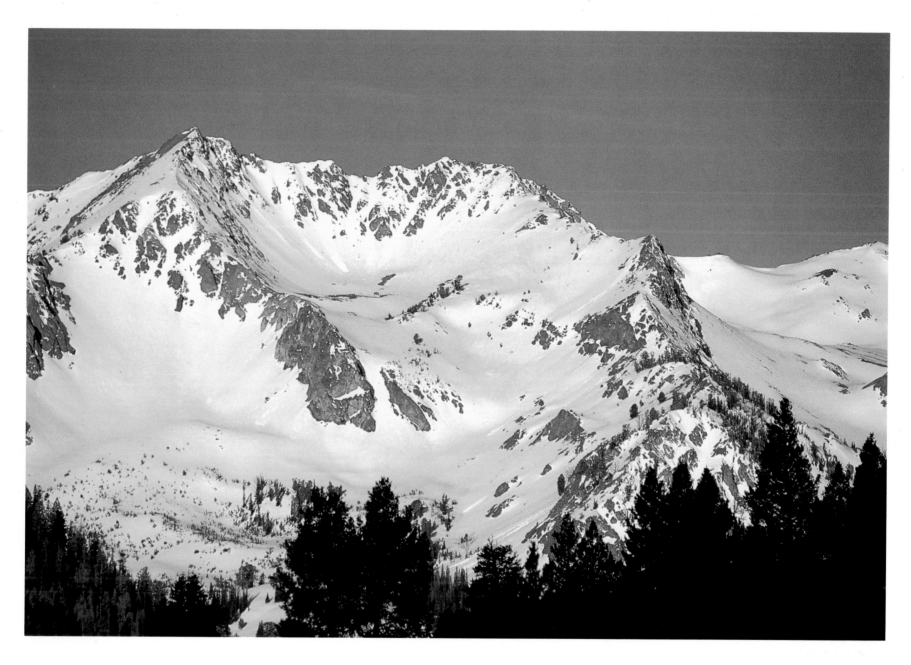

MORNING SUN SILVER PEAK—SMOKY MOUNTAINS
Plate 59

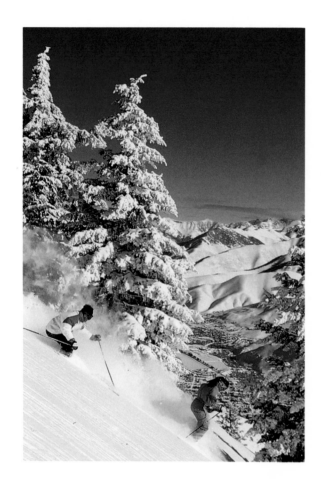

ROCK GARDEN
Plate 60

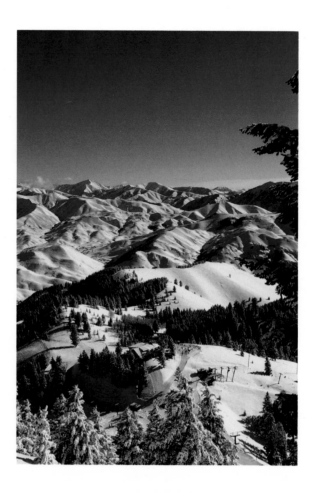

ROUND HOUSE
Plate 61

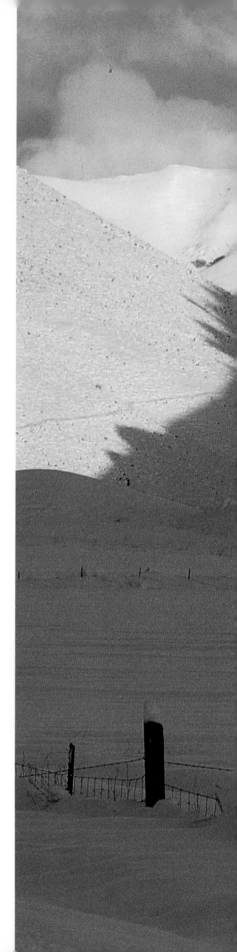

LANE RANCH
Plate 62

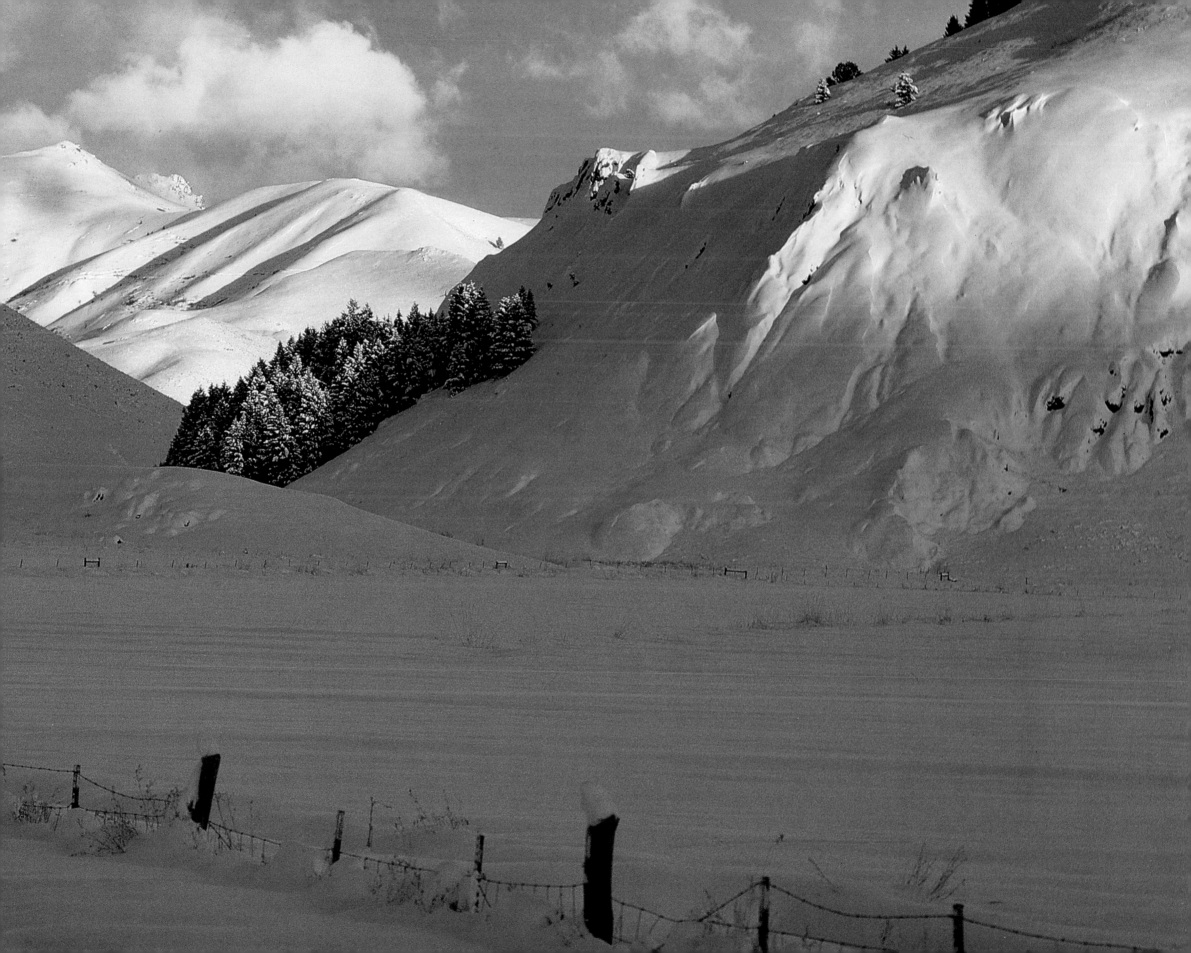

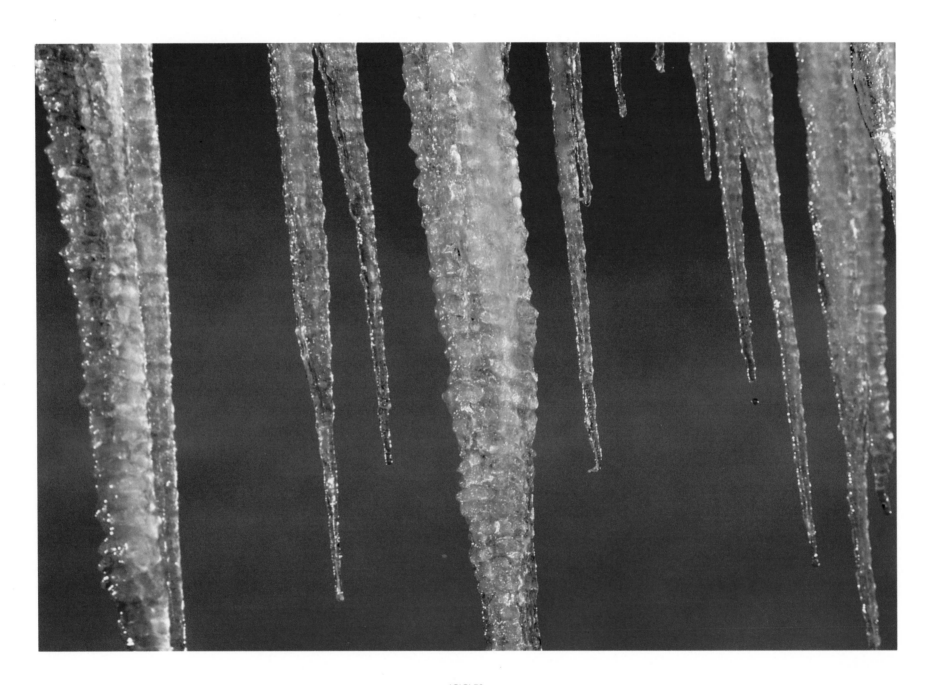

ICICLES
Plate 63

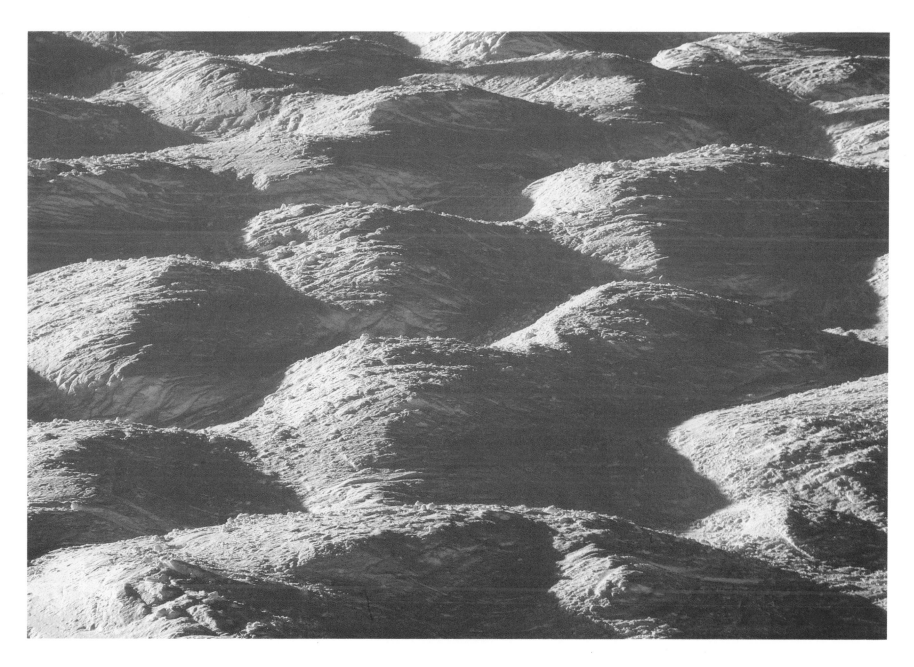

LOWER HOLIDAY
Plate 64

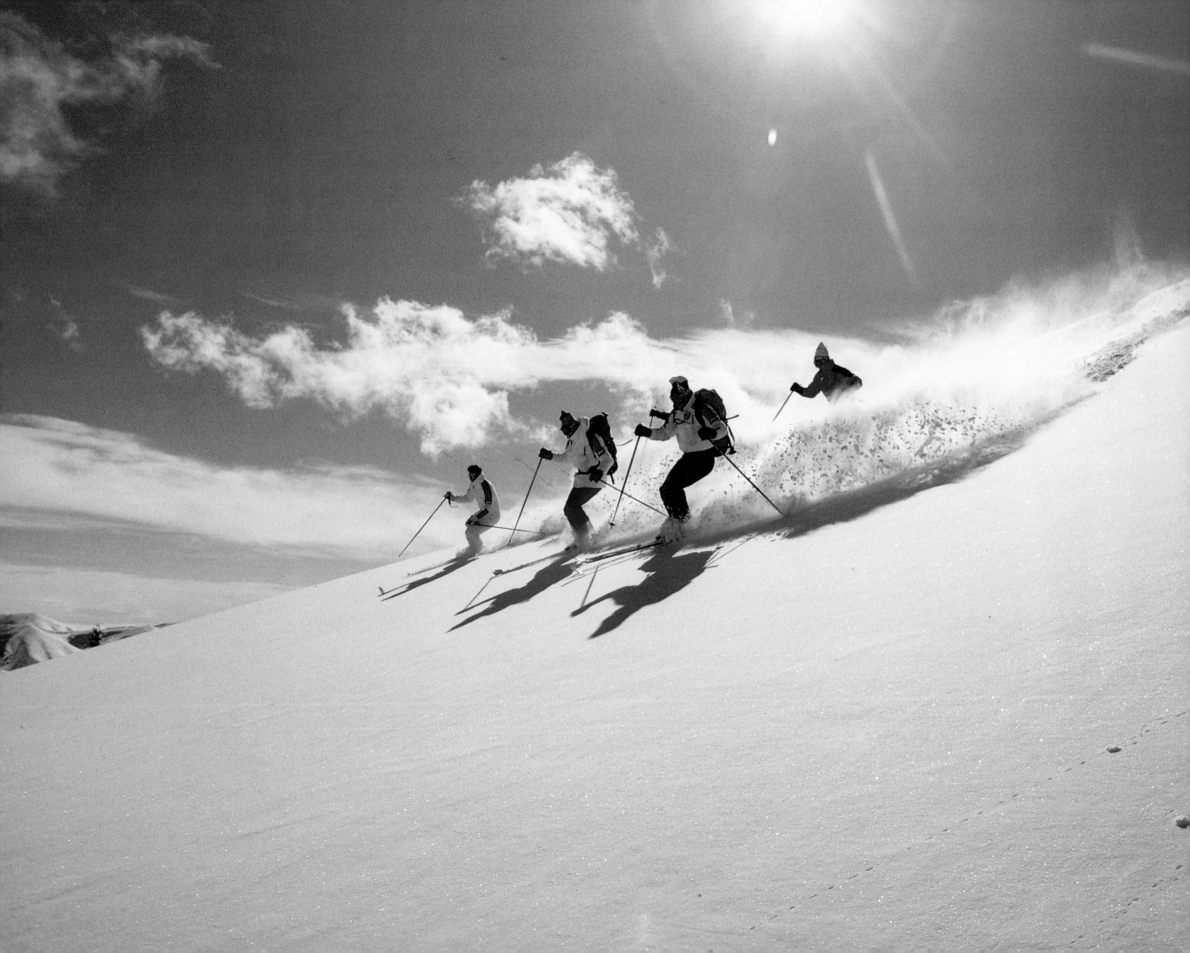

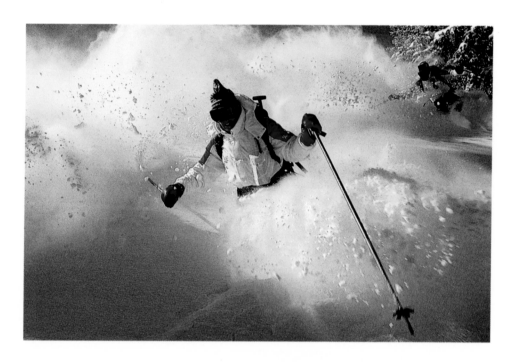

FRESH POWDER—SEATTLE RIDGE
Plate 66

BACKSIDE OF SEATTLE RIDGE
Plate 65

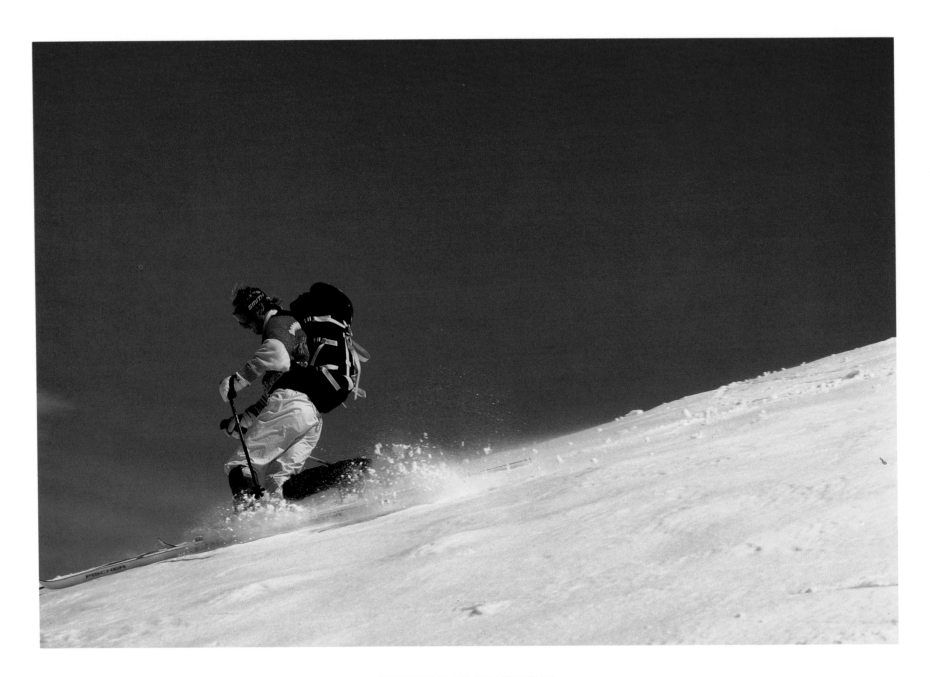

TELEMARKING PIONEER MOUNTAINS
Plate 67

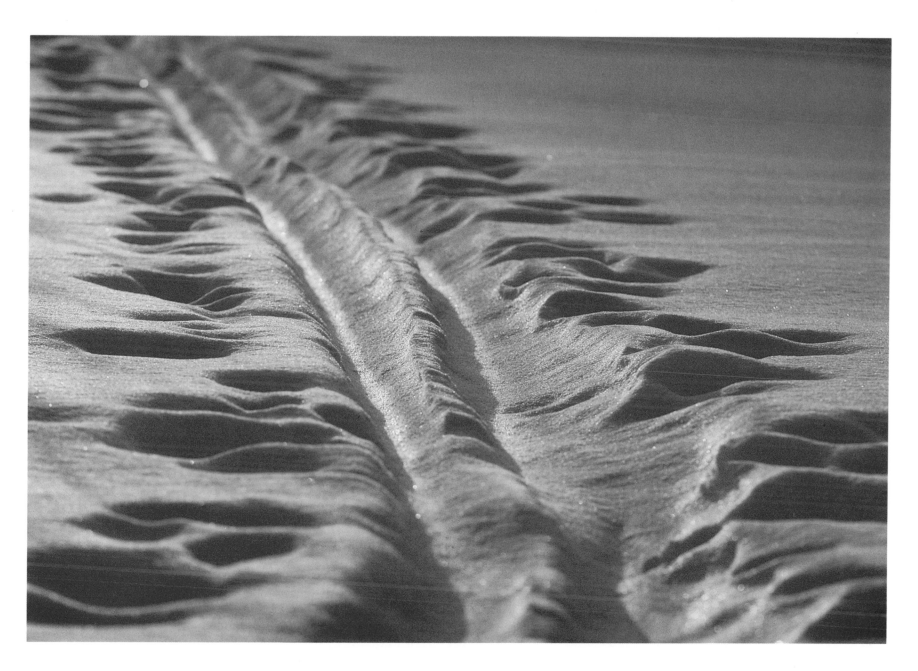

FROZEN TRACKS
Plate 68

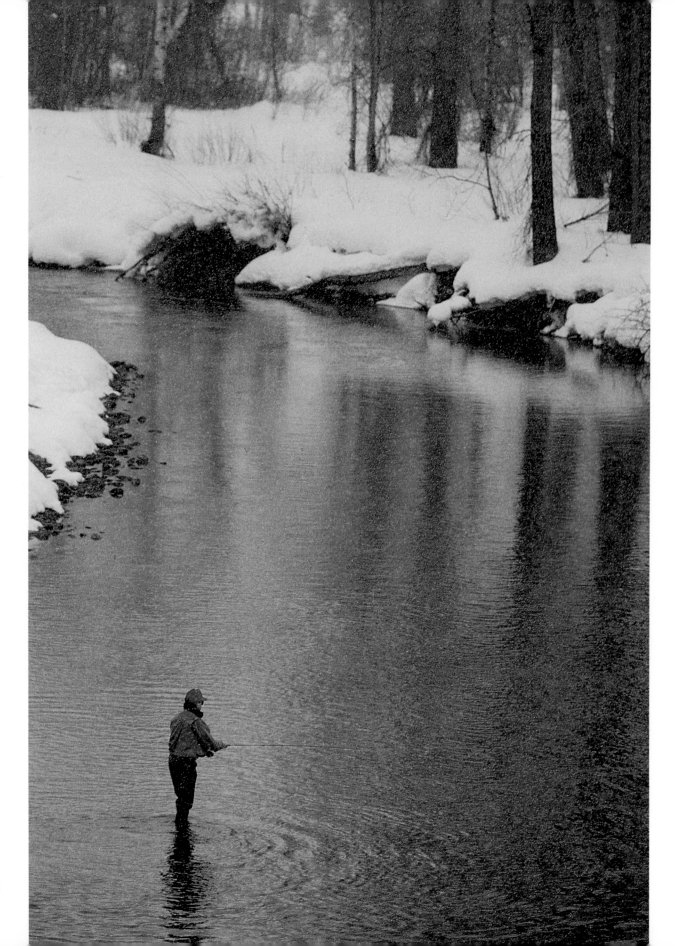

FISHING THE BIG WOOD RIVER
Plate 69

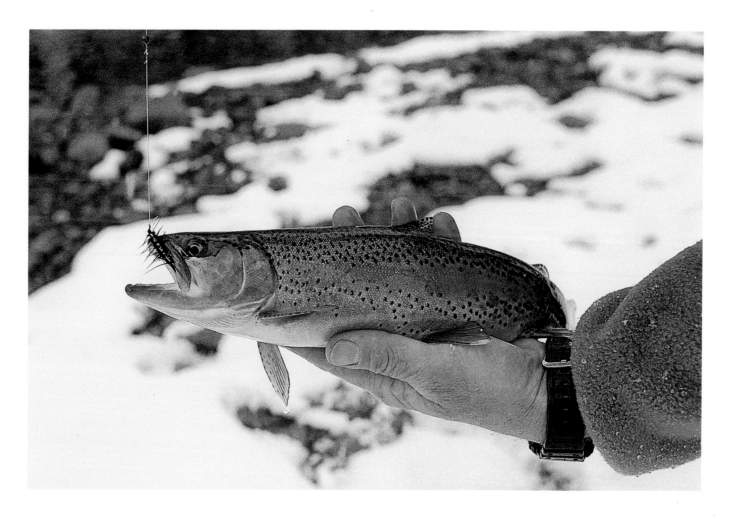

WOOD RIVER RAINBOW
Plate 70

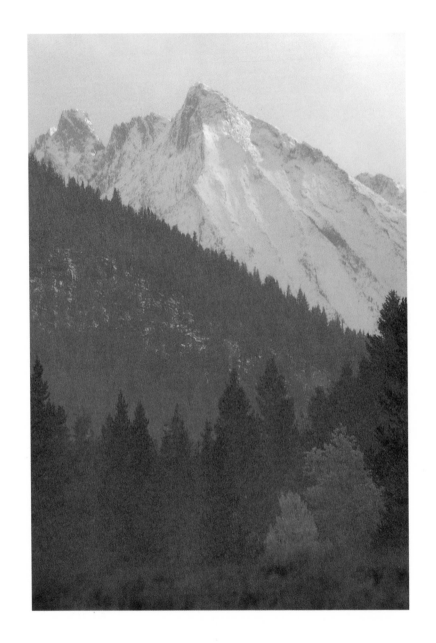

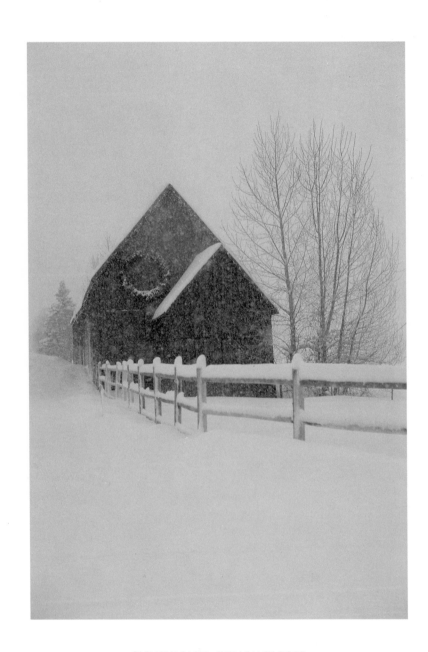

PIONEER MOUNTAINS
Plate 71

OLD MILK BARN—SUN VALLEY ROAD
Plate 72

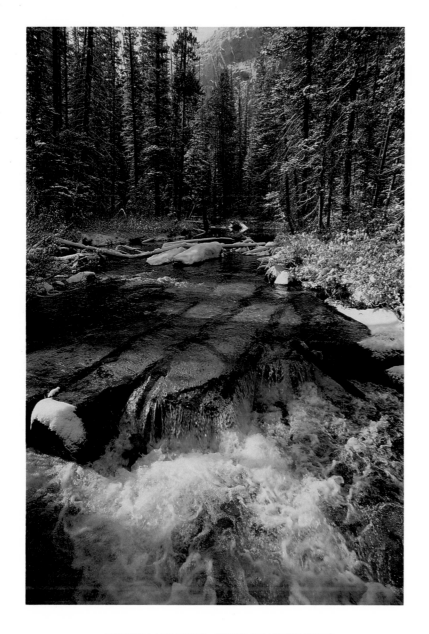

REDFISH LAKE CREEK—SAWTOOTH MOUNTAINS
Plate 73

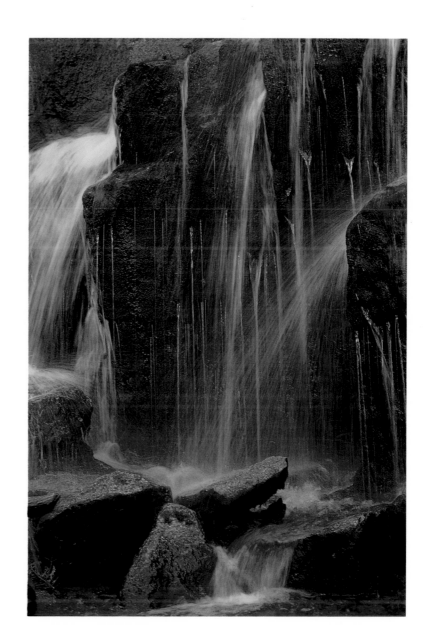

WATERFALL ON HELL ROARING CREEK
Plate 74

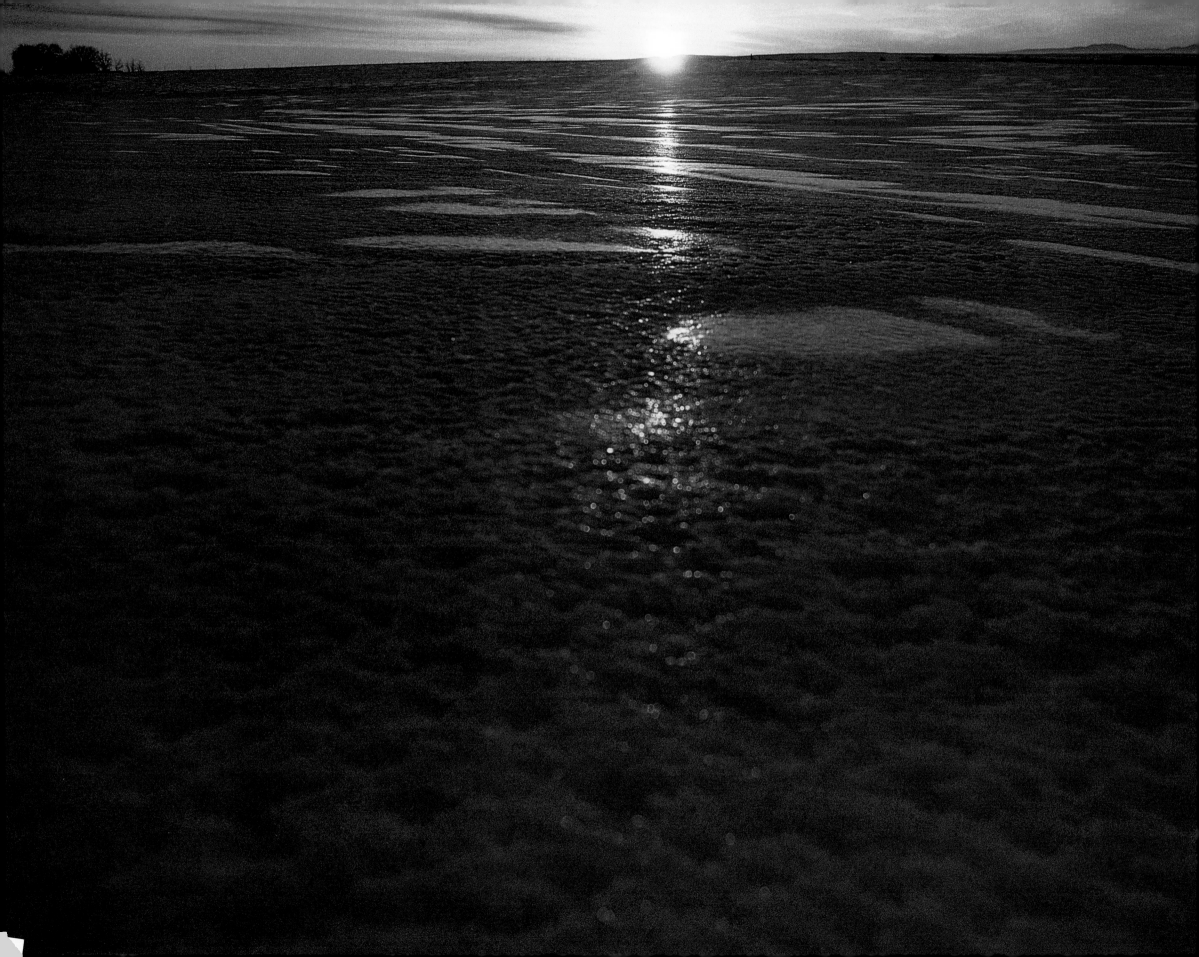

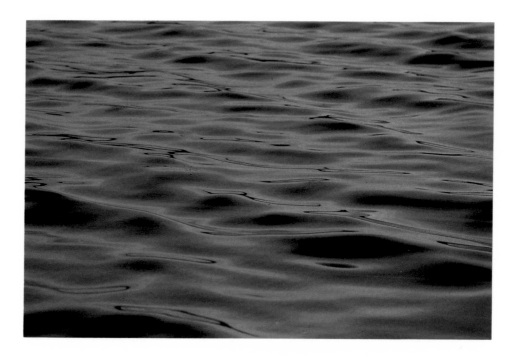

SILVER CREEK
Plate 76

FROZEN CAMAS PRAIRIE
Plate 75

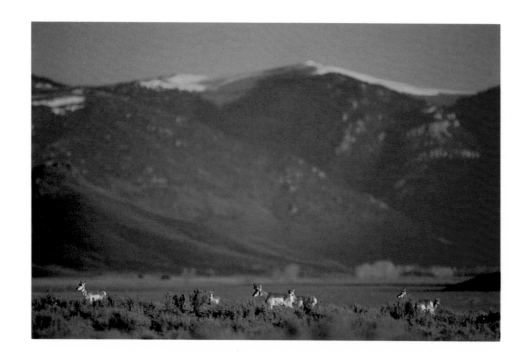

ANTELOPE—COPPER BASIN
Plate 77

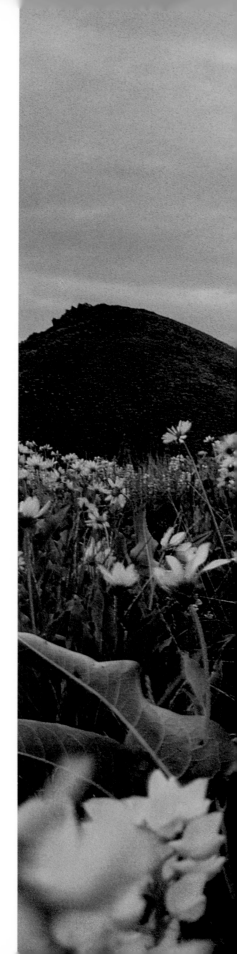

SPRING IN THE SUN VALLEY HILLS
Plate 78

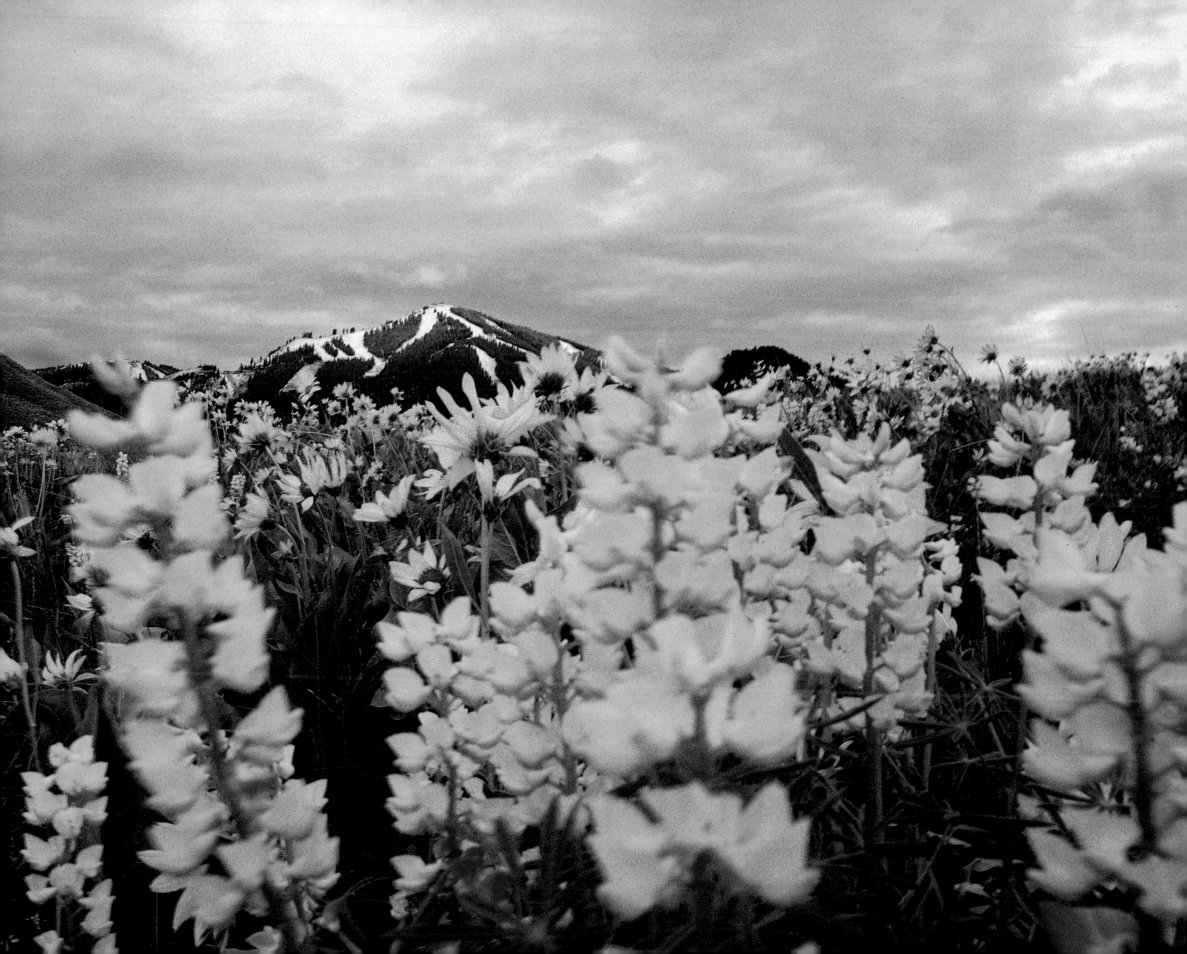

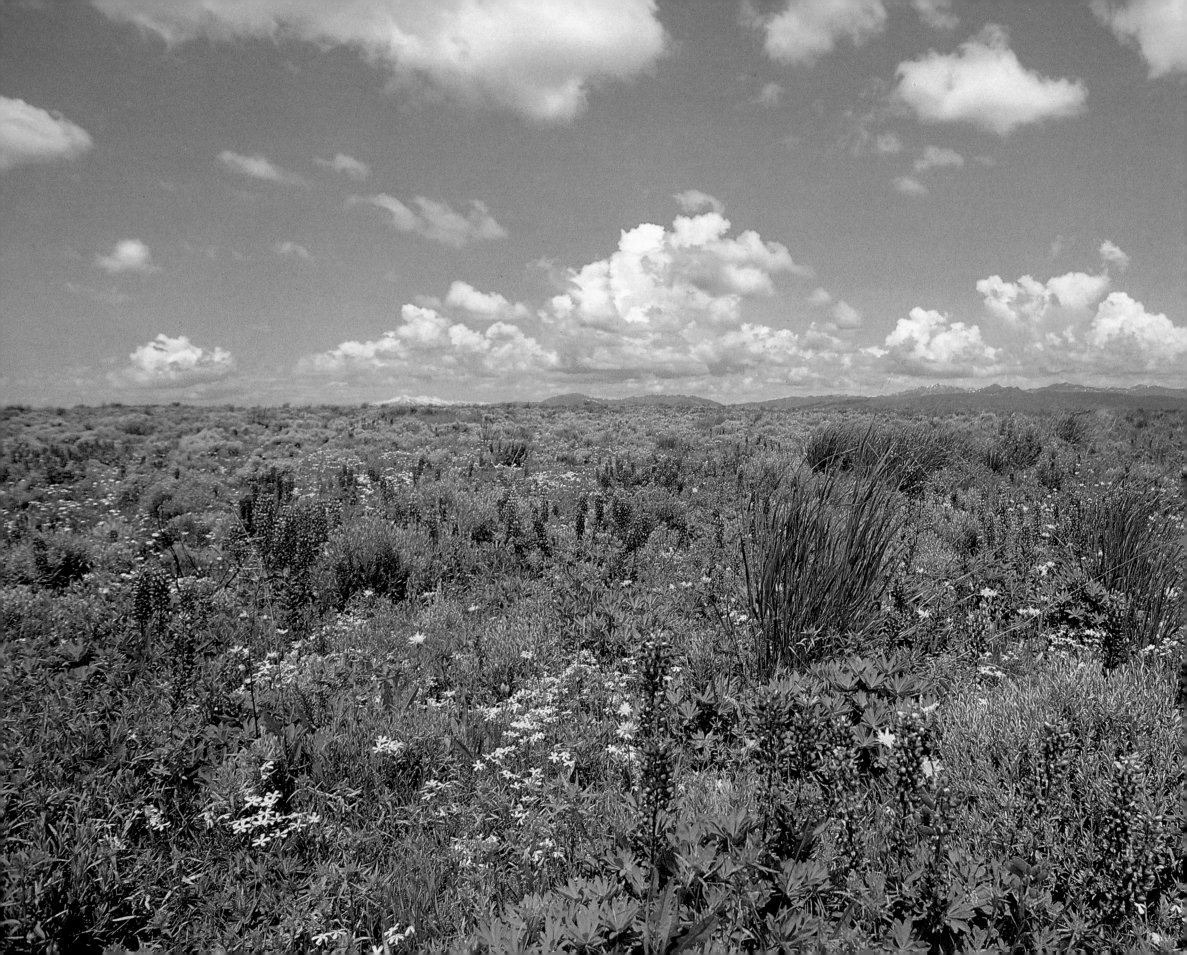

CAMAS PRAIRIE
Plate 79

BEAR VALLEY CREEK
Plate 80

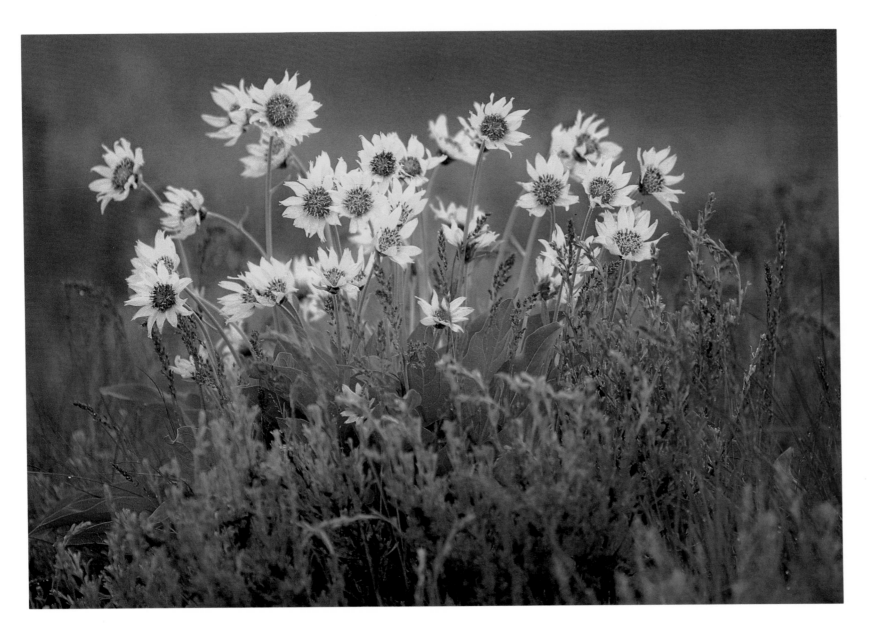

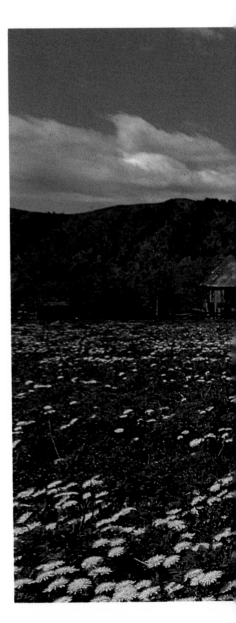

MULE EARS
Plate 81

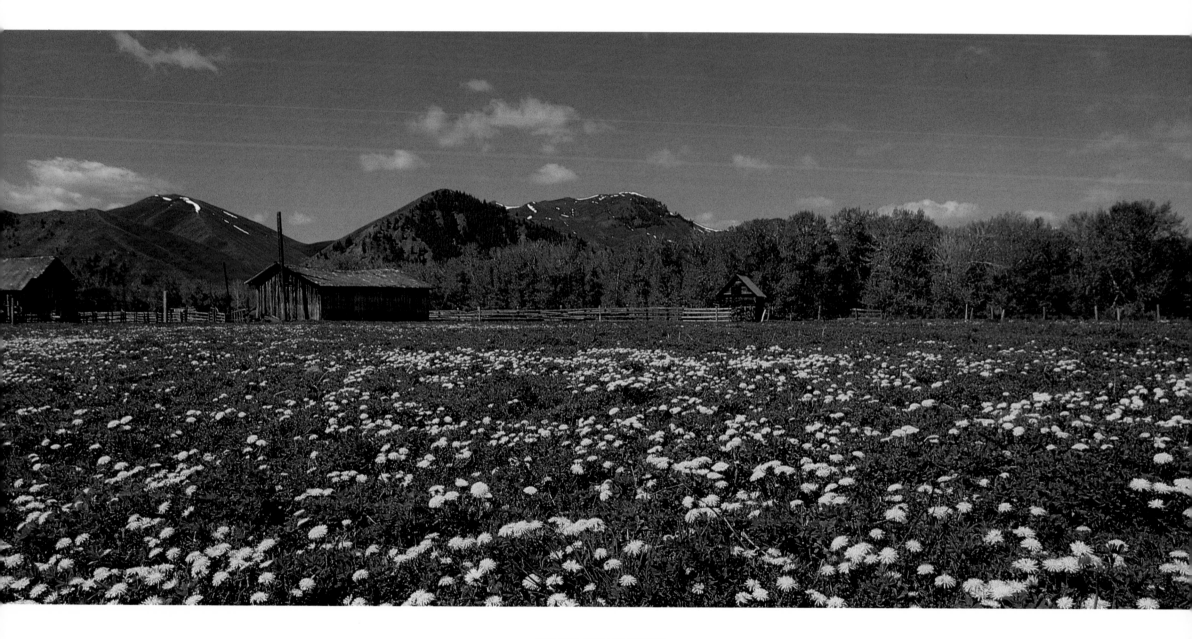

THE OLD HIBBARD RANCH
Plate 82

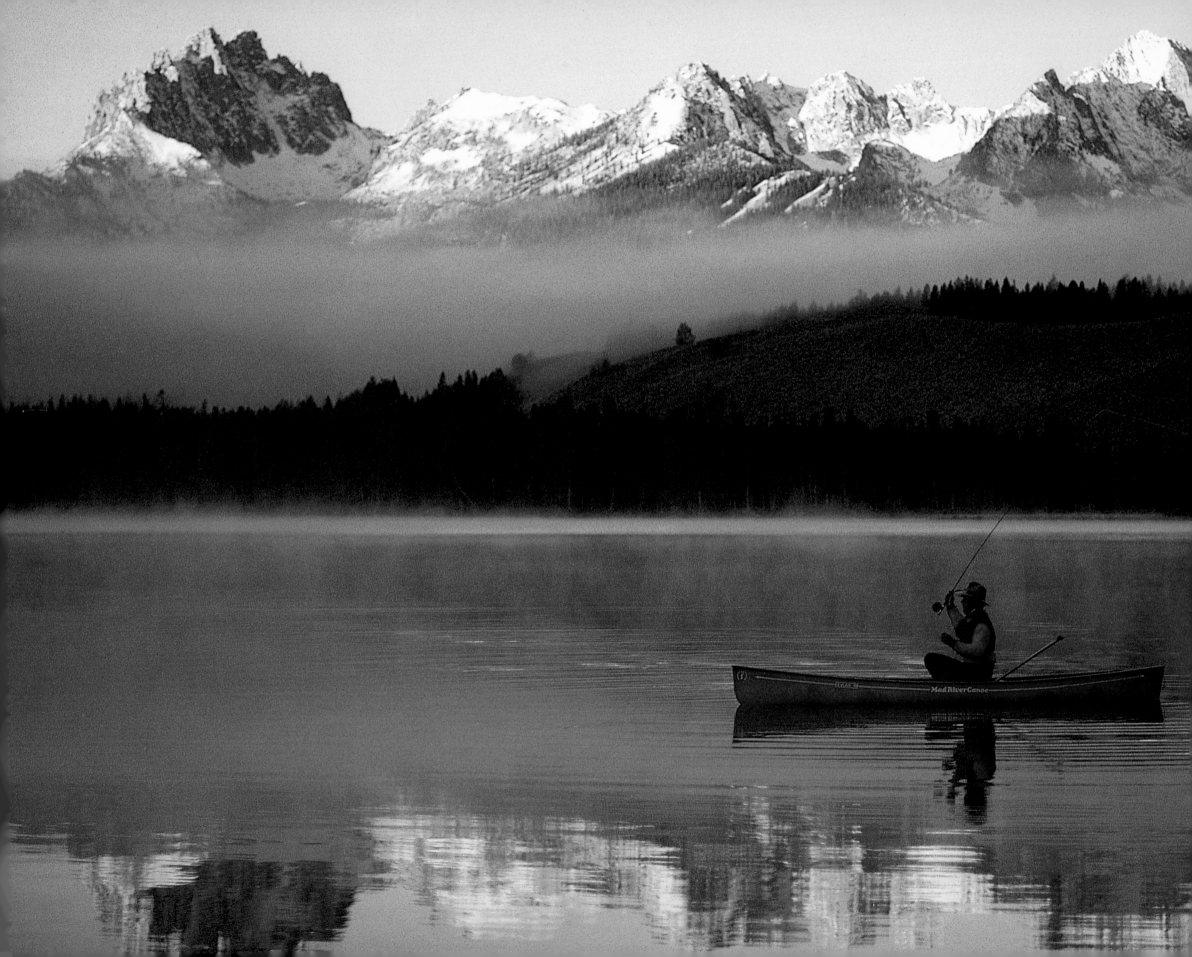

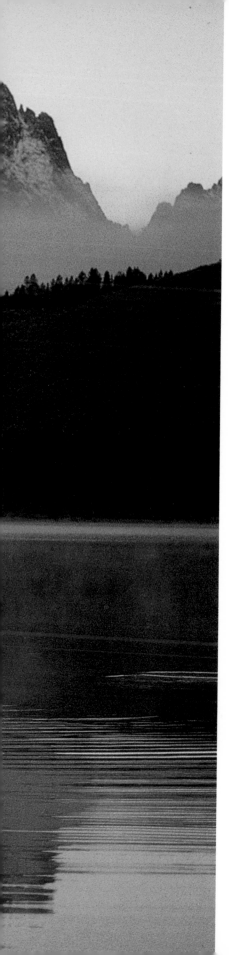

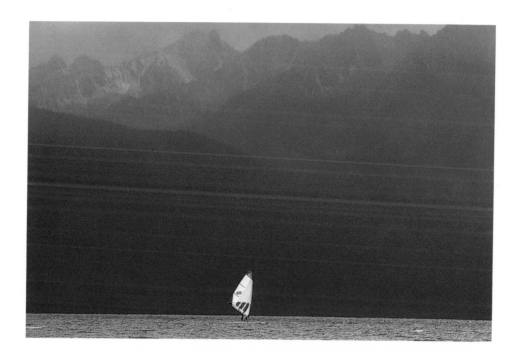

WINDSURFER—REDFISH LAKE
Plate 84

FLY FISHING LITTLE REDFISH LAKE
Plate 83

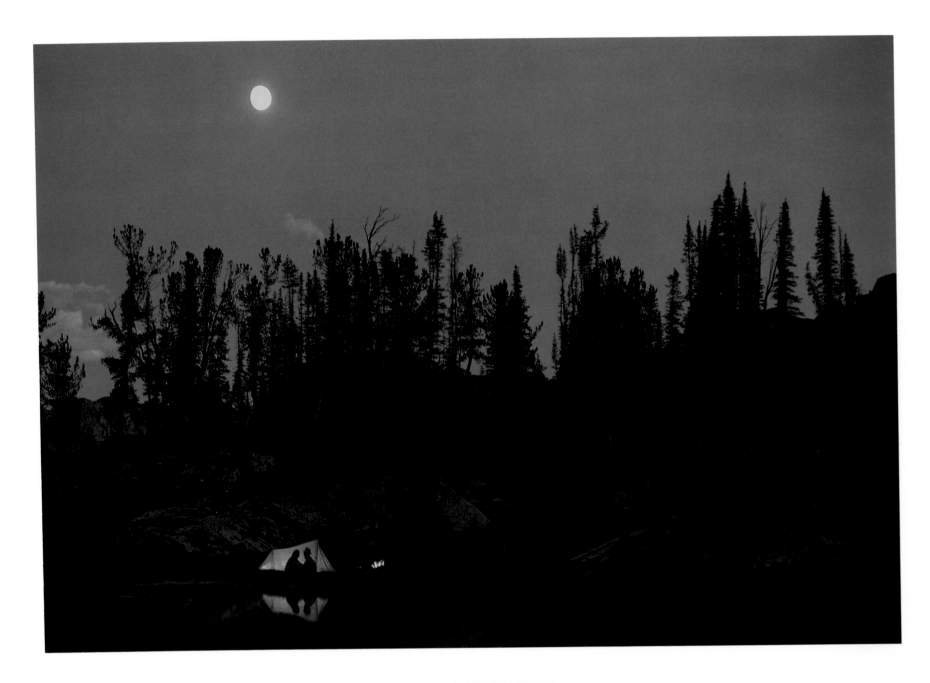

CAMPING—BOULDER MOUNTAINS
Plate 85

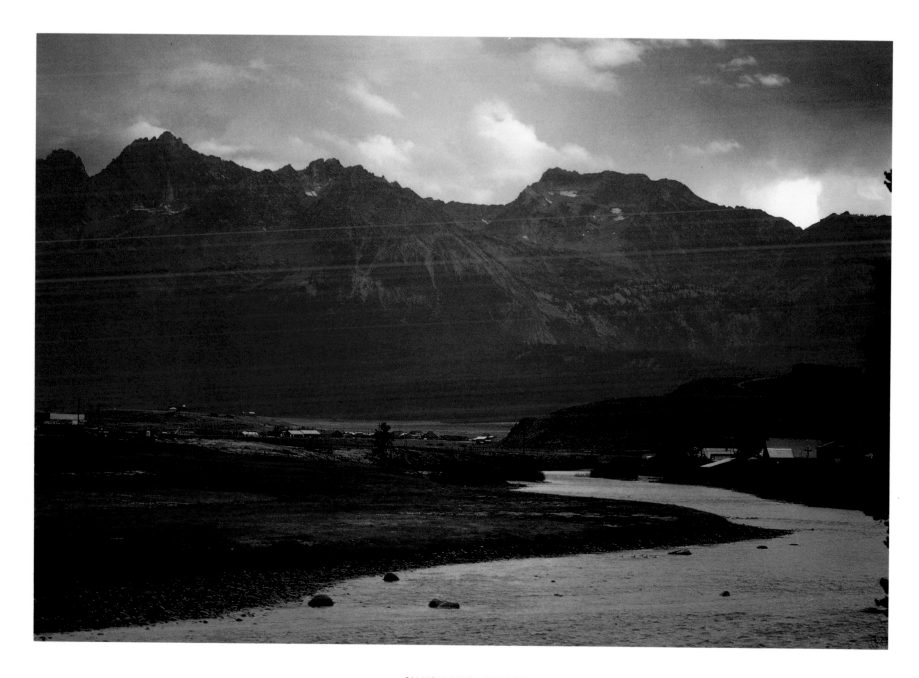

SALMON RIVER—STANLEY
Plate 86

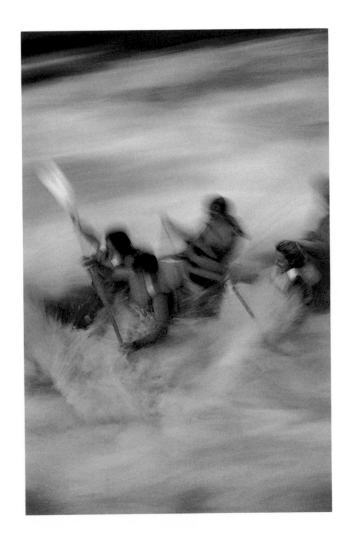

RAFTING THE PAYETTE RIVER
Plate 87

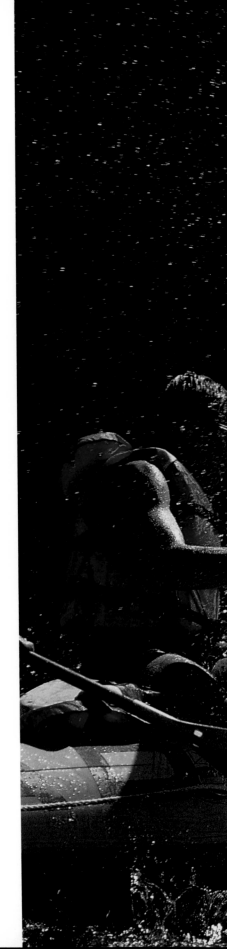

WATER FIGHT—PAYETTE RIVER
Plate 88

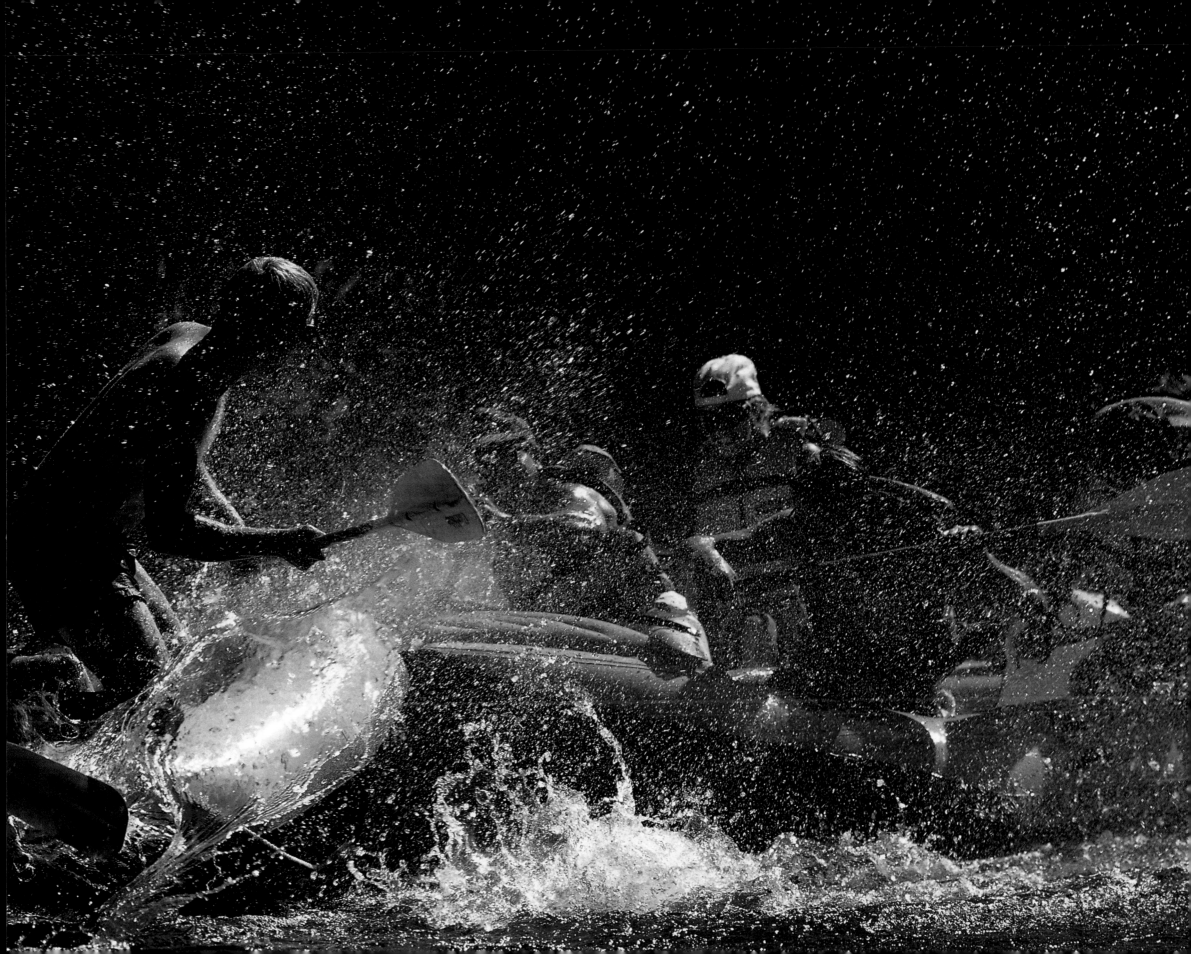

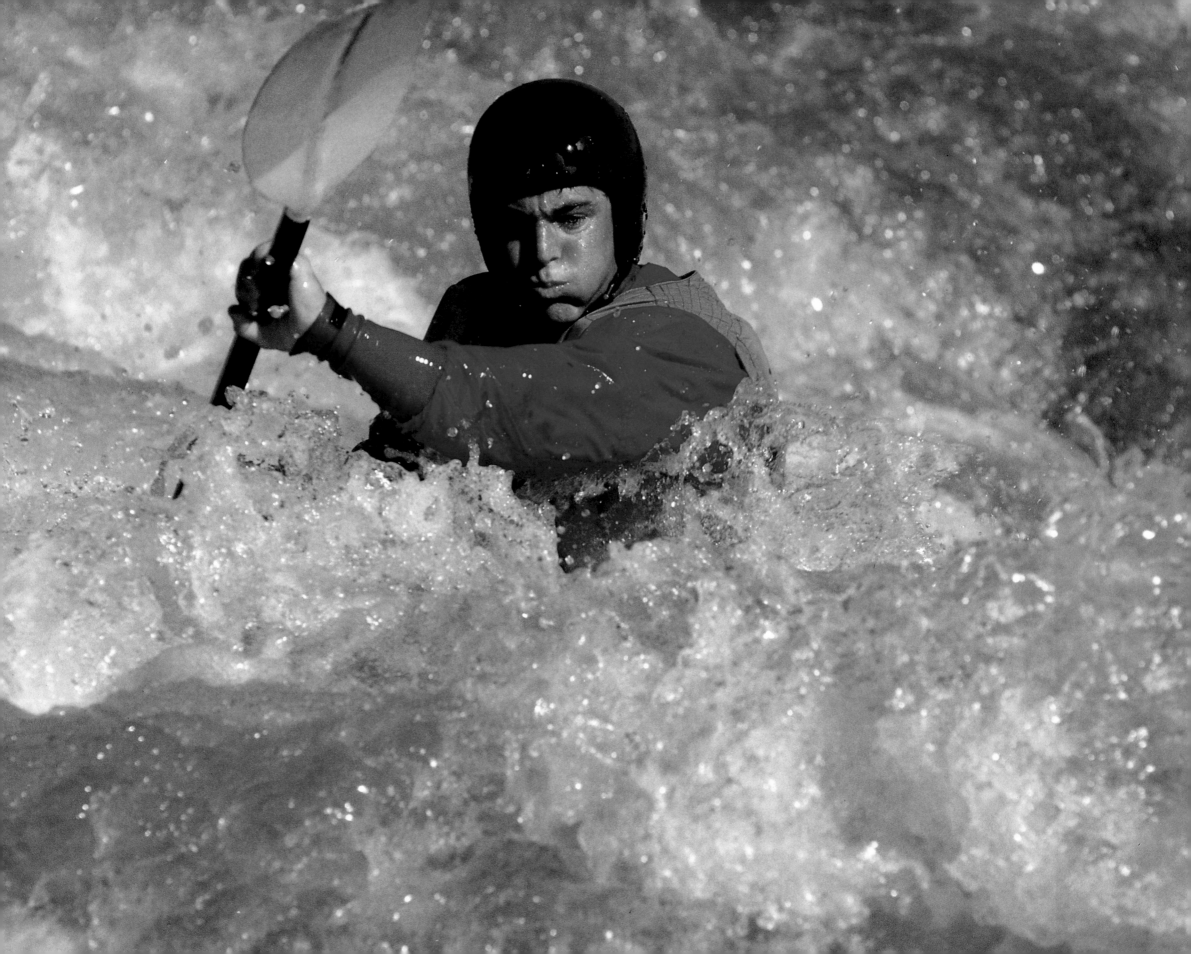

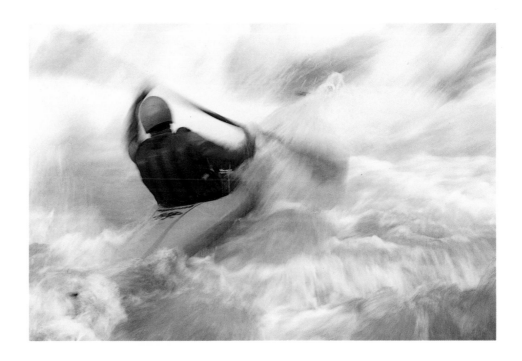

KAYAKING THE PAYETTE RIVER
Plate 90

KAYAKING THE SNAKE RIVER
Plate 89

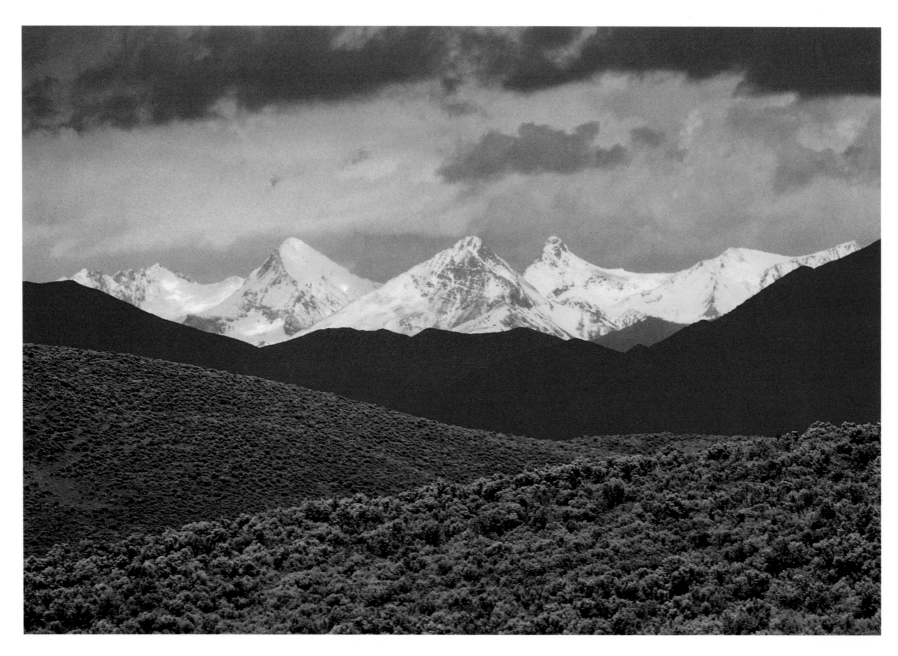

PIONEER MOUNTAINS FROM TIMMERMAN HILL
Plate 91

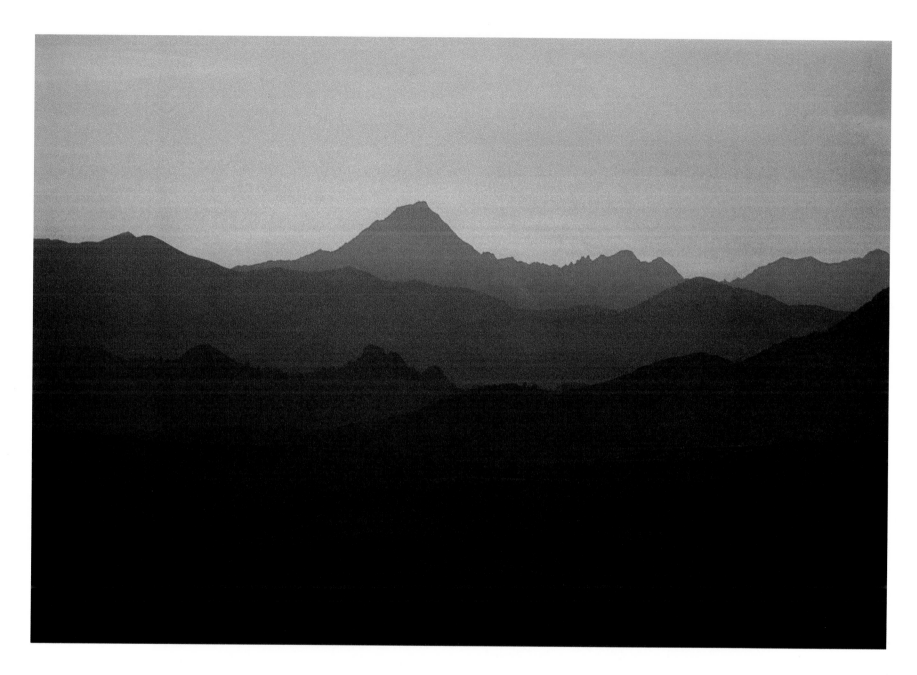

WHITE CLOUD MOUNTAINS FROM COPPER BASIN
Plate 92

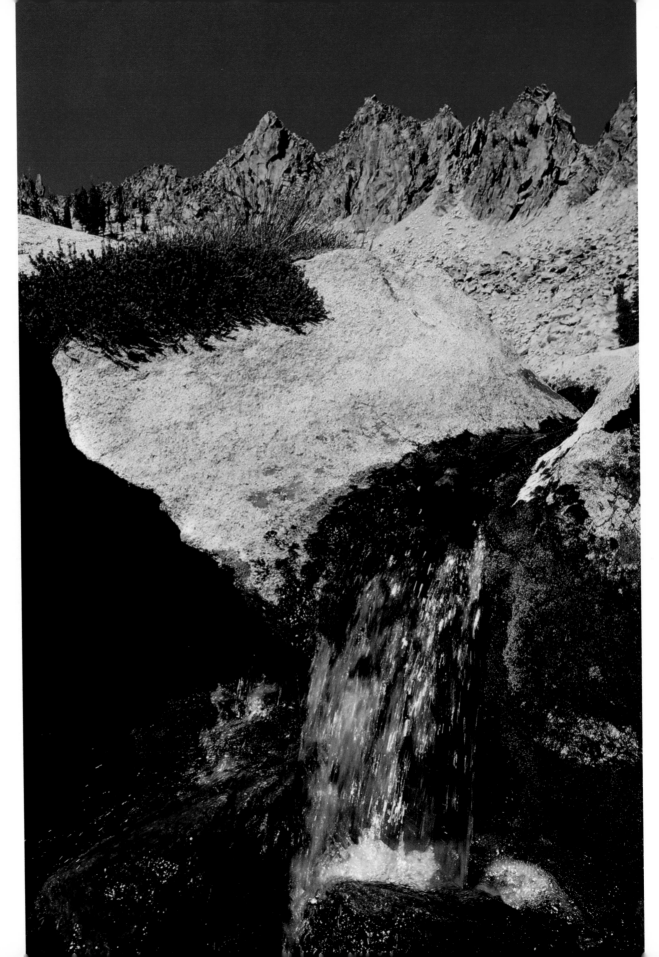

IN THE HELL ROARING BASIN ABOVE
IMOGENE LAKE
Plate 93

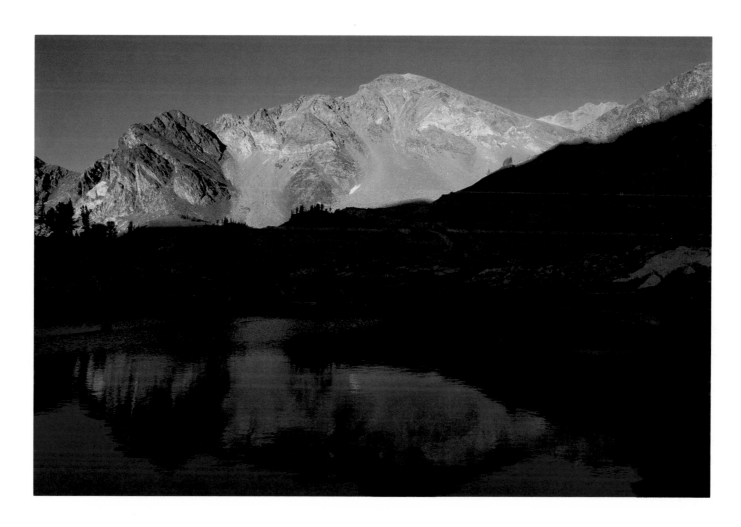

BOULDER CITY
Plate 94

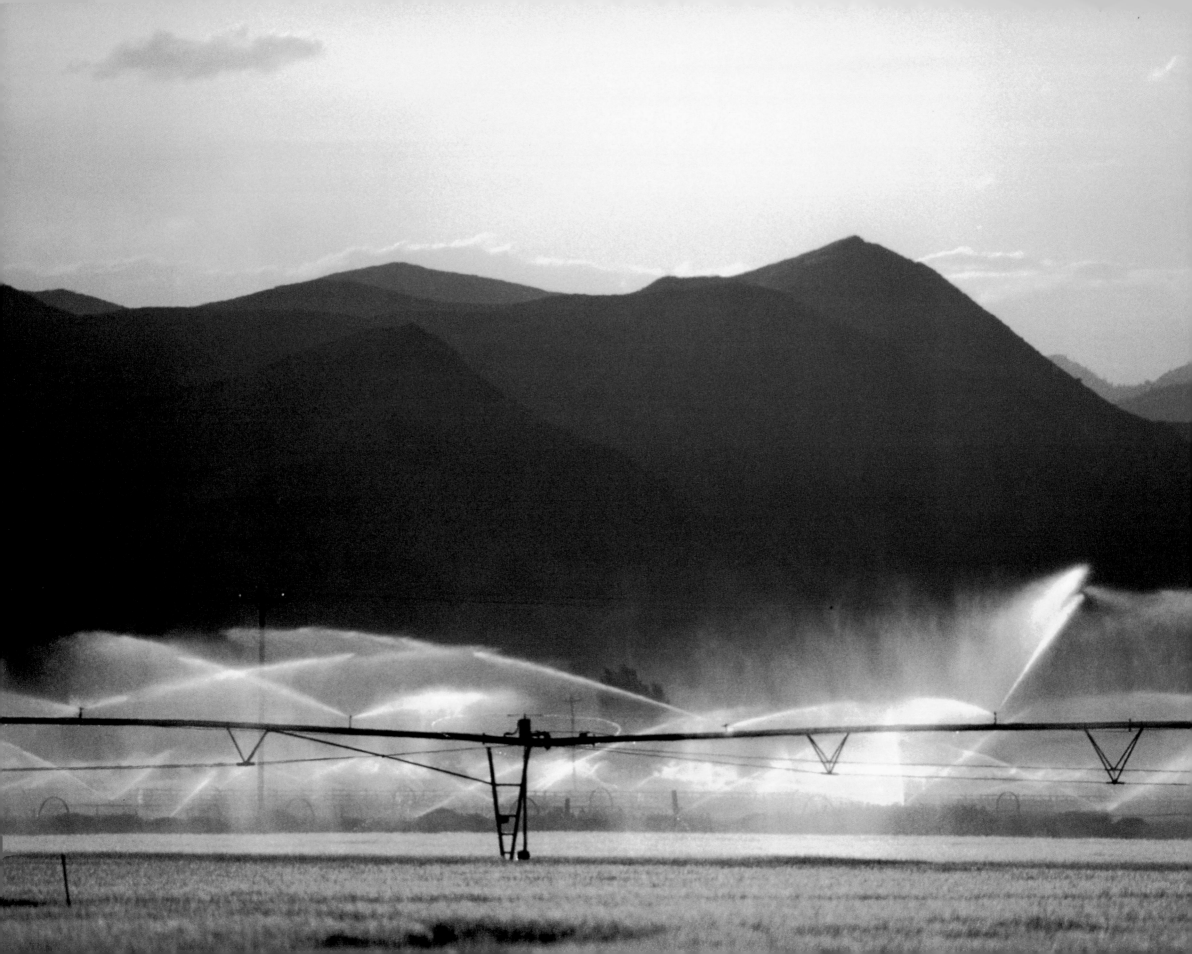

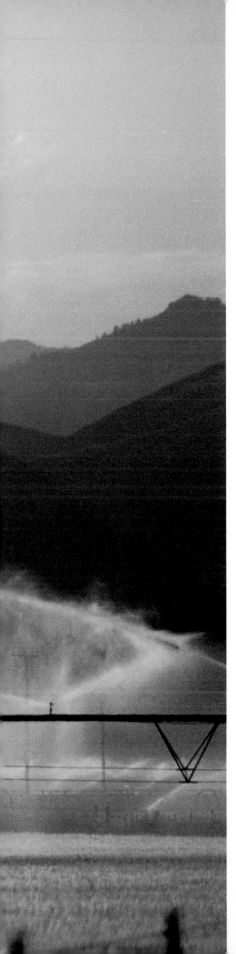

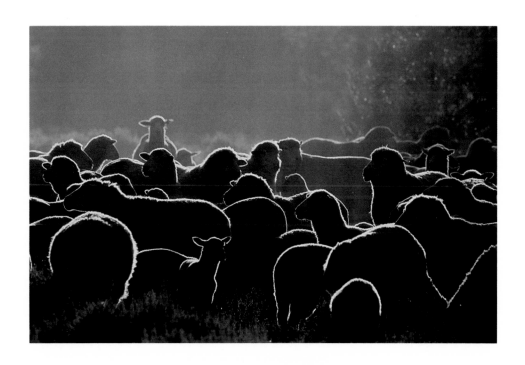

SHEEP—SAWTOOTH SUMMER RANGE
Plate 96

IRRIGATION—BELLEVUE TRIANGLE
Plate 95

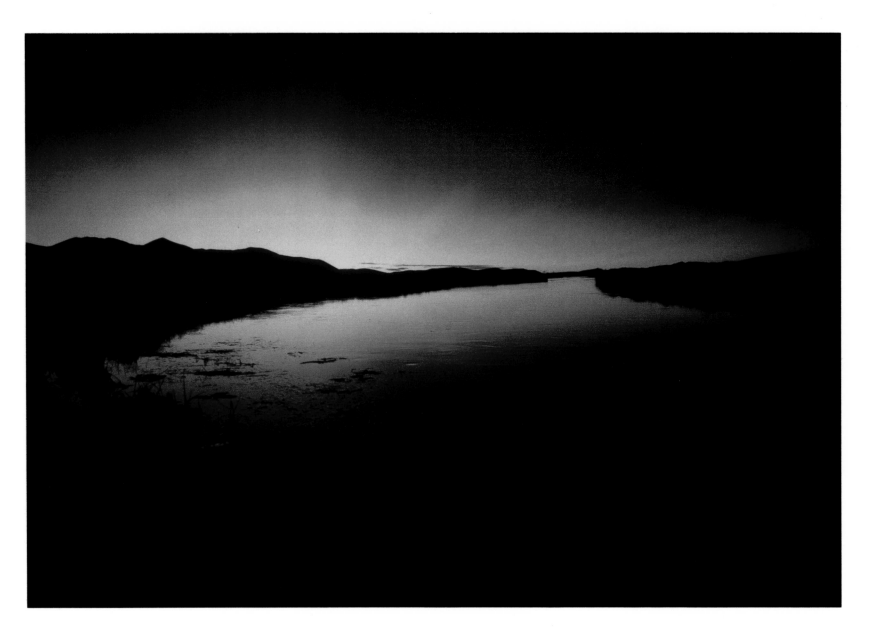

SUNSET POINT OF ROCKS—SILVER CREEK
Plate 97

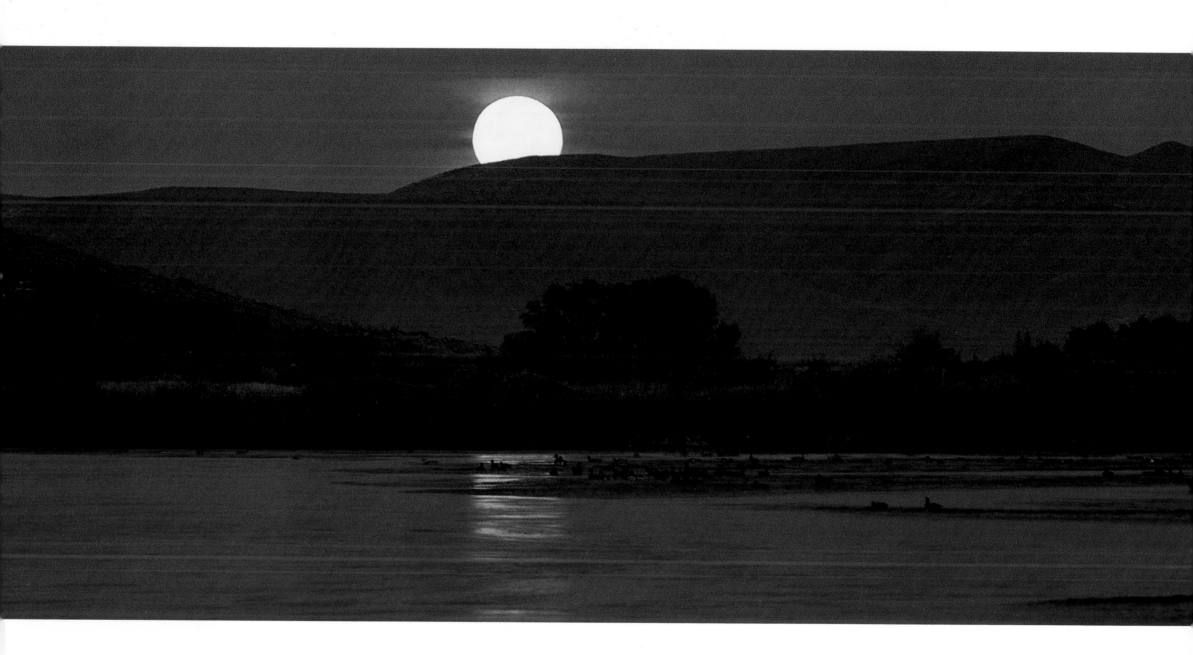

FULL MOON OVER SILVER CREEK
Plate 98

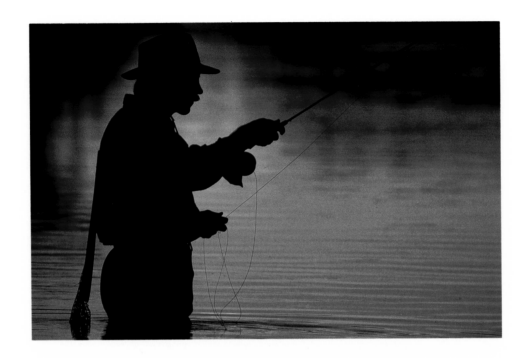

FLY FISHING SILVER CREEK
Plate 99

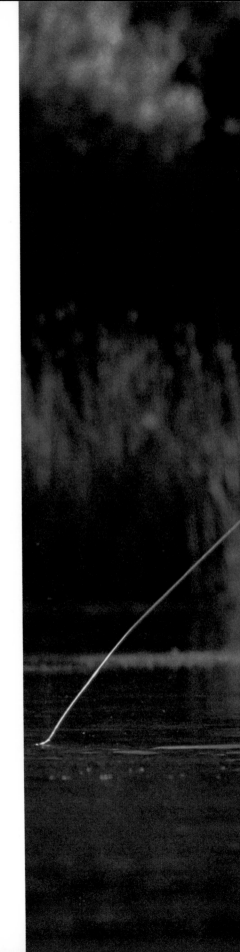

FLY FISHING SILVER CREEK
Plate 100

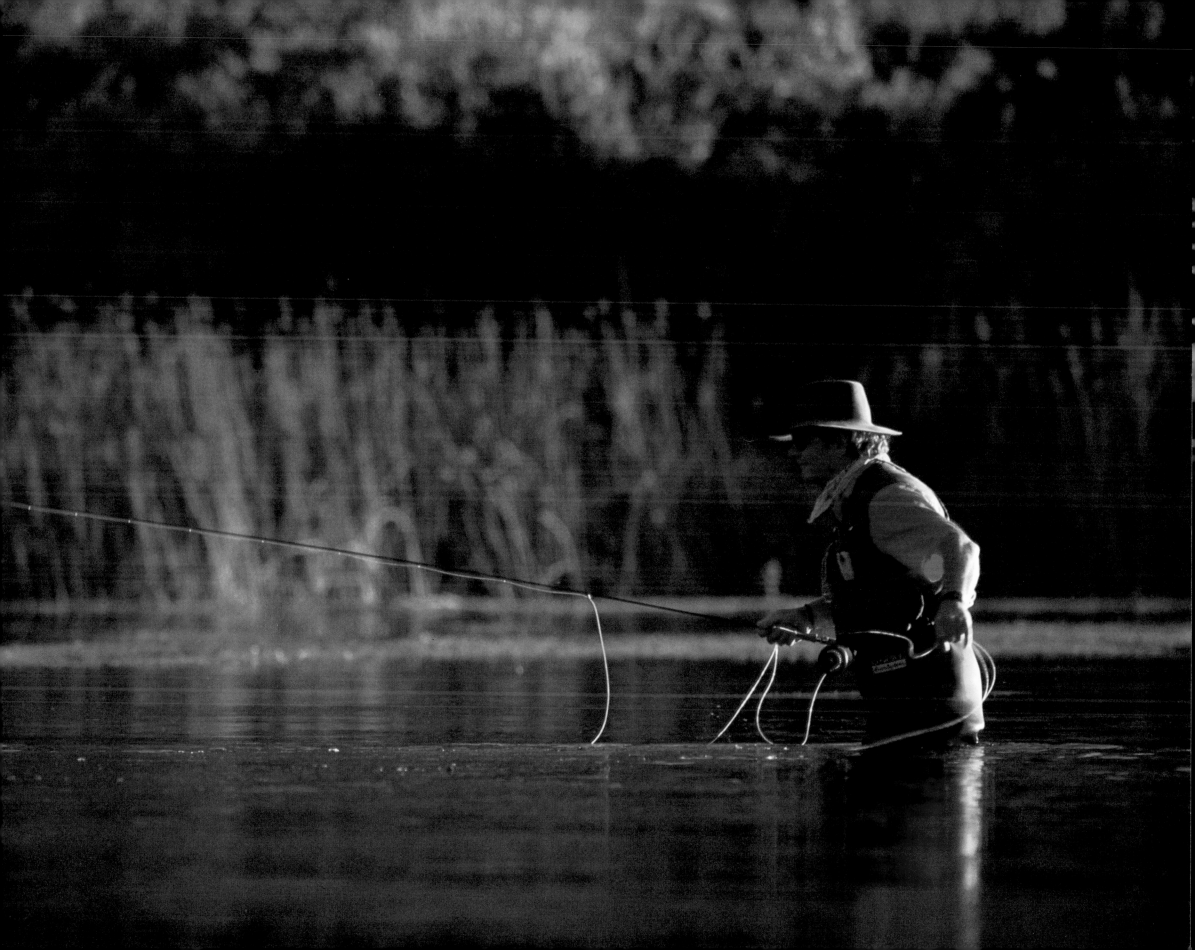

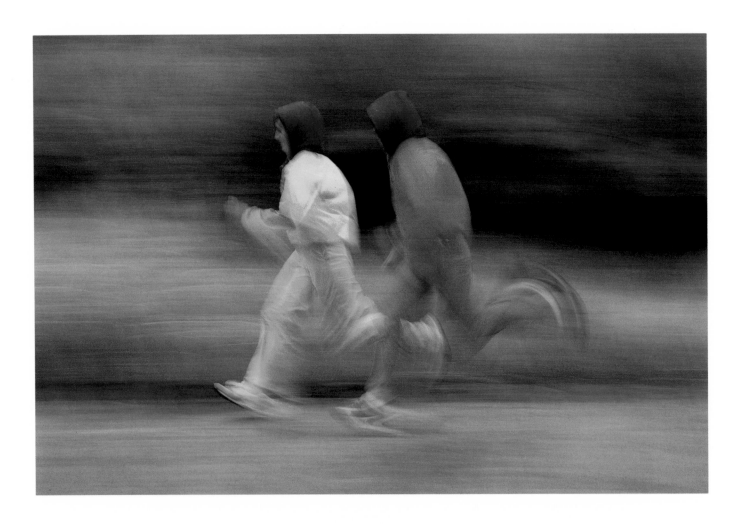

JOGGER—ADAMS GULCH
Plate 101

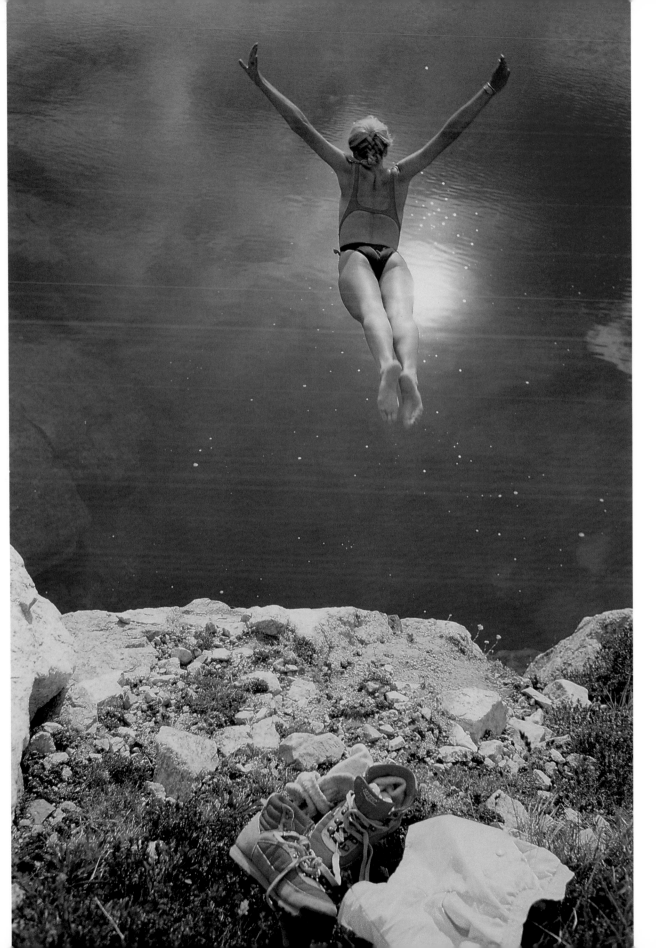

SWIMMING A HIGH MOUNTAIN LAKE
IN THE SAWTOOTHS
Plate 102

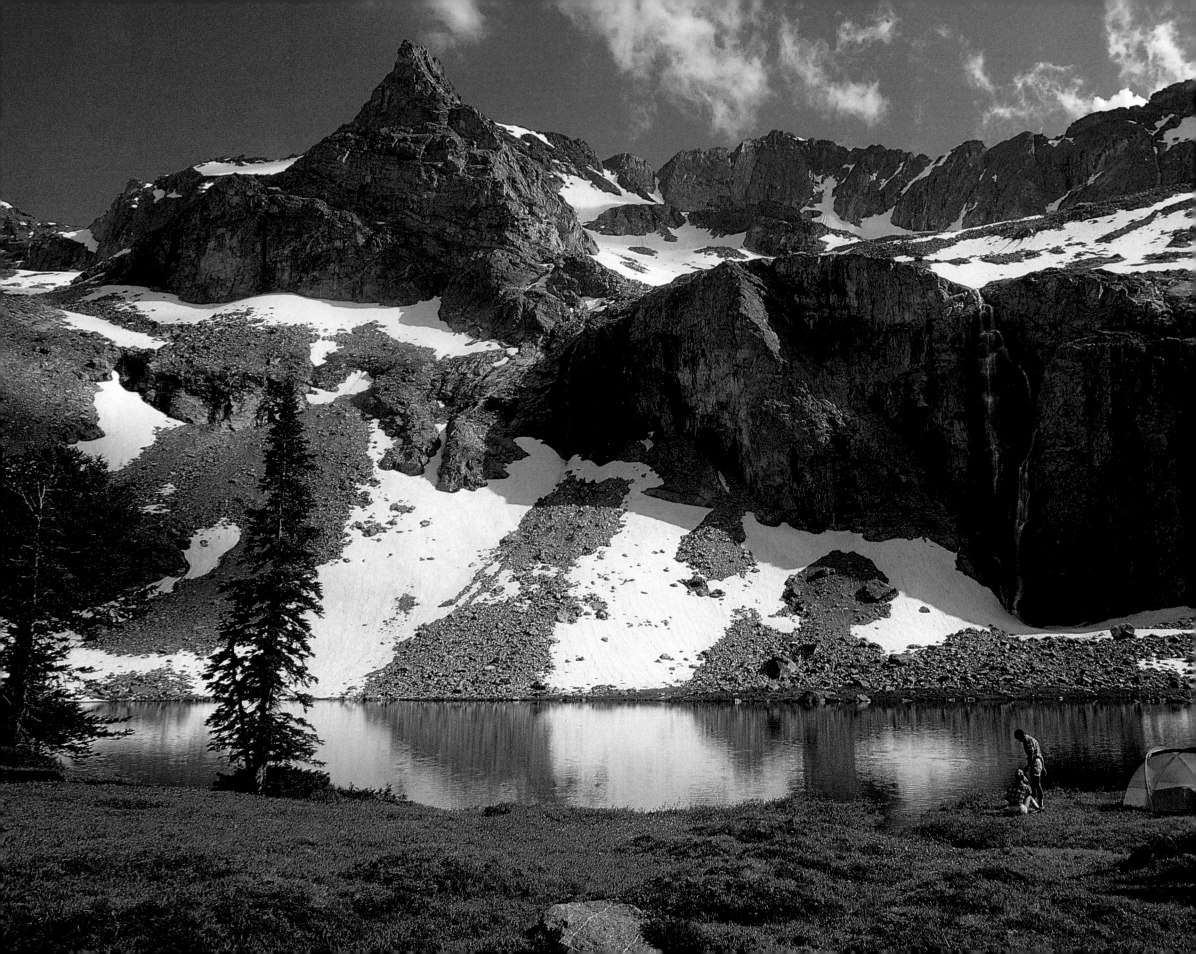

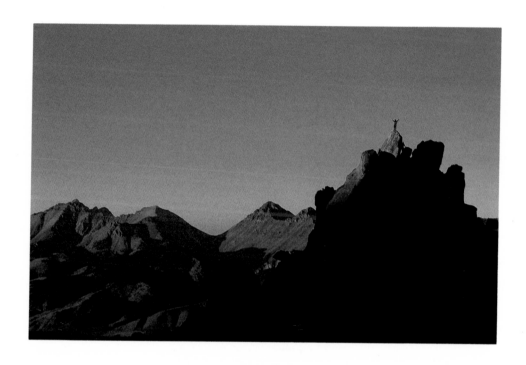

THE BIG LOST RIVER RANGE—MACKAY
Plate 104

KANE LAKE—PIONEER MOUNTAINS
Plate 103

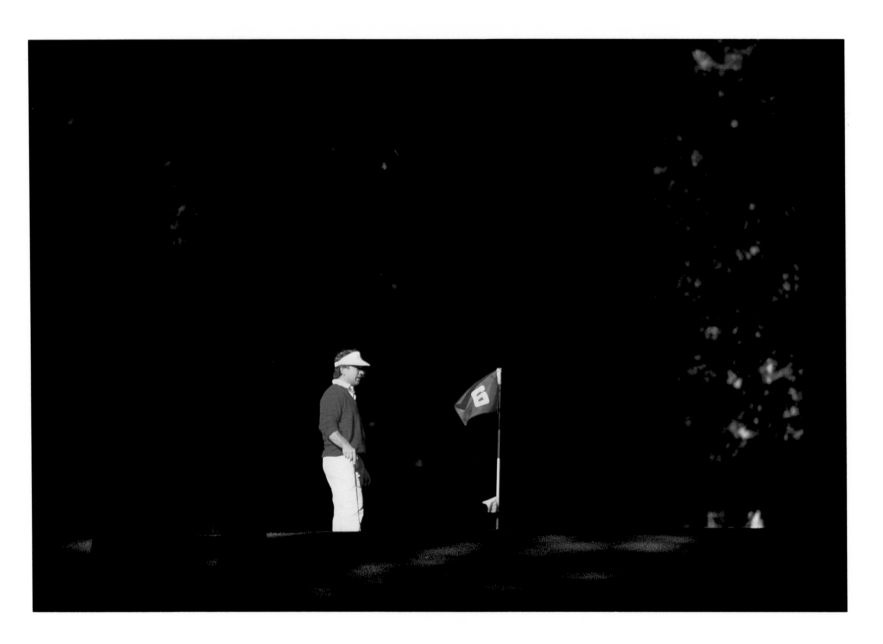
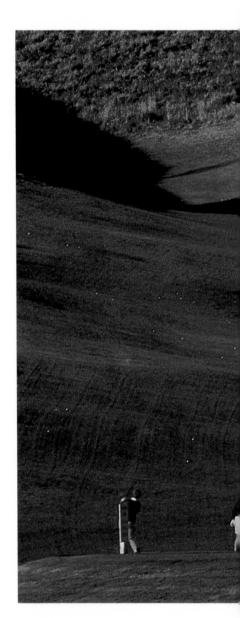

WARM SPRINGS GOLF COURSE
Plate 105

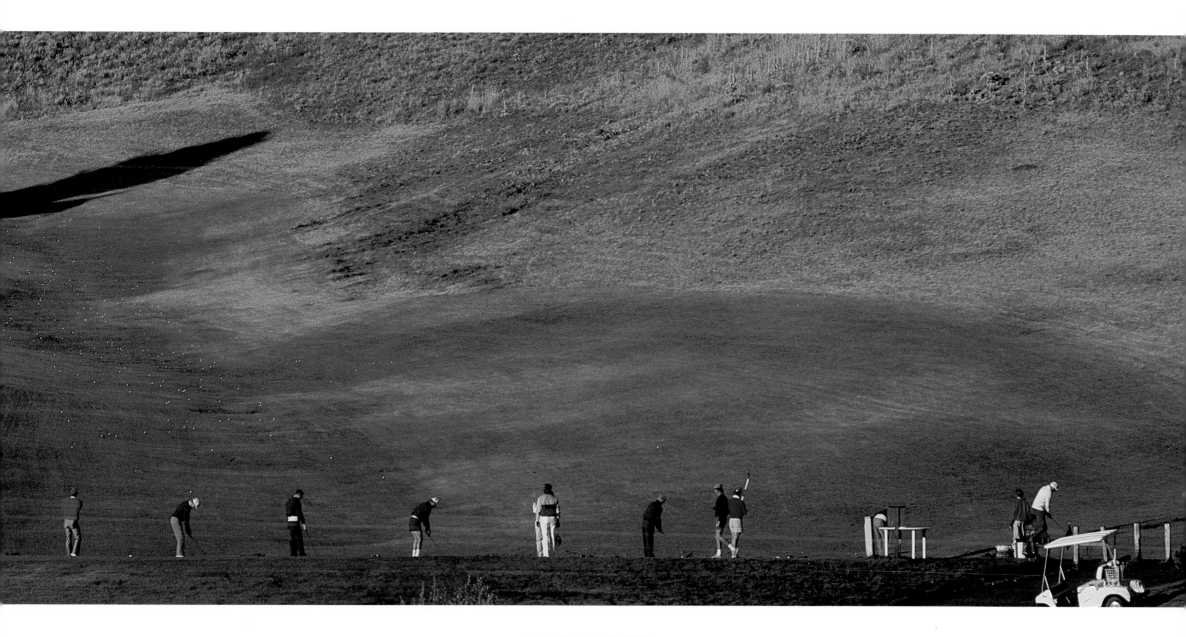

PRACTICE TEE—ELKHORN
Plate 106

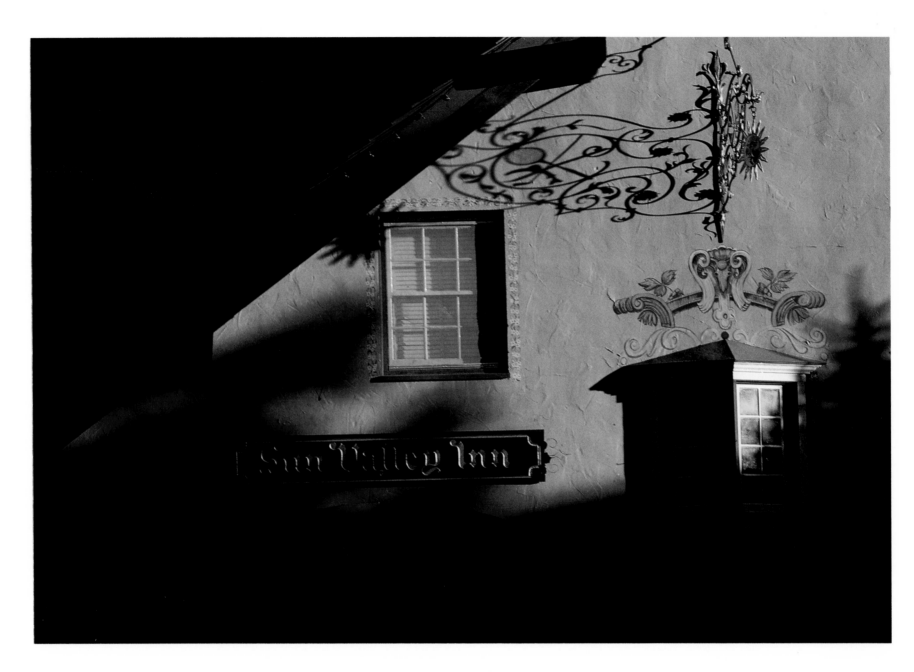

SUN VALLEY INN
Plate 107

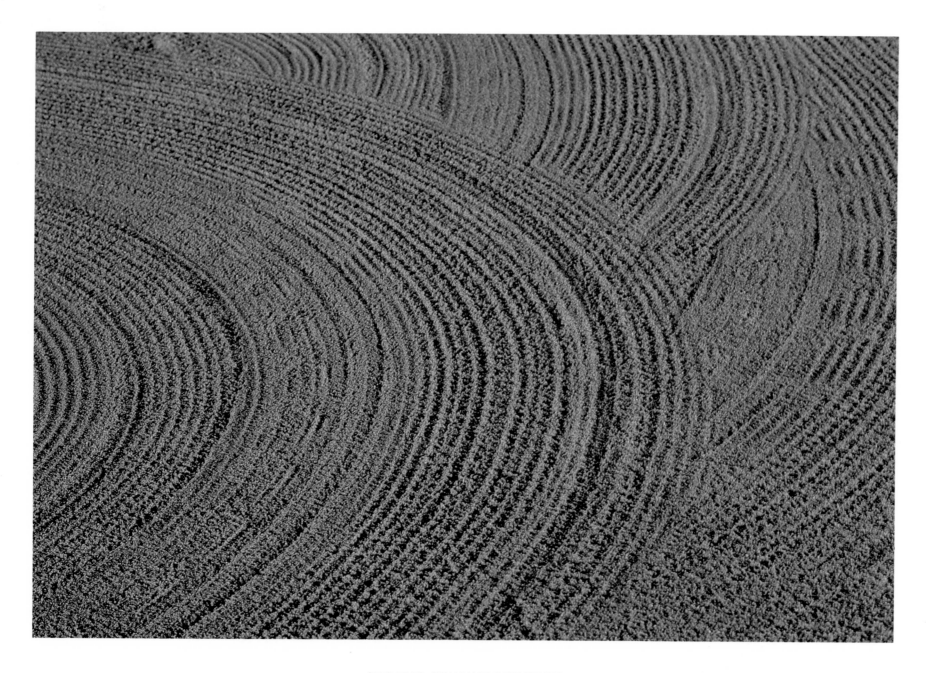

SAND TRAP—SUN VALLEY GOLF COURSE
Plate 108

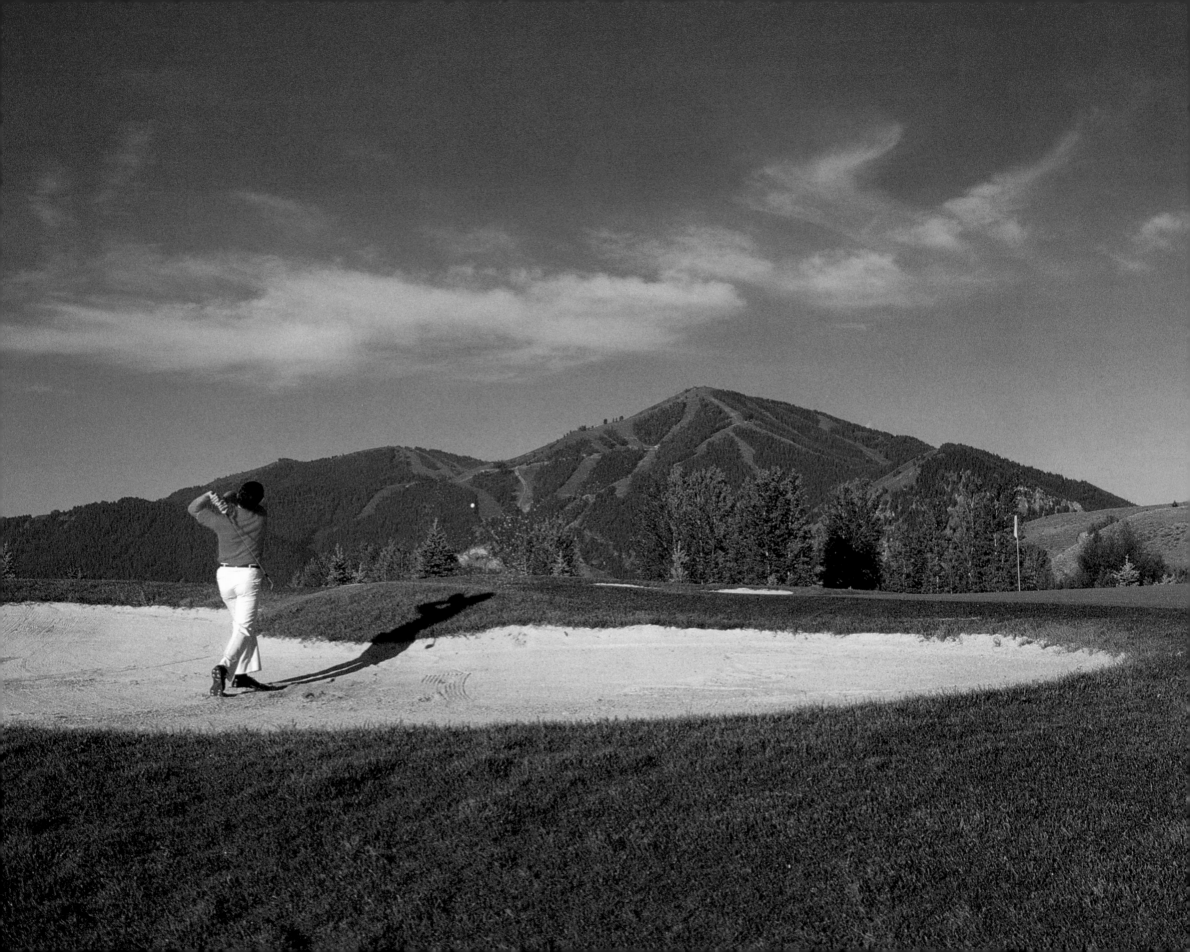

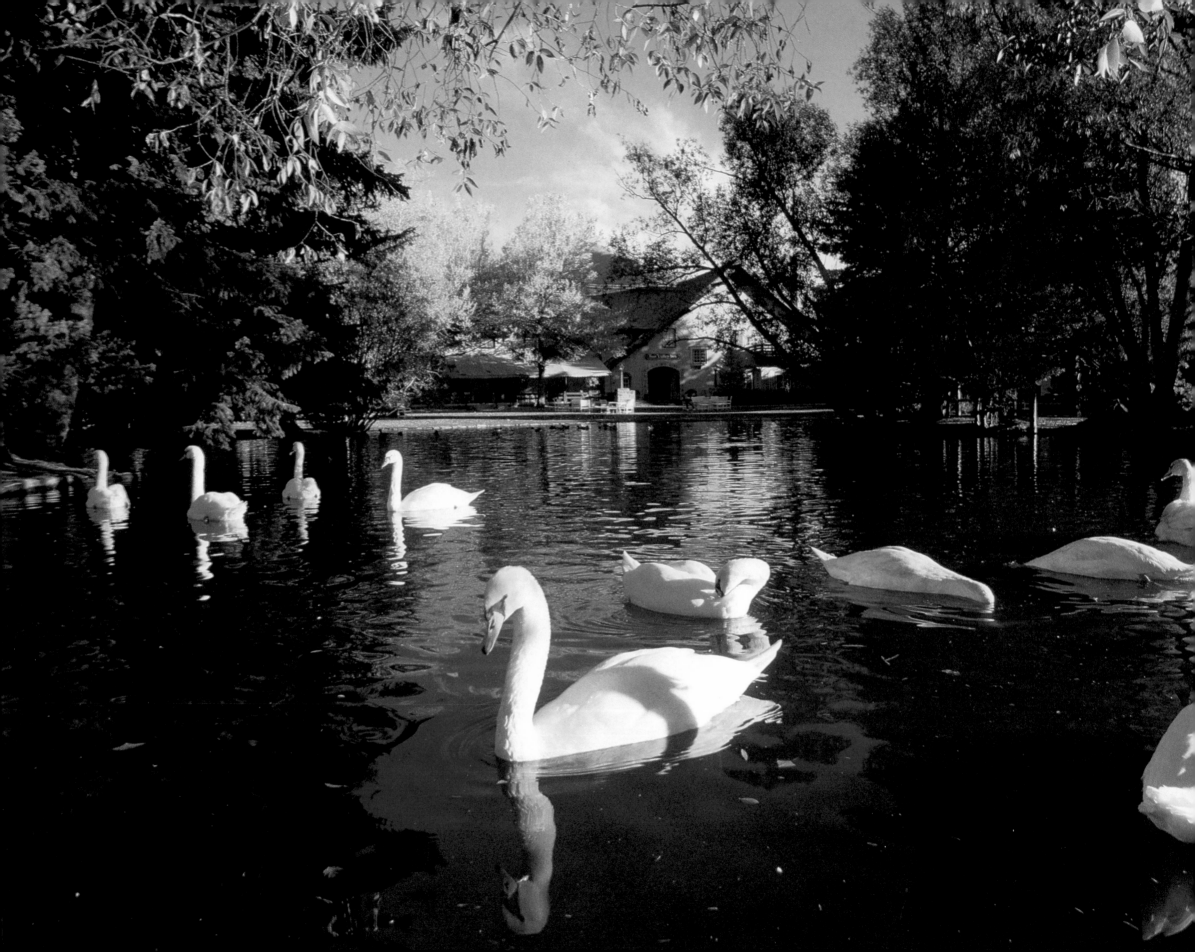

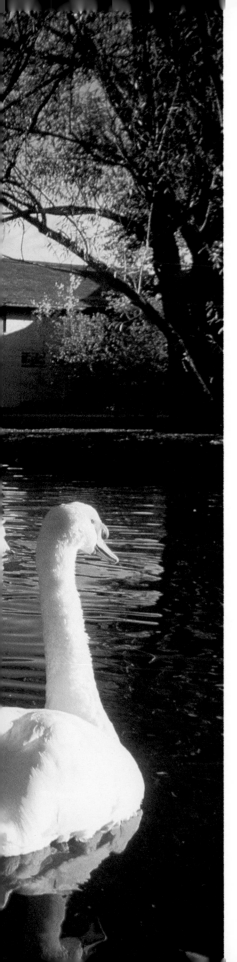

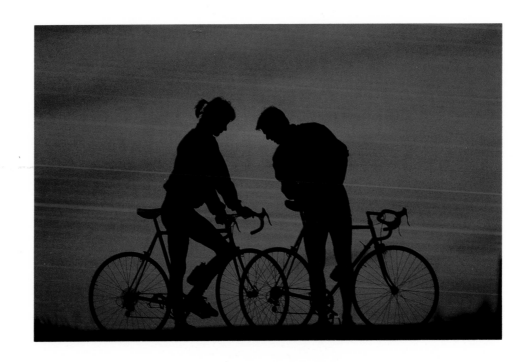

ROAD BIKING—SHOSHONE
Plate 116

SWANS—SUN VALLEY MALL
Plate 115

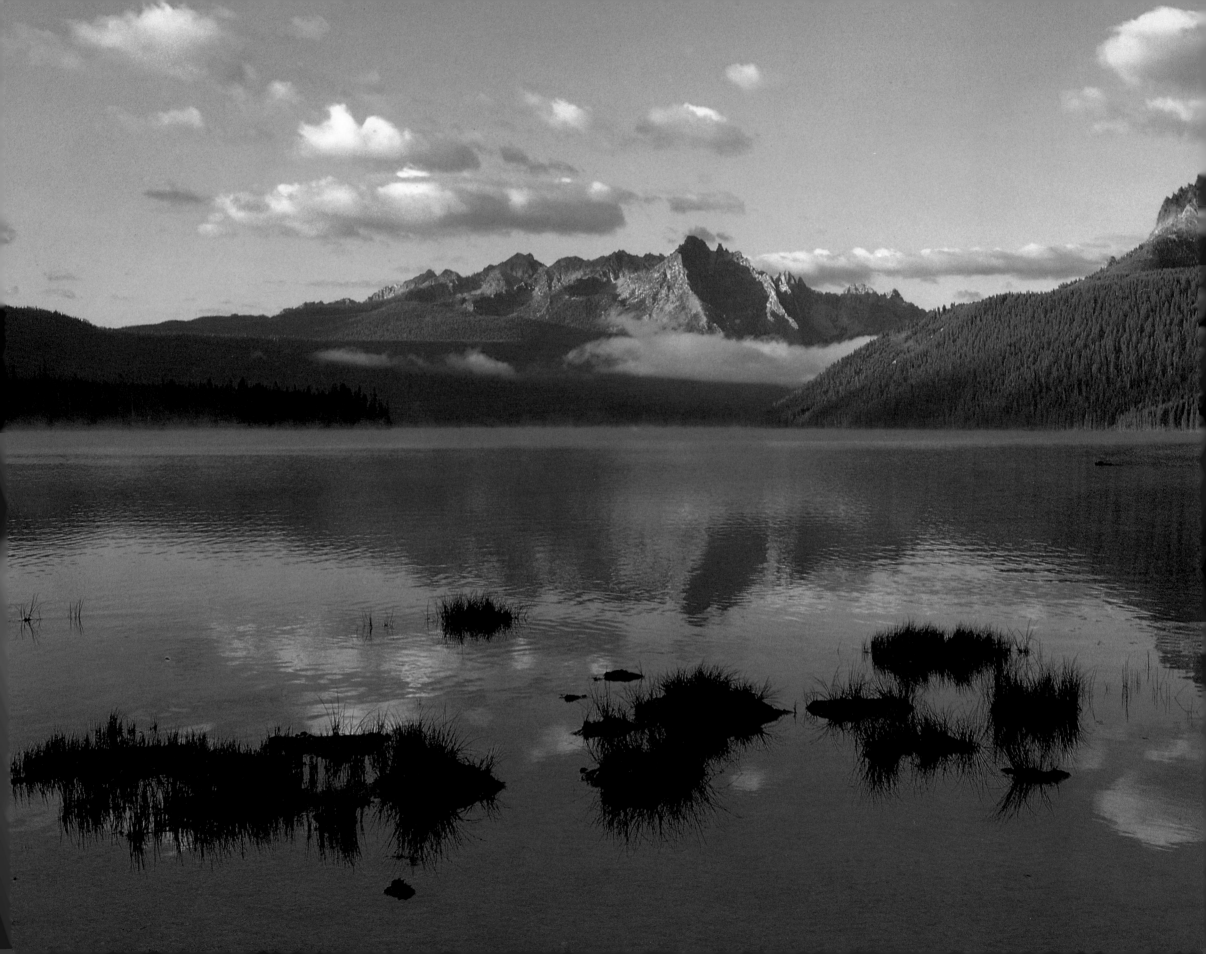

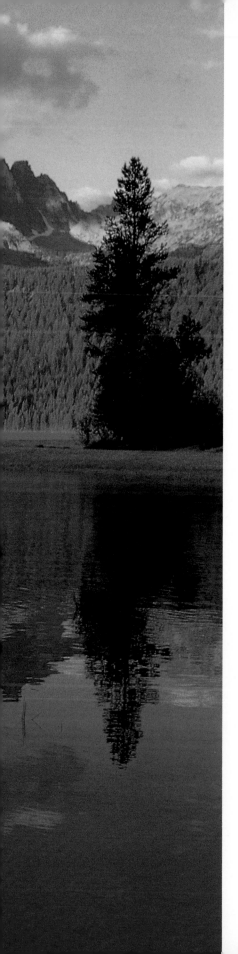

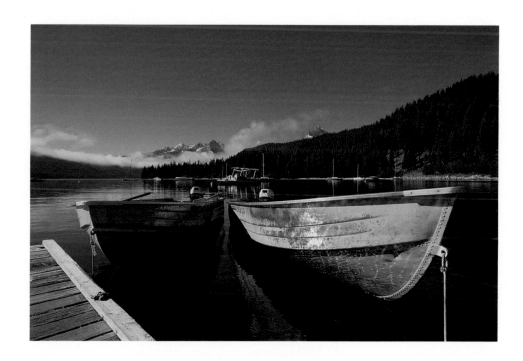

DOCKS—REDFISH RESORT
Plate 118

REDFISH LAKE
Plate 117

LITTLE REDFISH LAKE
Next Page: Plate 119

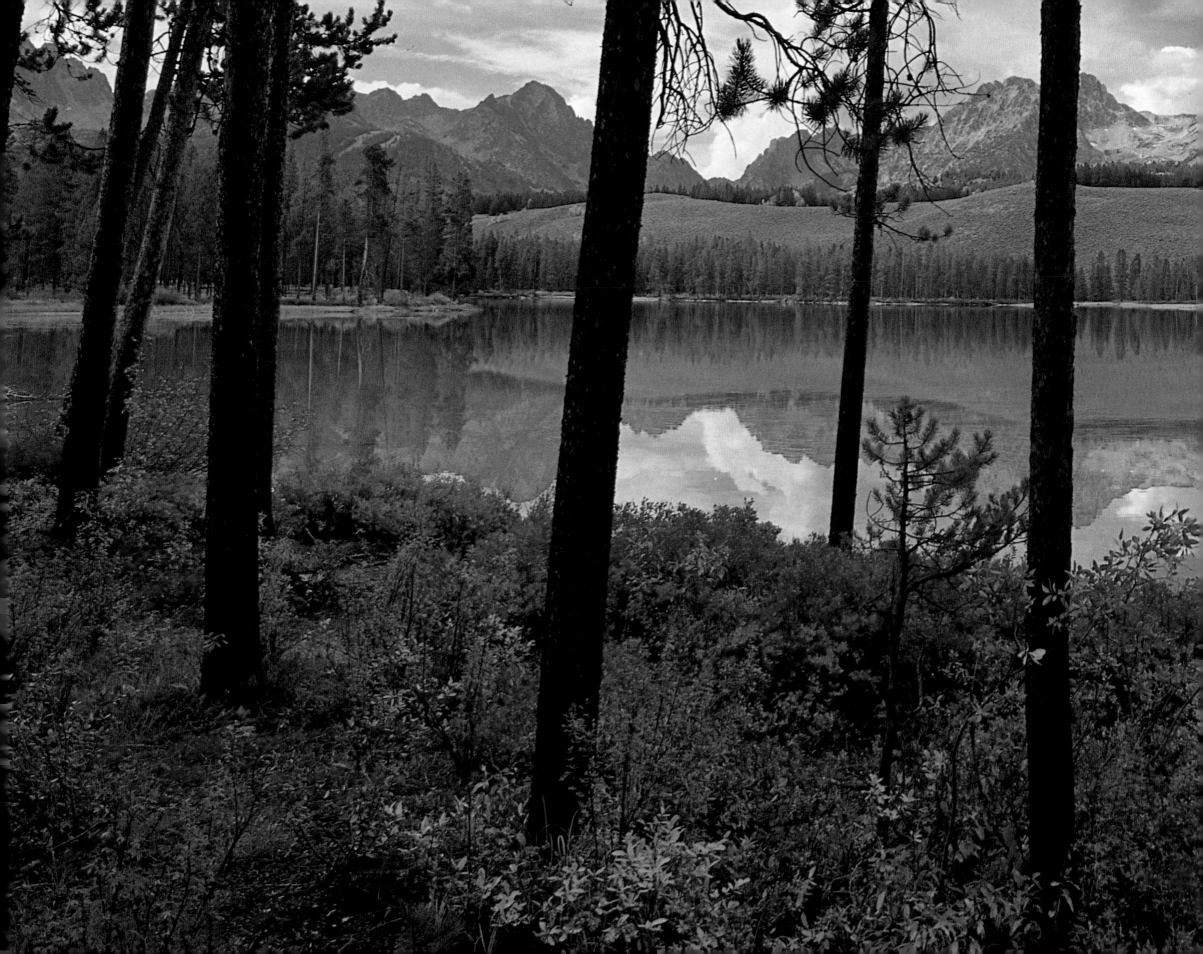

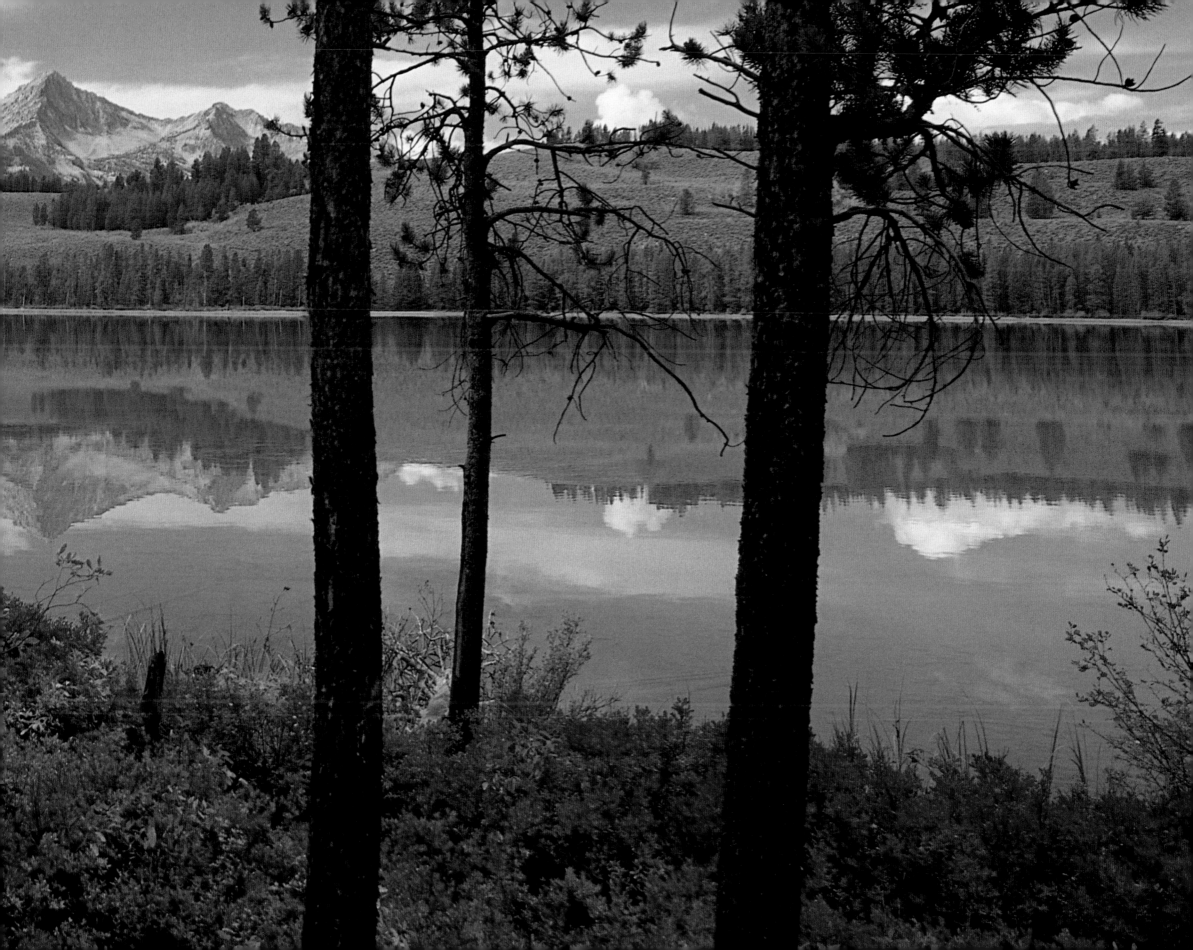

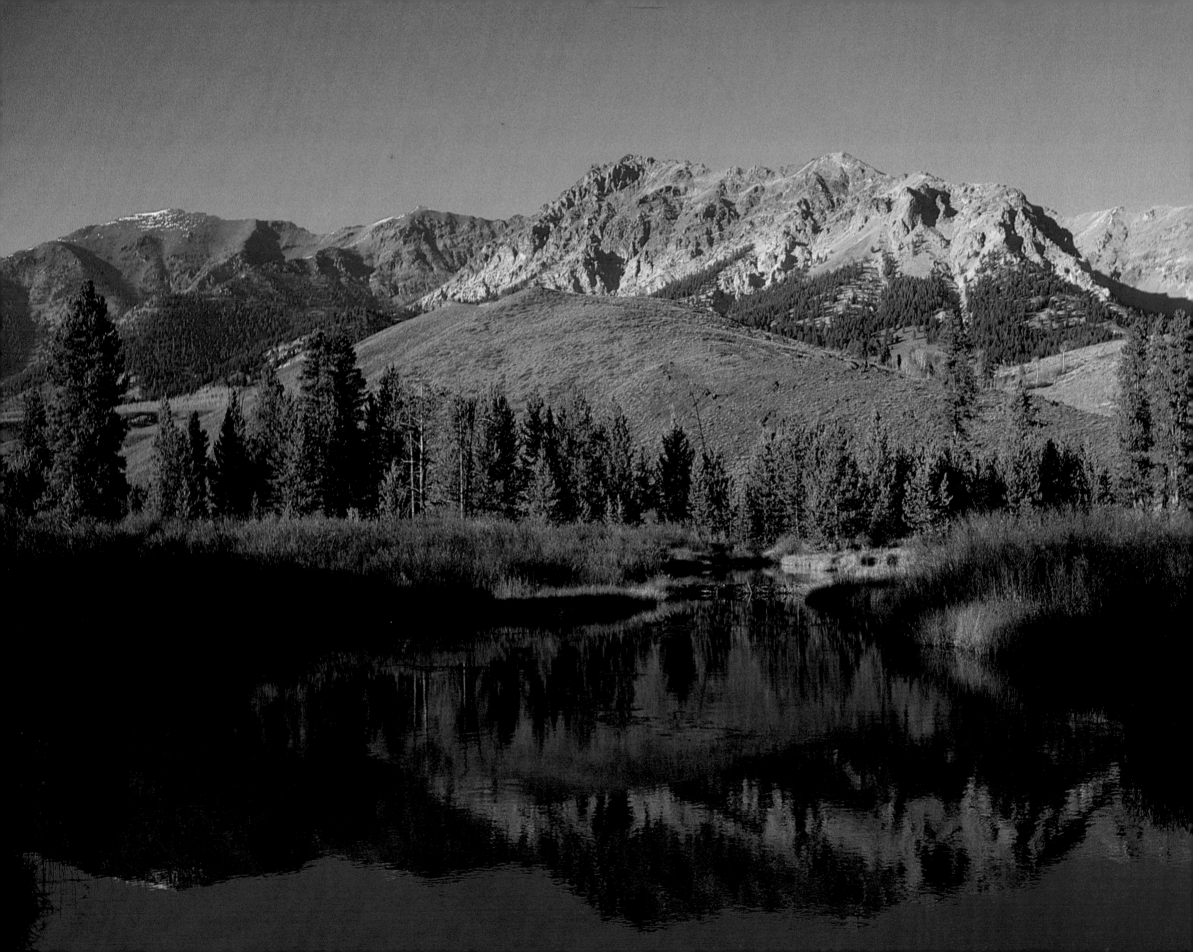

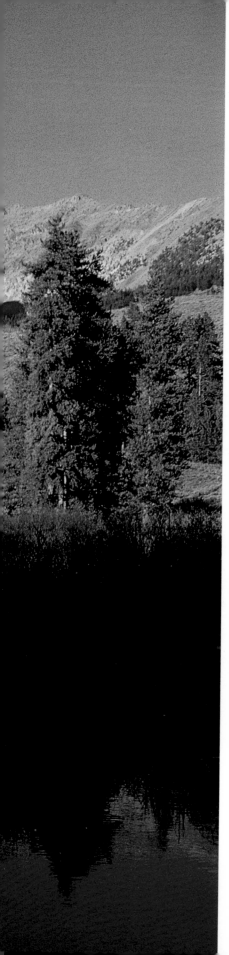

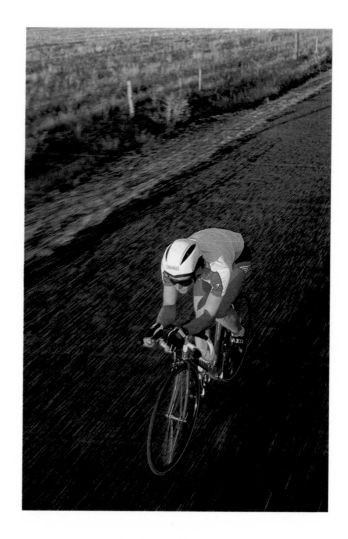

BIKING—GANNETT
Plate 121

BEAVER PONDS—BOULDER MOUNTAINS
Plate 120

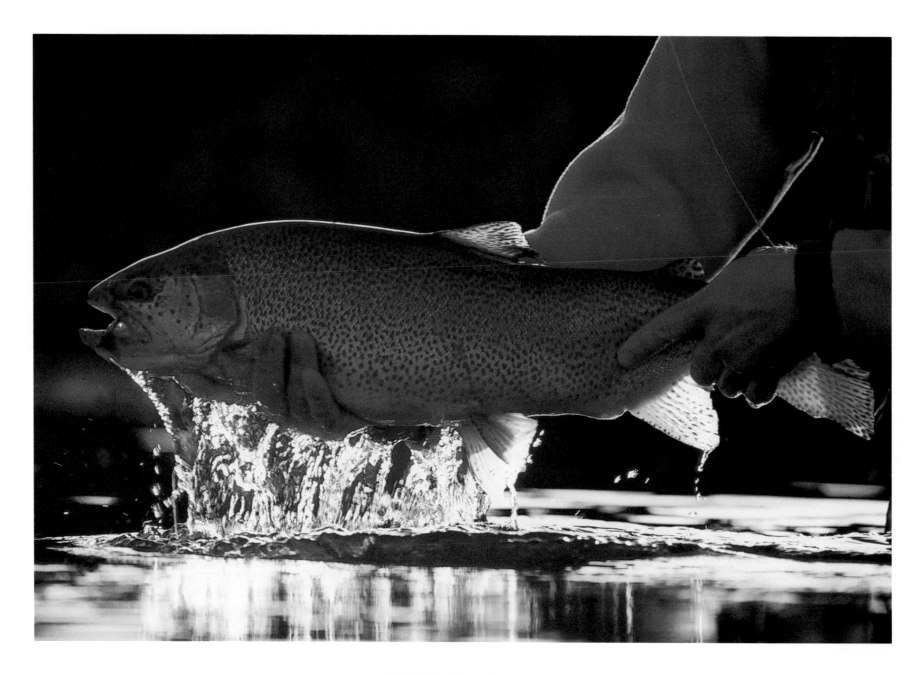

RAINBOW TROUT—LOVING CREEK
Plate 122

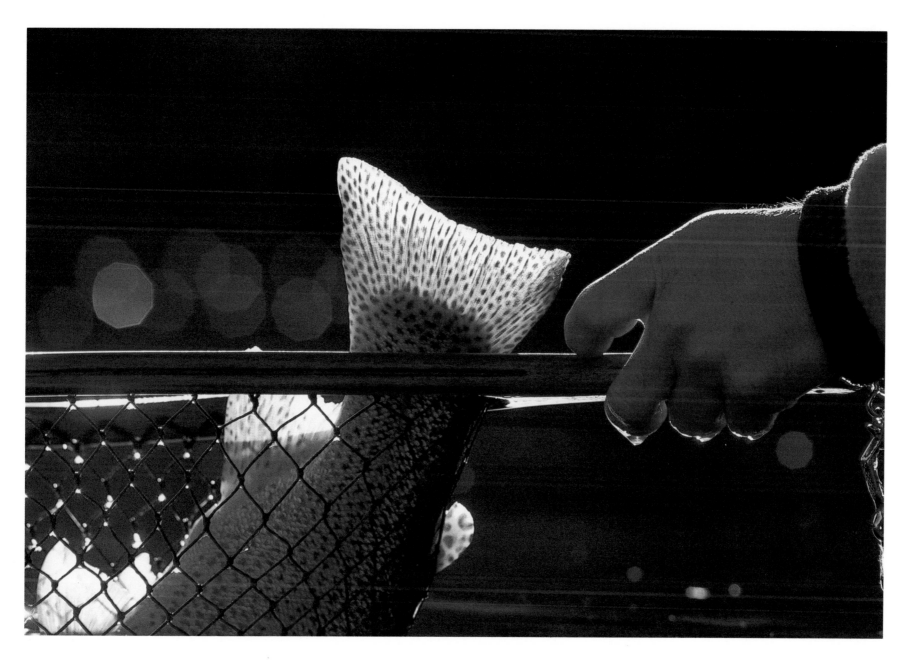

"THE CATCH"—LOVING CREEK
Plate 123

FISHING—SALMON RIVER
Next Page: Plate 124

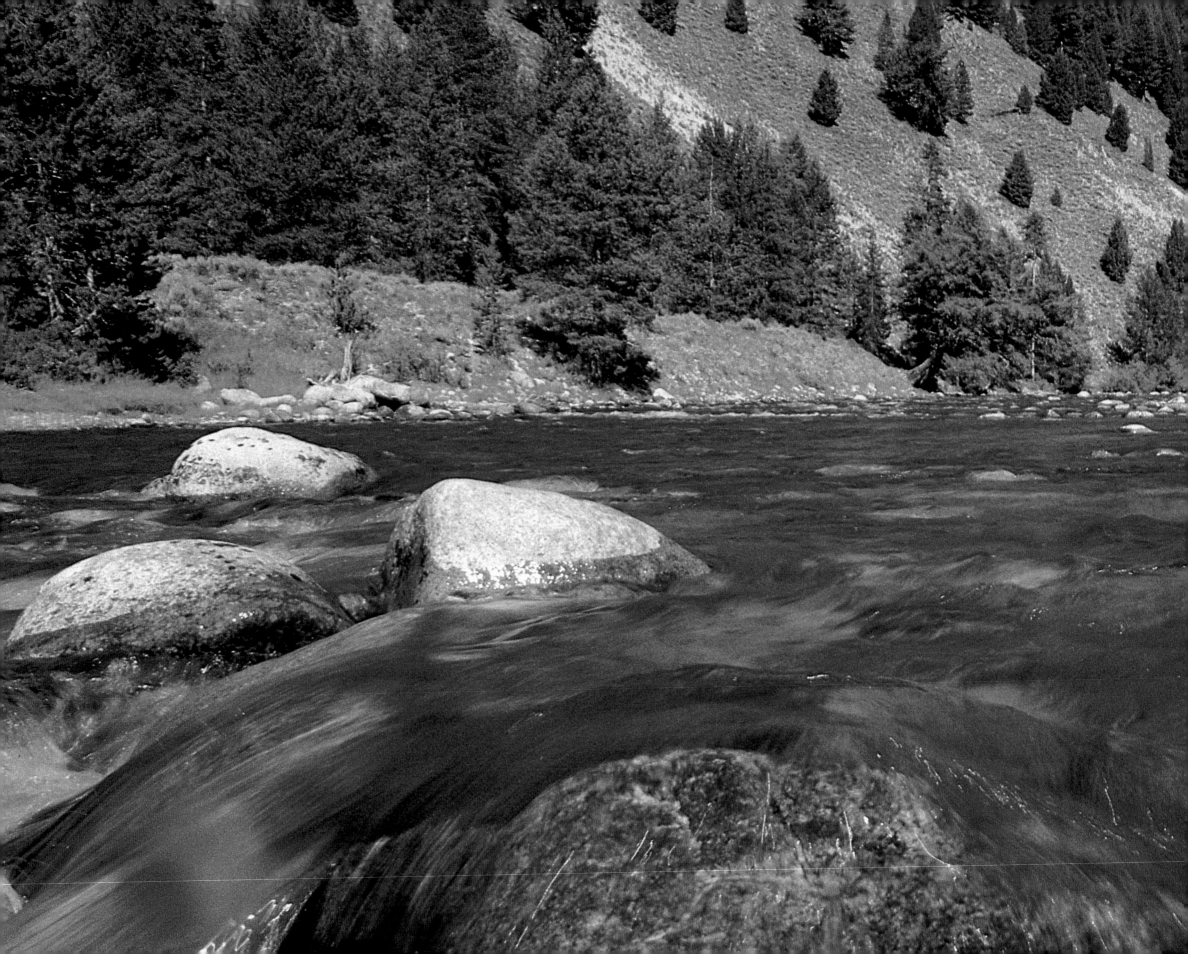

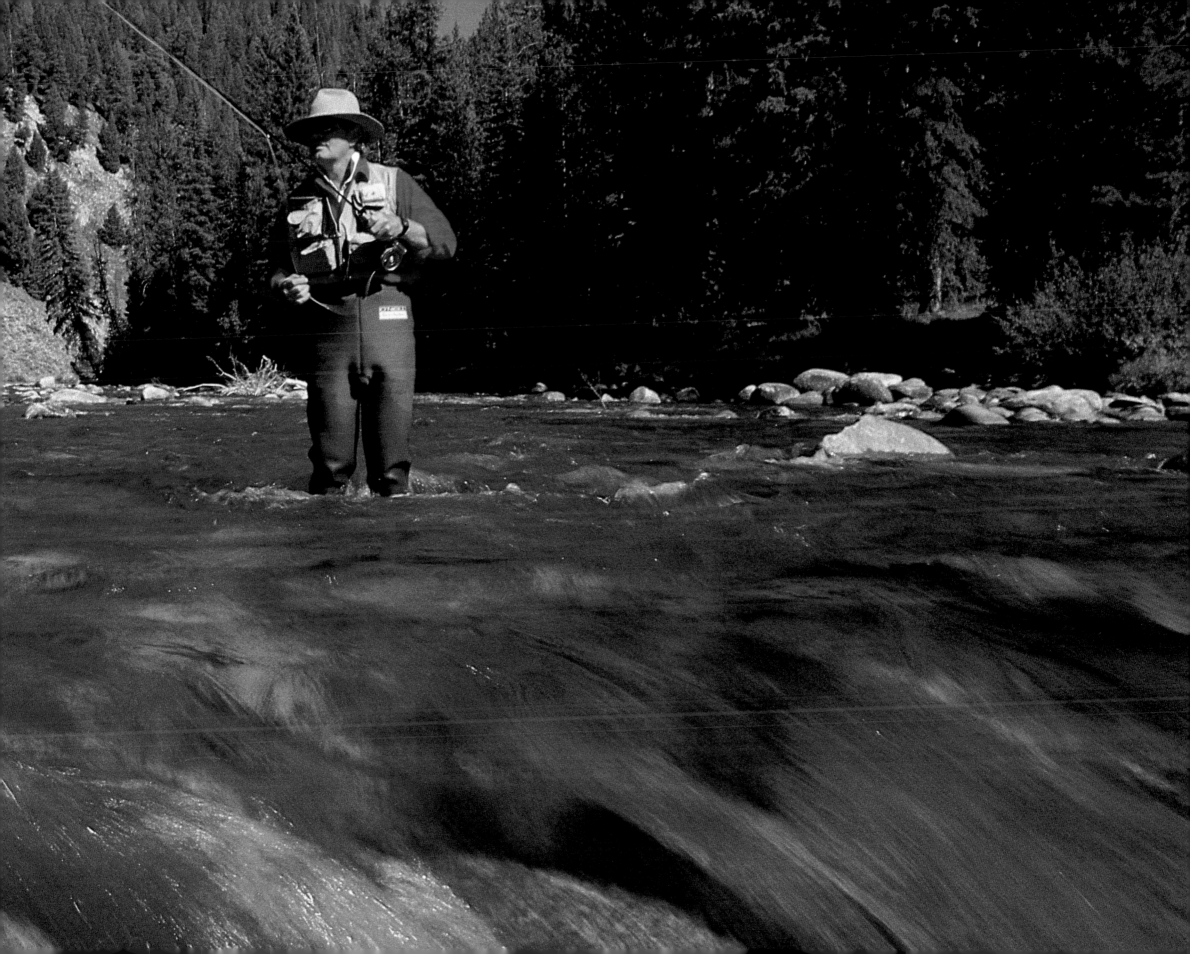

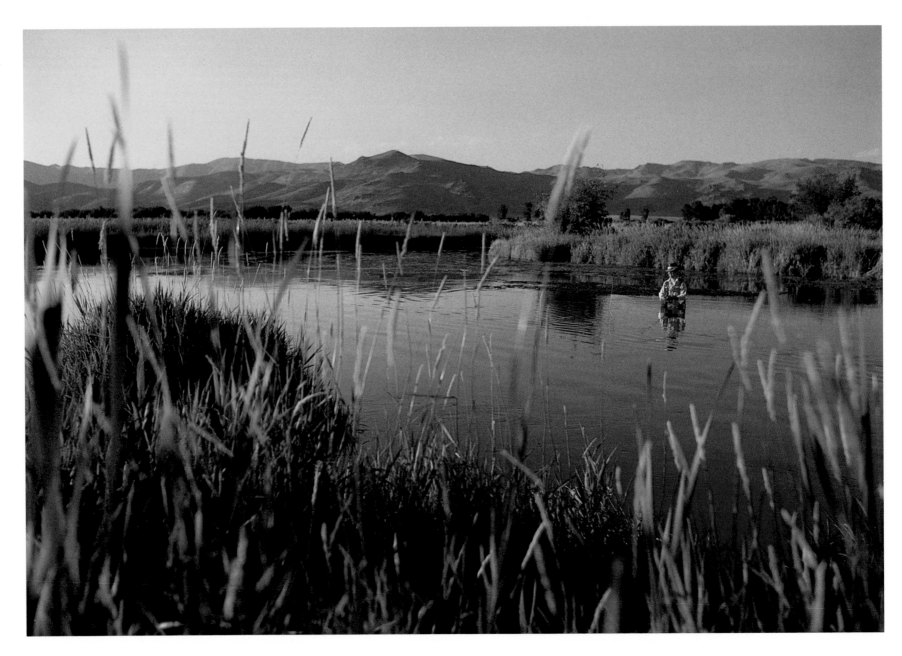

SILVER CREEK
Plate 125

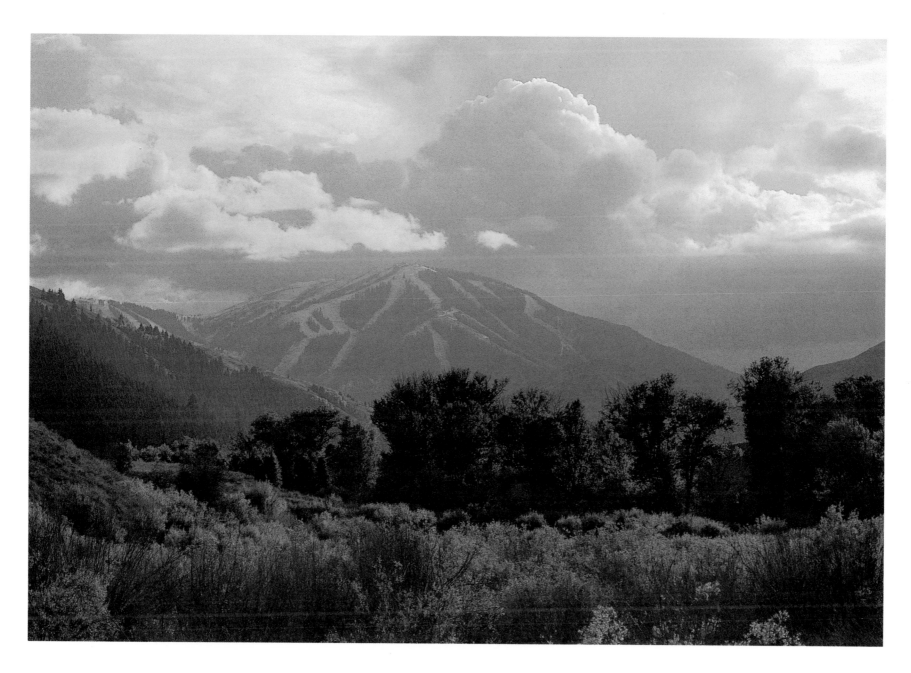

BALDY FROM TRAIL CREEK
Plate 126

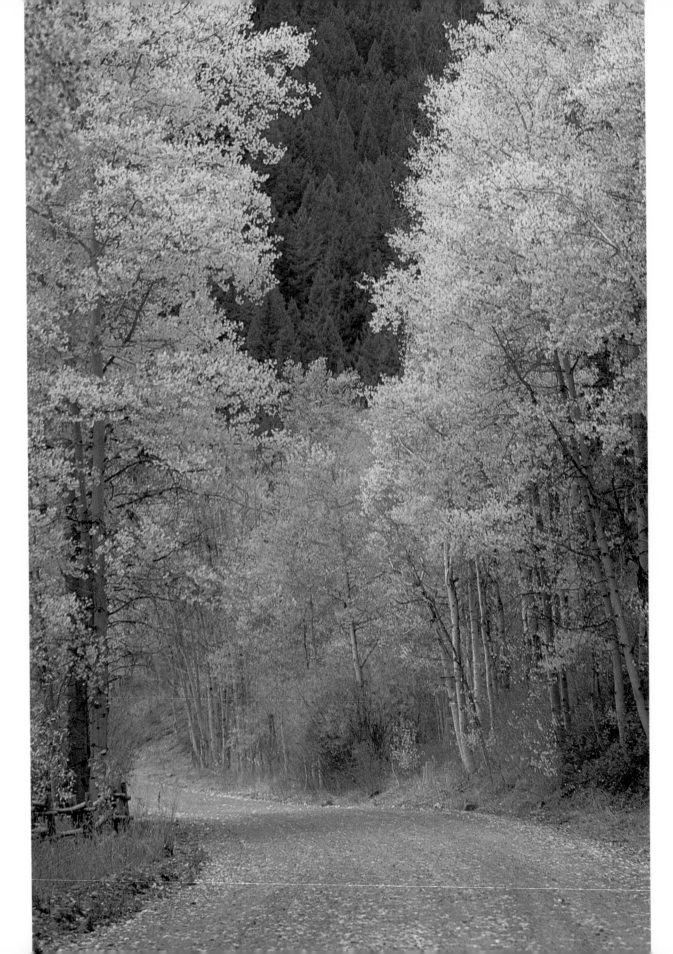

WARM SPRINGS ROAD—BOARD RANCH
Plate 127

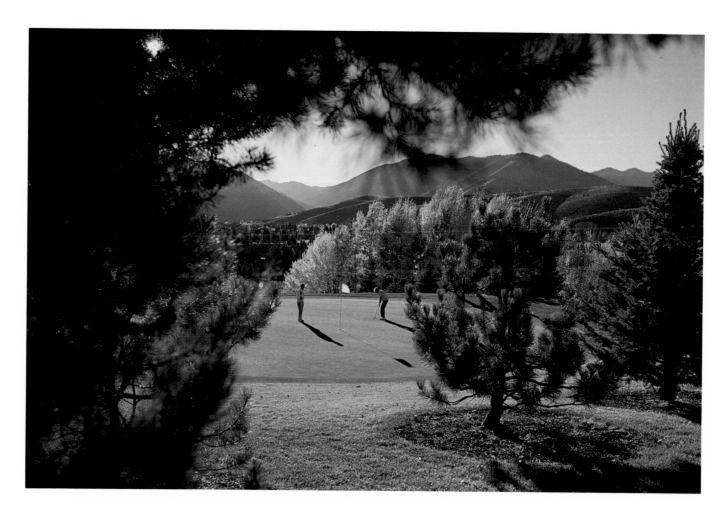

SUN VALLEY GOLF COURSE
Plate 128

ASPEN TREES—BOULDER MOUNTAINS
Next Page: Plate 129

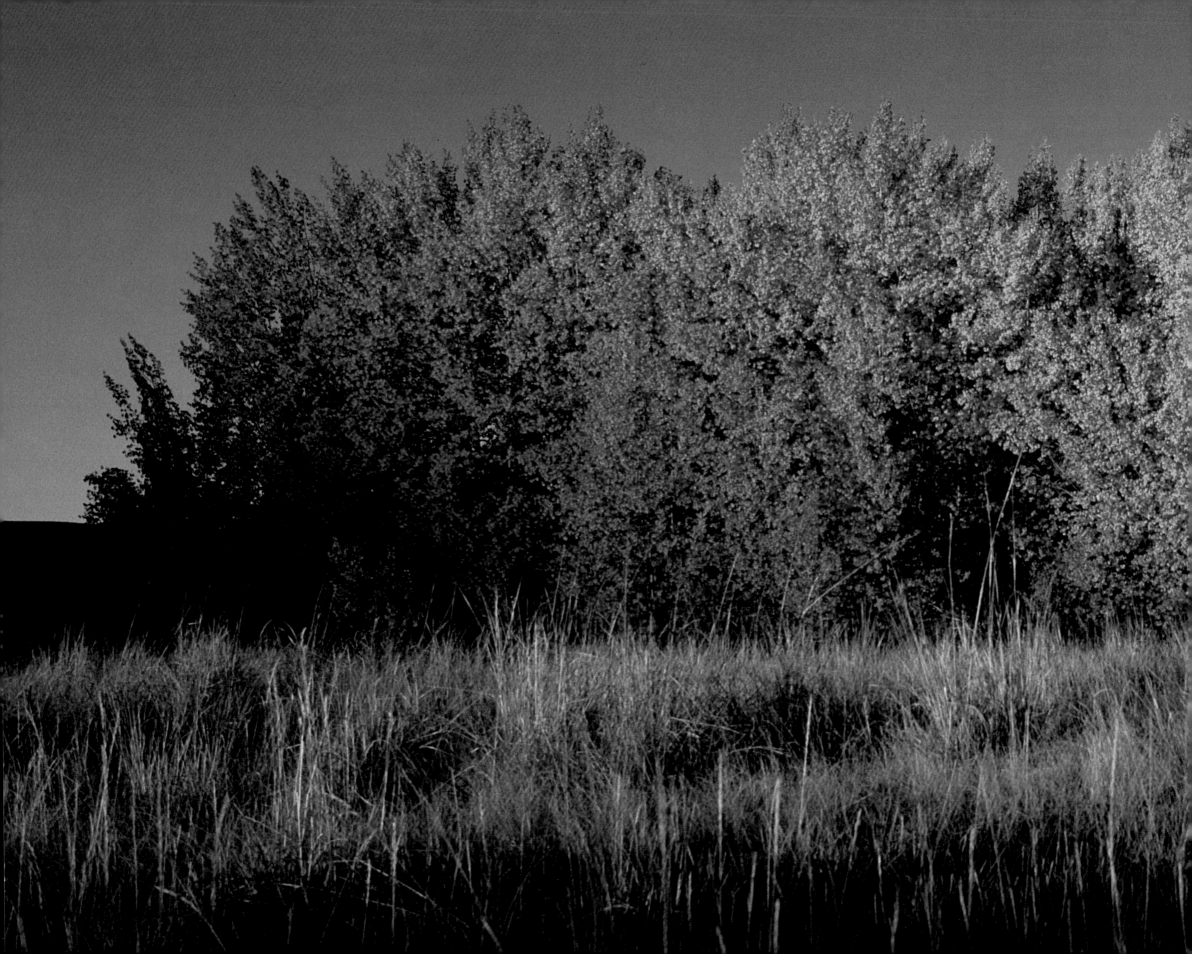

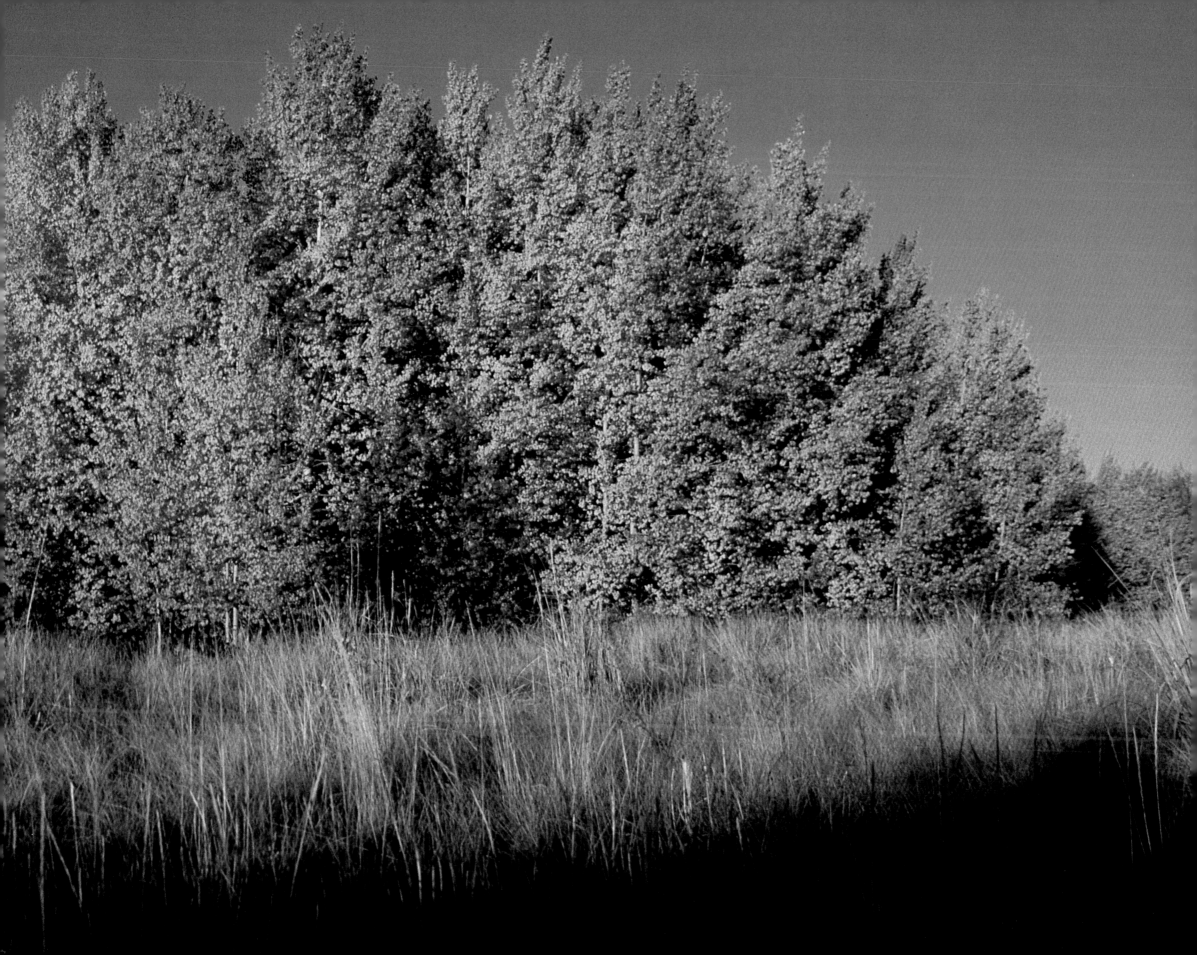

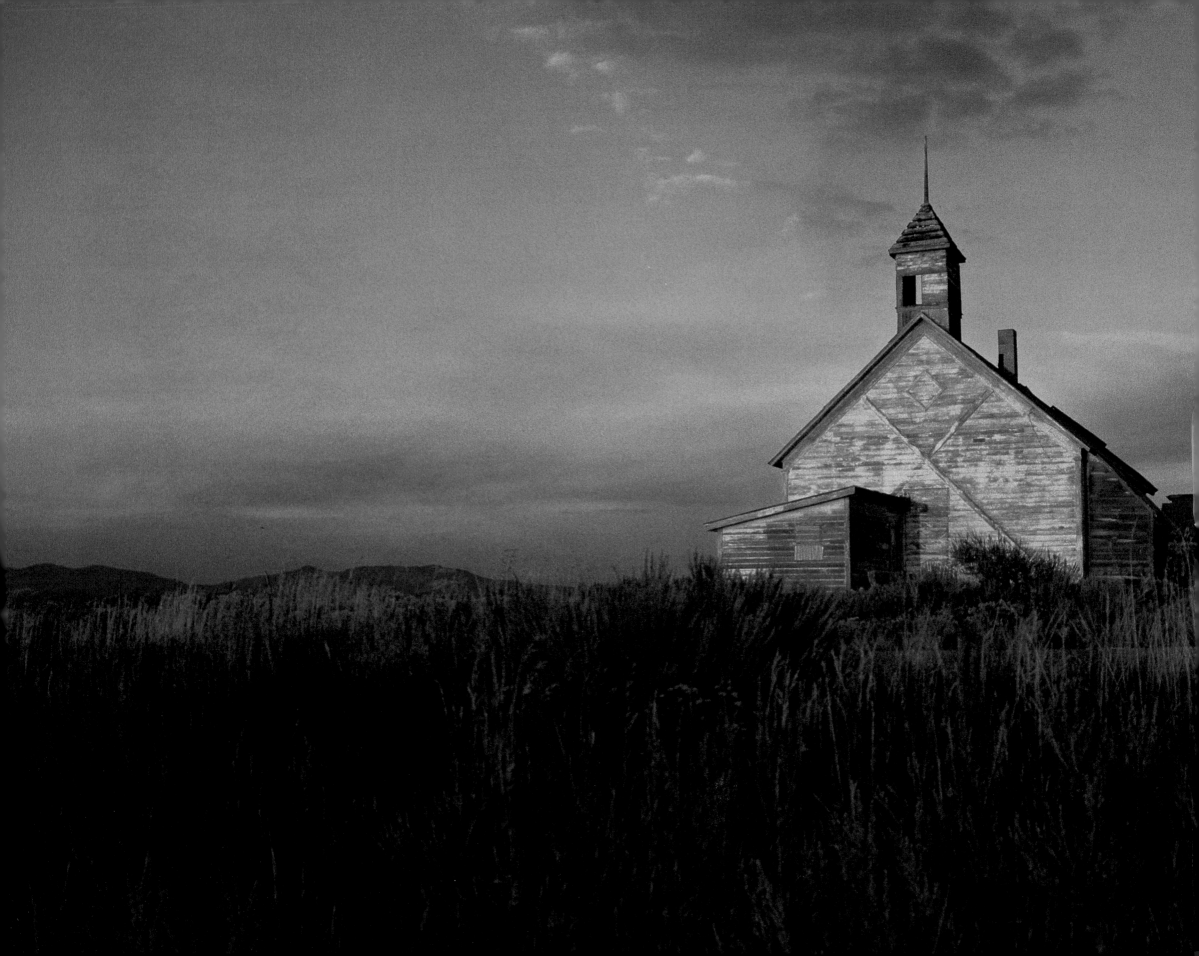

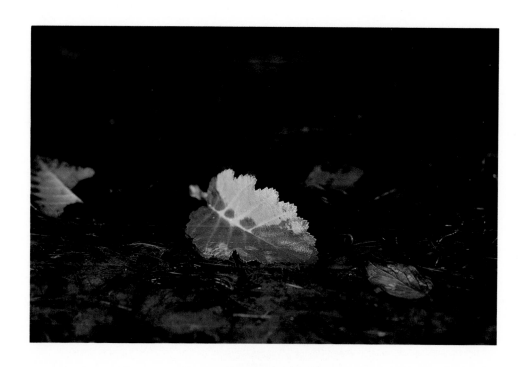

WARM SPRINGS CREEK
Plate 131

OLD SCHOOL—CORRAL
Plate 130

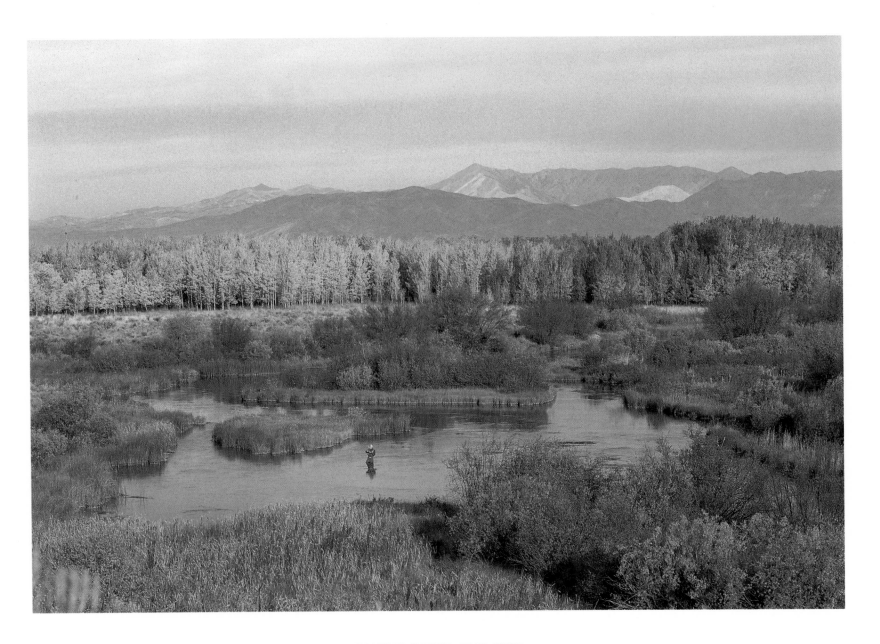
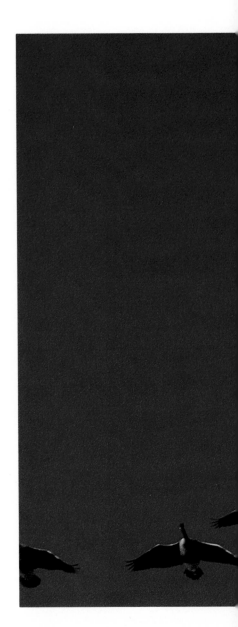

SULLIVAN'S SLOUGH—SILVER CREEK
Plate 132

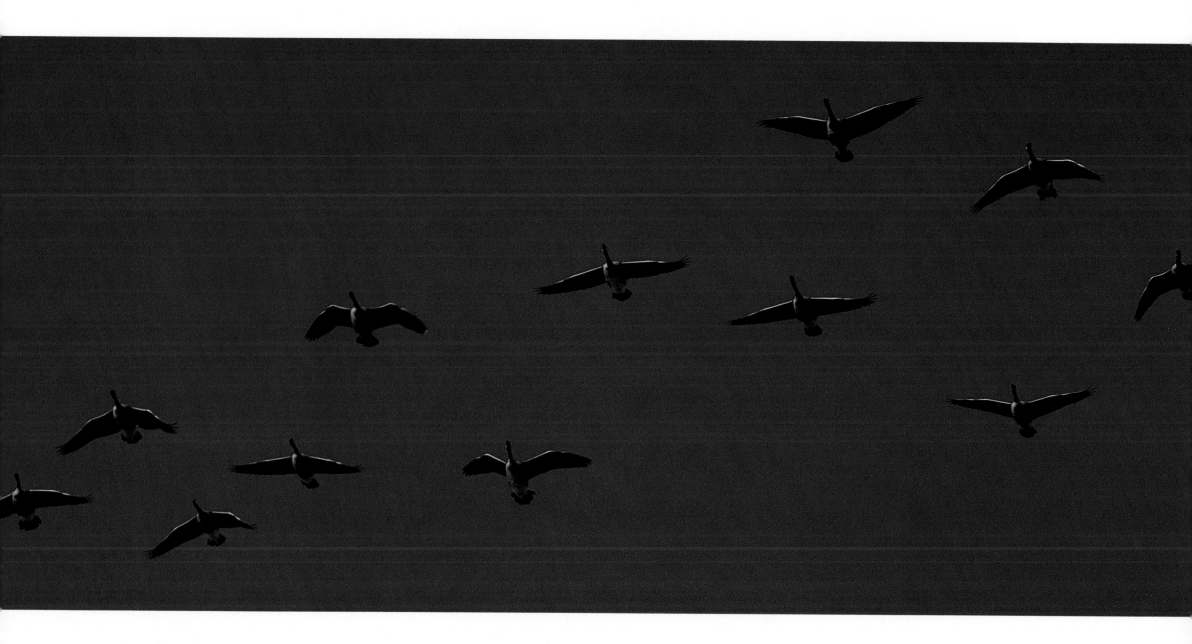

CANADIAN GEESE—SILVER CREEK
Plate 133

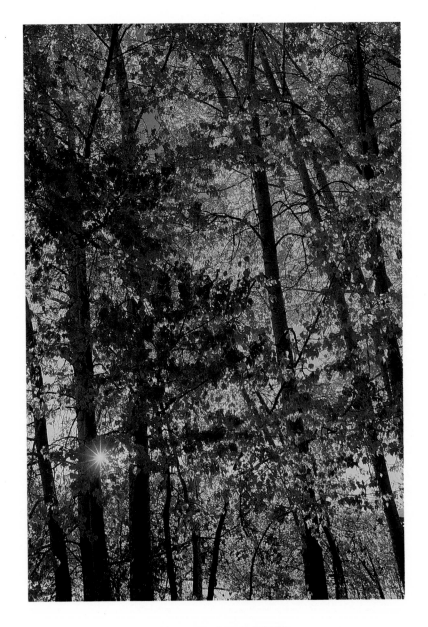

ASPEN TREES—WARM SPRINGS
Plate 134

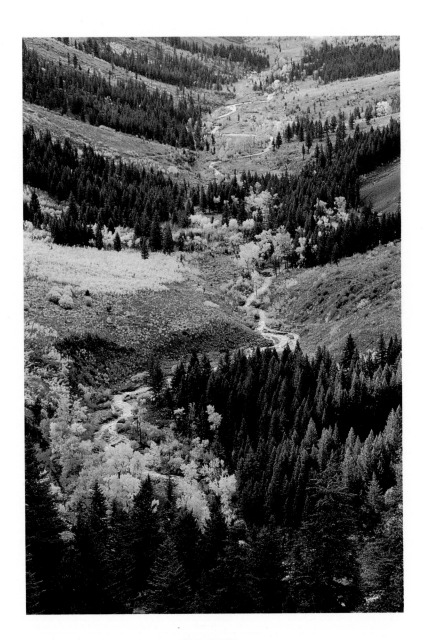

TRAIL CREEK
Plate 135

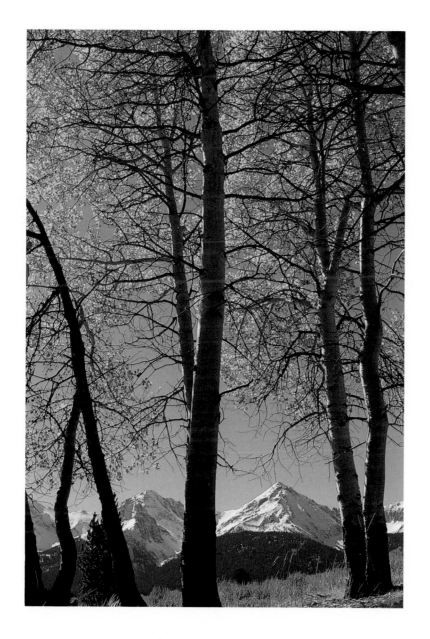

NORTH FORK OF THE BIG LOST RIVER
Plate 136

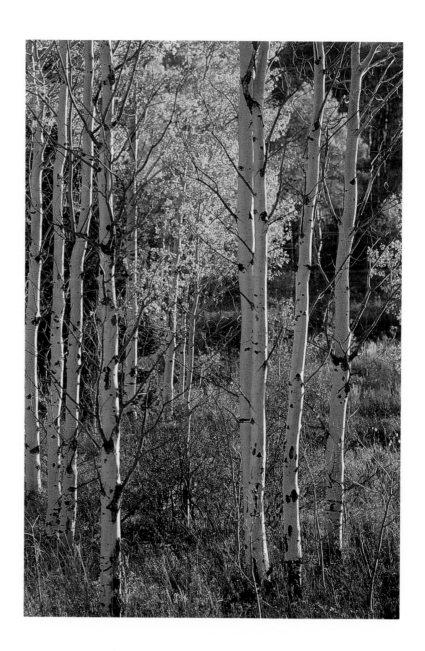

ASPEN GROVE IN THE BOULDER MOUNTAINS
Plate 137

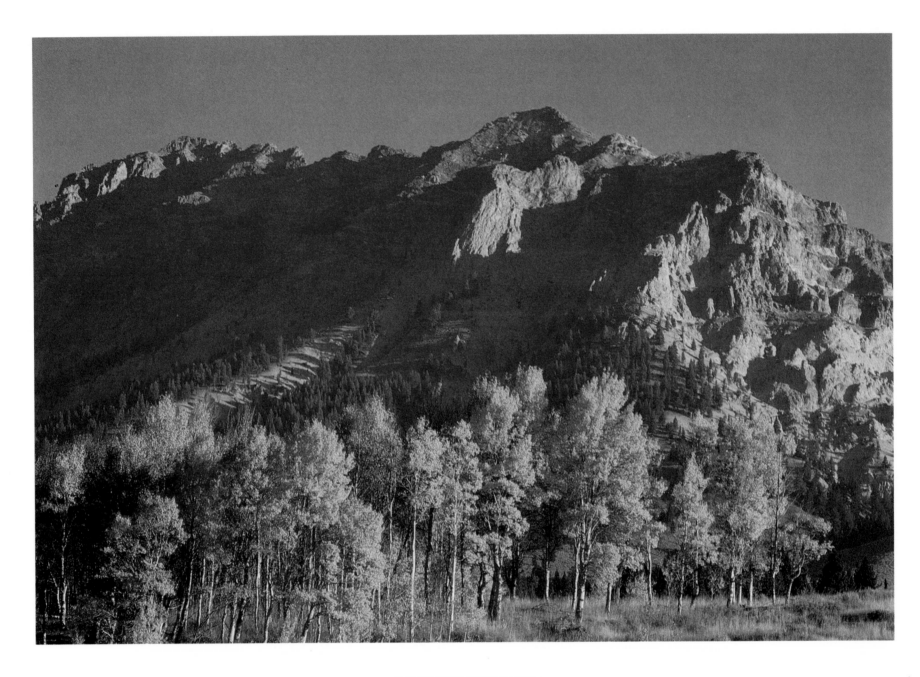

TOP OF SILVER CREEK IN THE
BOULDER MOUNTAINS
Plate 138

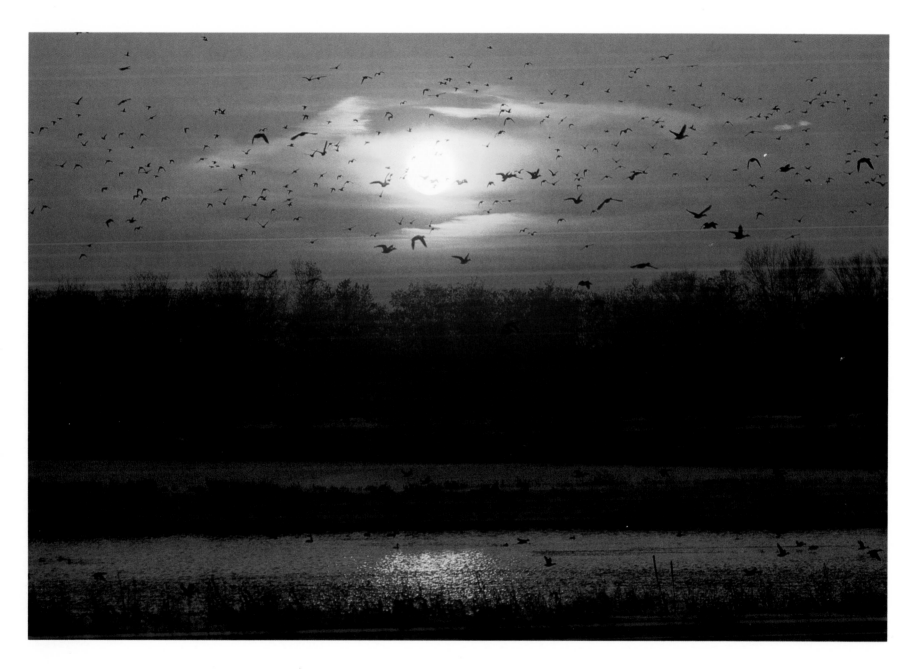

SUNSET ON THE SNAKE RIVER—HAGERMAN
Plate 139

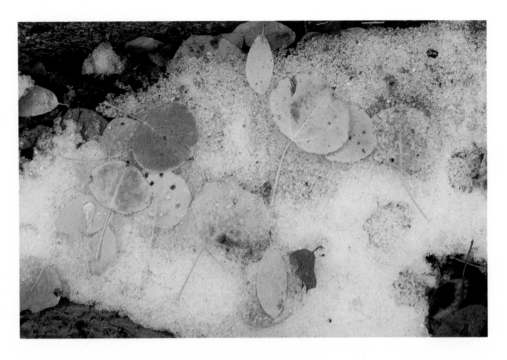

FROZEN ASPEN LEAVES
Plate 140

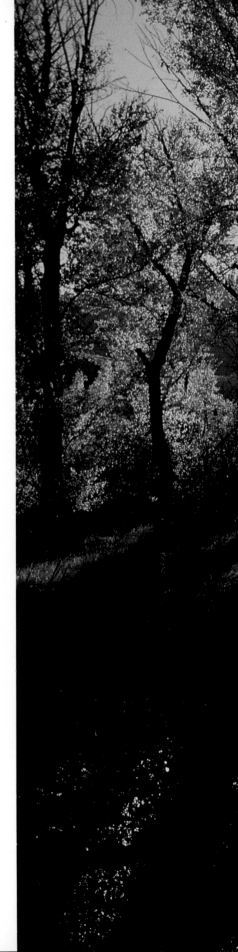

BIG WOOD RIVER
Plate 141

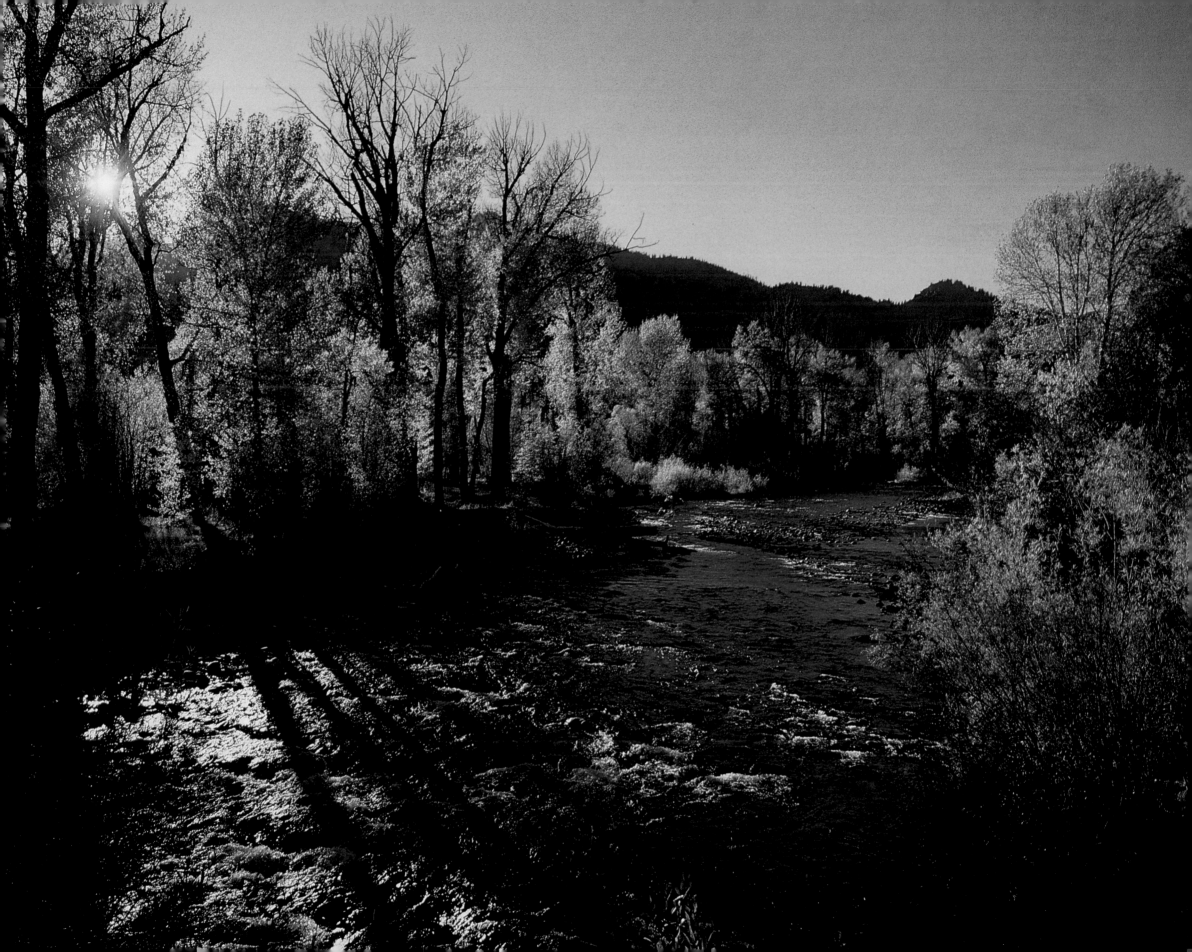

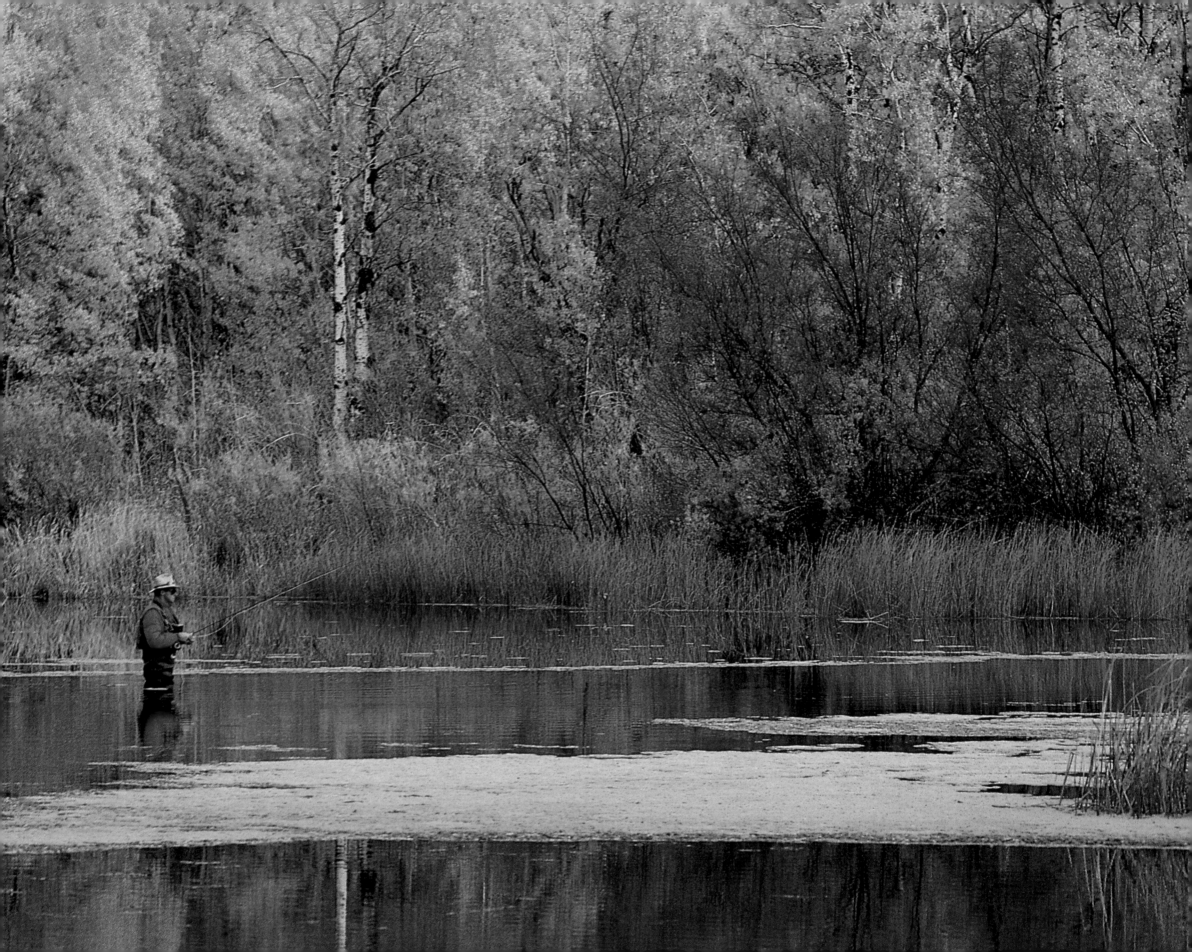

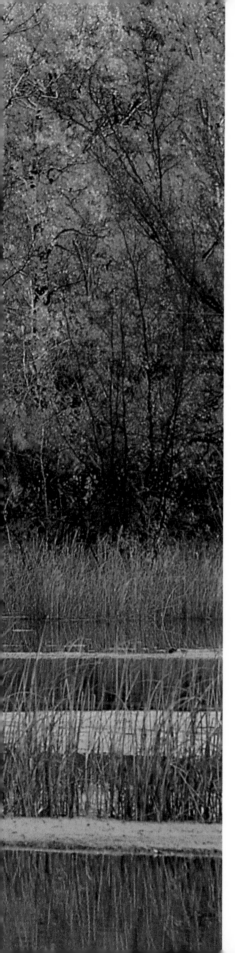

SULLIVAN'S SLOUGH
Plate 143

FLY FISHING SULLIVAN'S SLOUGH
Plate 142

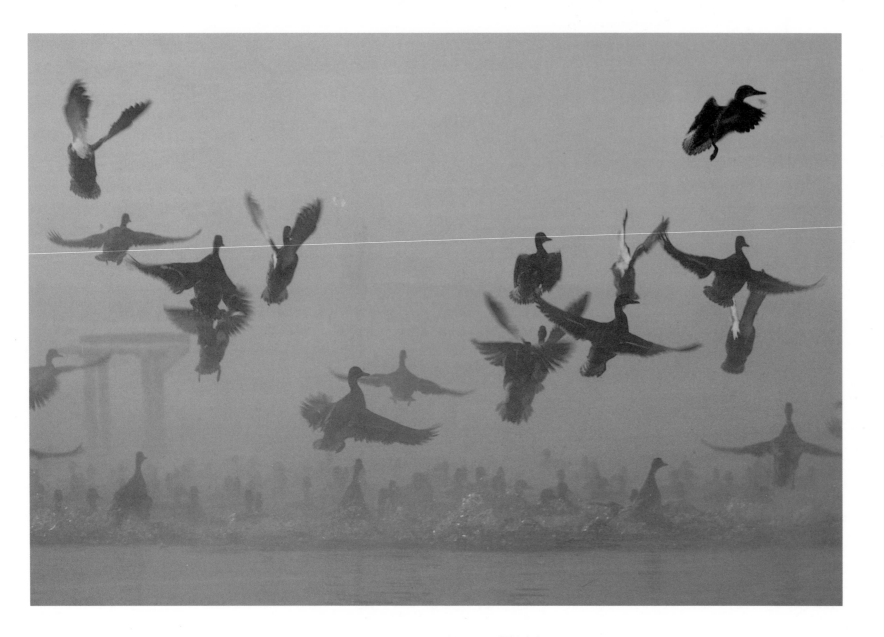

MALLARDS—STATE PRESERVE—HAGERMAN
Plate 144

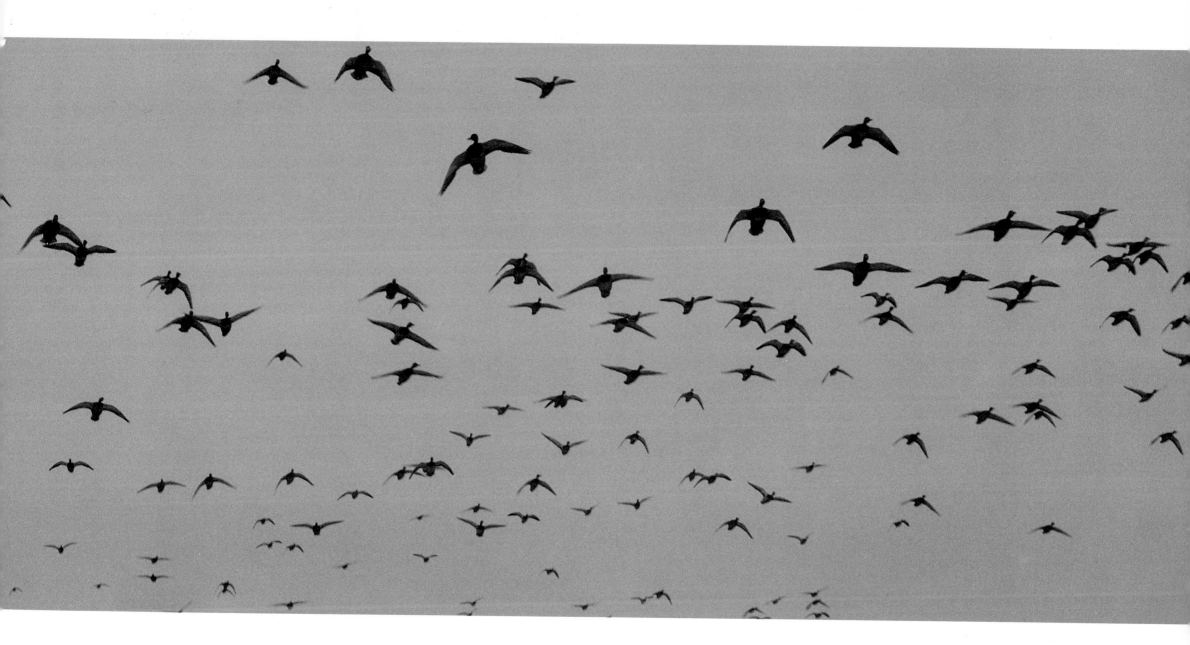

MALLARDS COMING INTO CORN—HAGERMAN
Plate 145

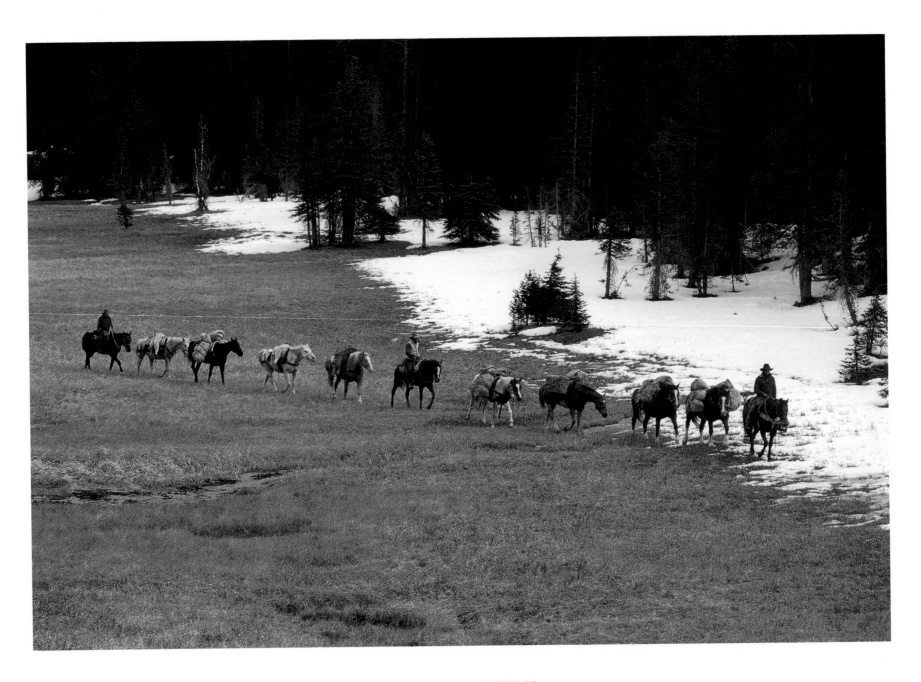

ELK HUNTING—HEADWATERS OF
THE SALMON RIVER
Plate 146

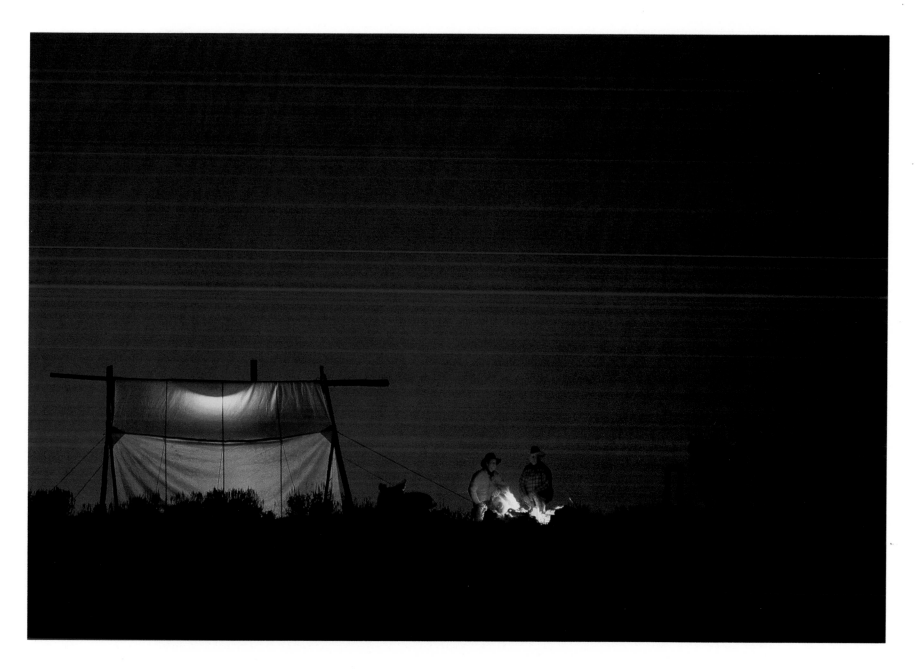

ELK CAMP—WHITE CLOUD MOUNTAINS
Plate 147

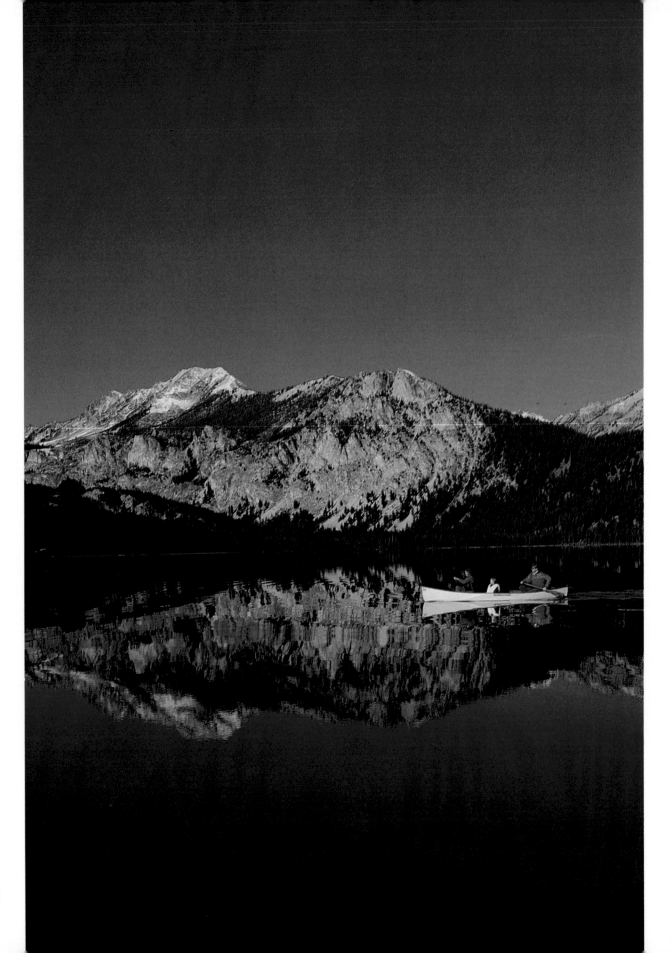

PETTIT LAKE
Plate 148

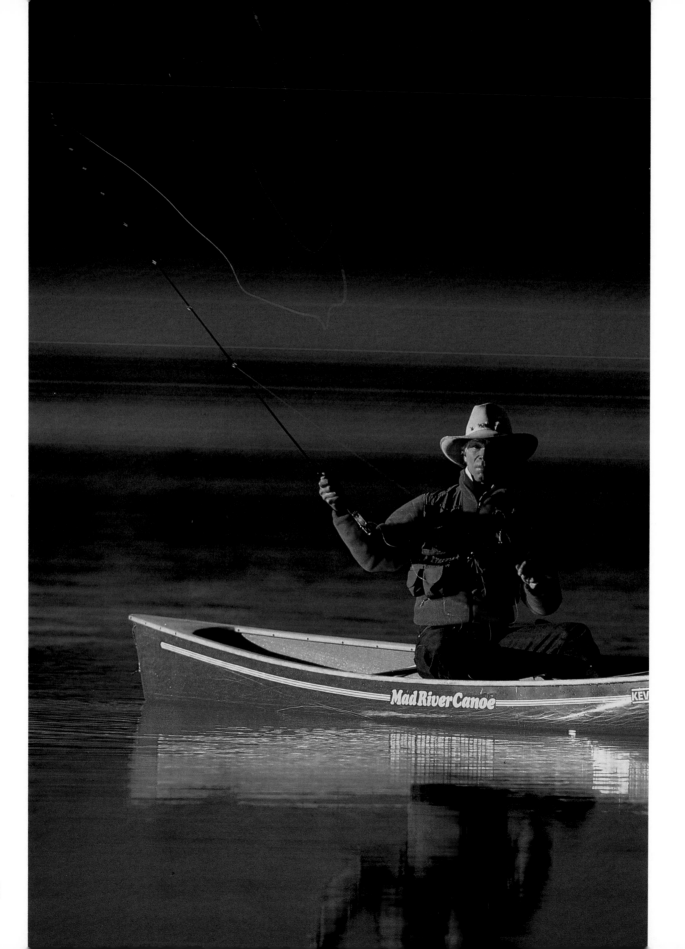

FISHING LITTLE REDFISH LAKE
Plate 149

SUN VALLEY POND
Next Page: Plate 150

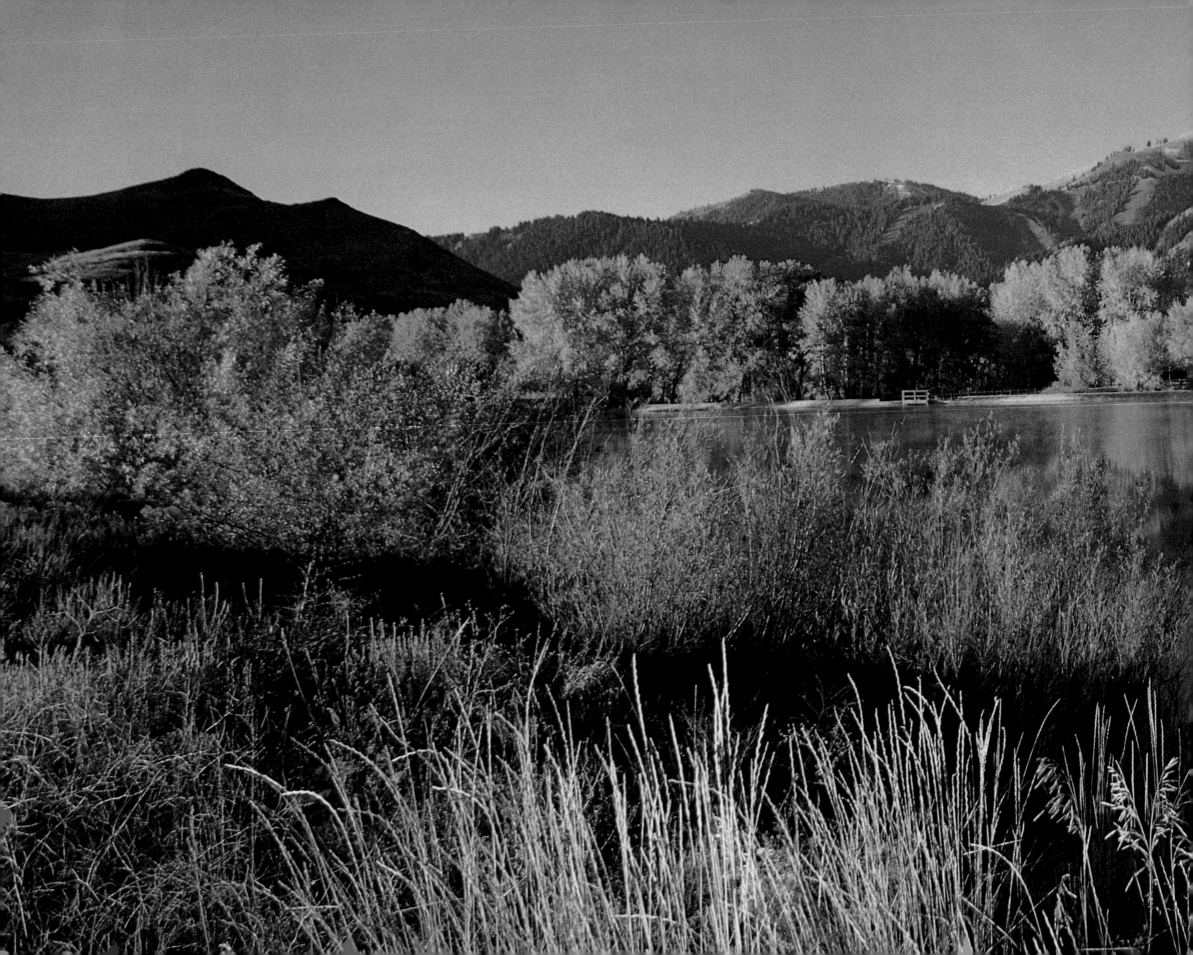

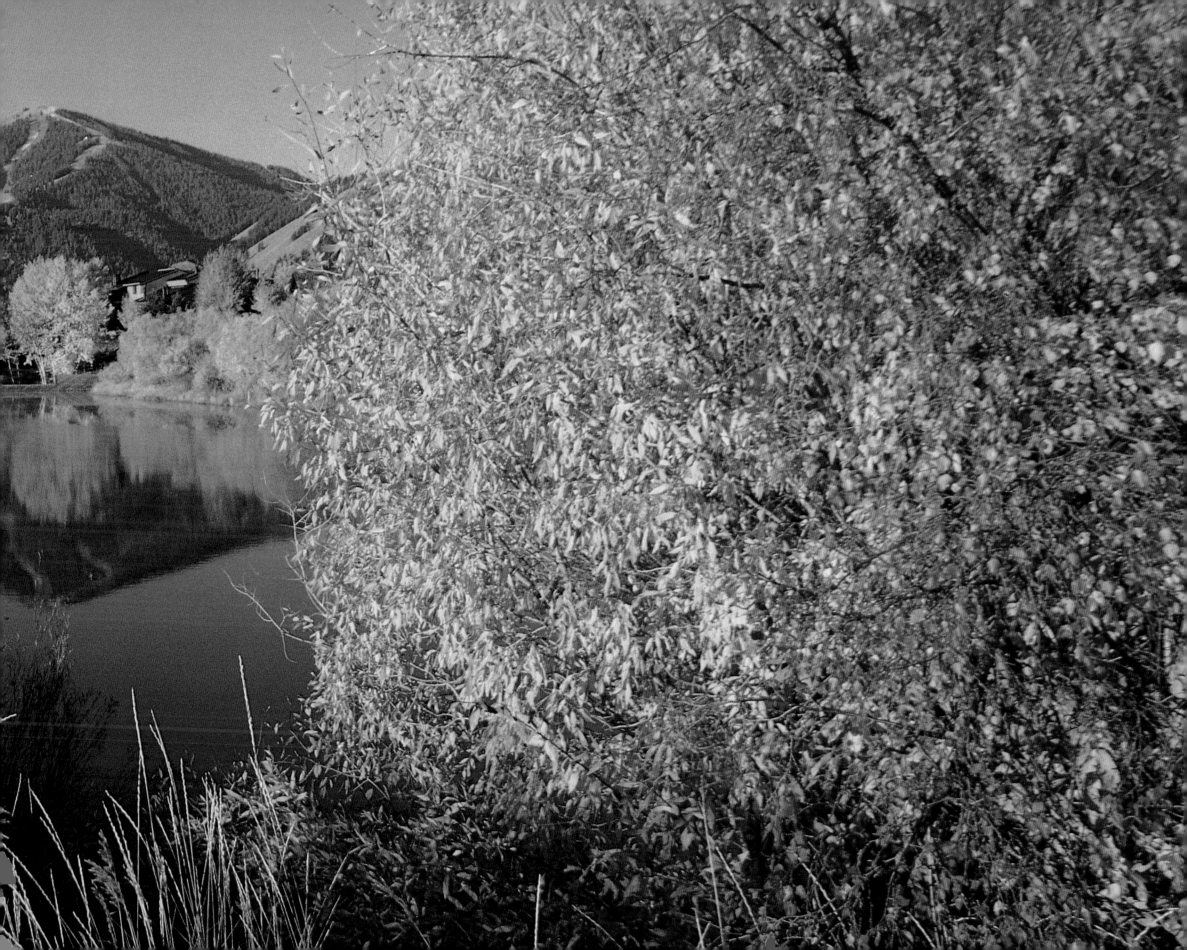

M O D E L S

Photo: Gretchen Palmer

ABOUT THE PHOTOGRAPHER

David Stoecklein is sought by international corporations including Kodak, Coca-Cola, Chrysler and Fila for his photography. Magazines and ad agencies around the world use his outdoor lifestyle images. Though his assignments require that he travel often, he still photographs in Sun Valley whenever possible. He lives in Sun Valley with his wife Mary and their children Drew, Taylor and Colby.

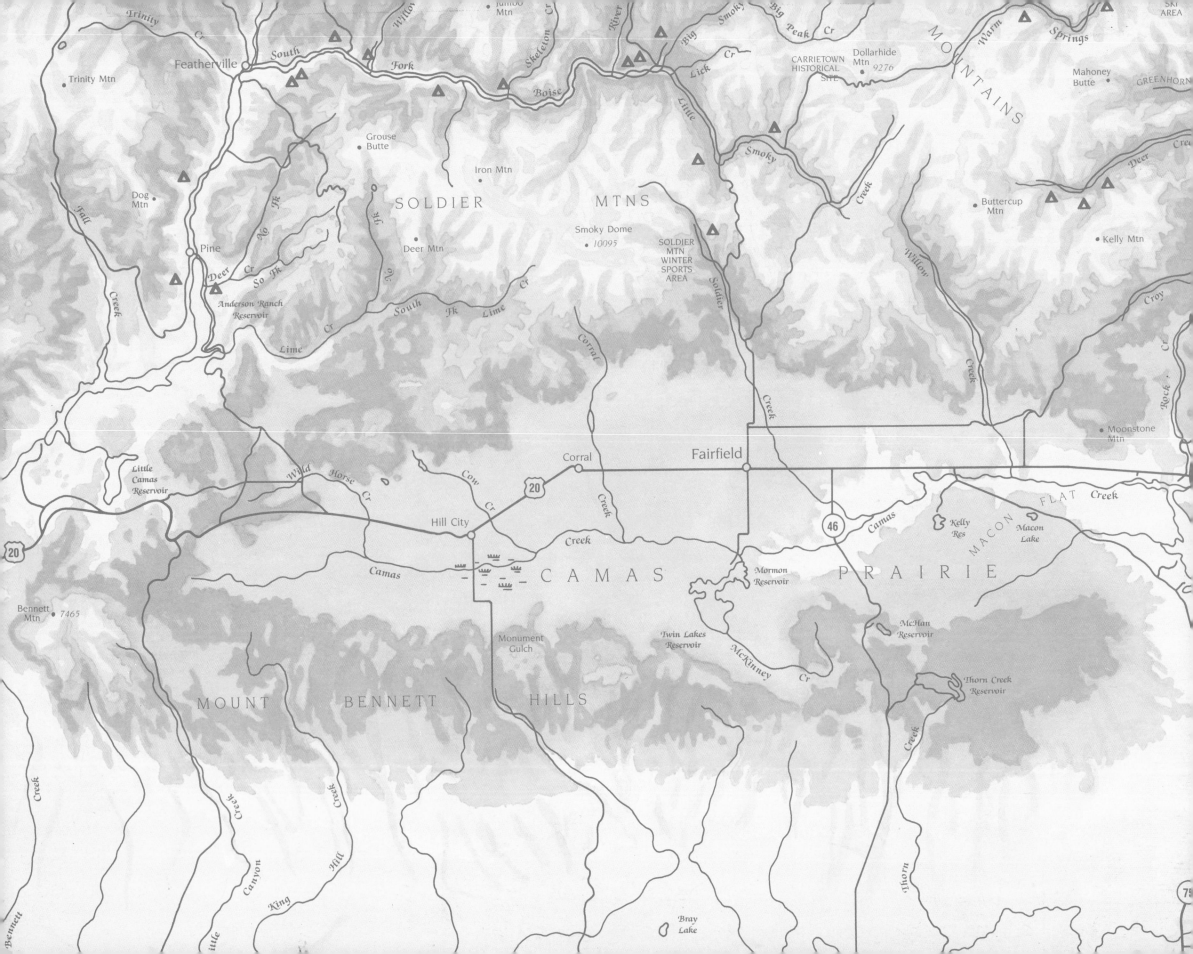